PREHISTORIC
ROCK ART
in NORTHUMBERLAND

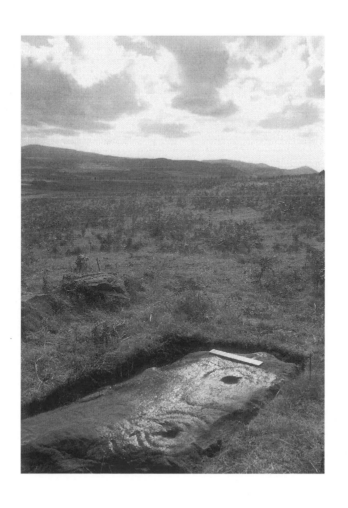

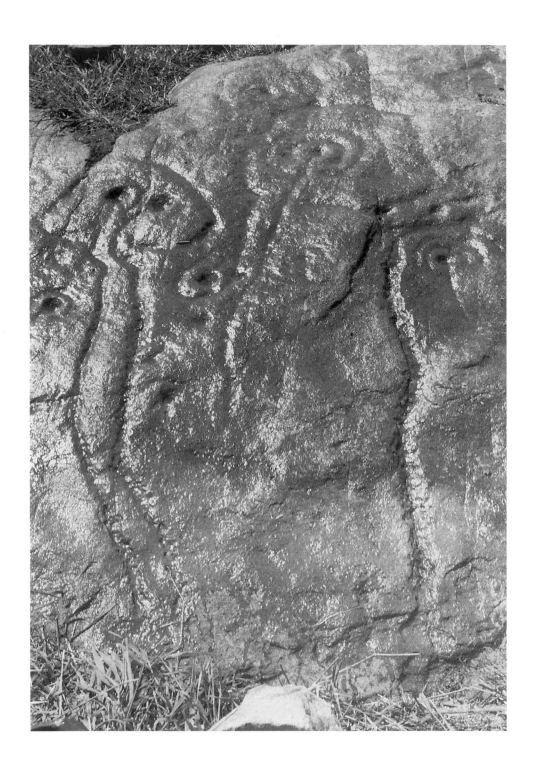

PREHISTORIC ROCK ART
in NORTHUMBERLAND

Stan Beckensall

The
History
Press

First published 2001
Reprinted 2006

Reprinted in 2014 by
The History Press
The Mill, Brimscombe Port,
Stroud, Gloucestershire, GL5 2QG
www.thehistorypress.co.uk

British Library Cataloguing in Publication Data.
A catalogue record for this book is available from the British Library.

ISBN 978 0 7524 1945 9

Typesetting and origination by
Tempus Publishing Limited.
Printed in Great Britain.

Contents

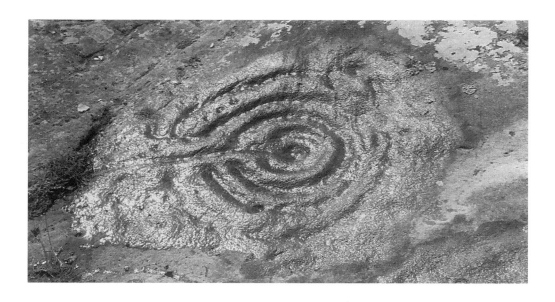

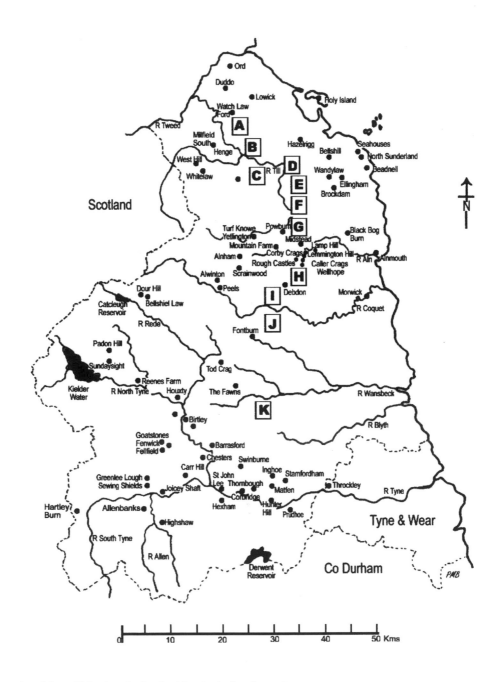

1 Map of Northumberland with principal rock art sites
 A: Broomridge, Roughting Linn, Hare Crags; B: Doddington;
 C: Weetwood, Fowberry, Lilburn; D: Chatton Park Hill;
 E: Amerside Law, Ros Castle, Chatton Sandyford; F: Hepburn, Old Bewick;
 G: Beanley, Hunterheugh; H: Millstone Burn, Snook Bank; I: Cartington, Chirnells Moor; J:
 Lordenshaw; K: Wallington, Middleton Bank, Shaftoe, Shortflatt.
 Paul Brown

1 Introduction: setting the scene

I shall use one panel of rock art to help explain what the study of rock art involves; it is accessible to the public and in an exciting landscape setting. Lordenshaw is south of Rothbury, a ridge that slopes to the River Coquet and that rises south-west to the Simonside Hills. To the north-west it overlooks the Coquet valley to the Cheviot Hills, and is naturally stepped in terraces. The highest part of the ridge is occupied by a large prehistoric enclosure of the kind referred to as a 'hill fort'. The next step down to the west has Fell sandstone outcrops that have been partly quarried away; the removal of some massive lumps of rock has left craters along the edge. One large outcrop has survived, however, although part of it has suffered from quarrying. As you stand in front of it, with the view across the Simonside Hills, the river and stream valleys and the Cheviots over and around it, you will see that its natural indentations have been included in a design that covers the sloping surface with 'cups and rings'. In dull weather the decoration may not be easily visible, but when the sun is low in the sky it is brought to life by deep shadows that fill the cups and grooves.

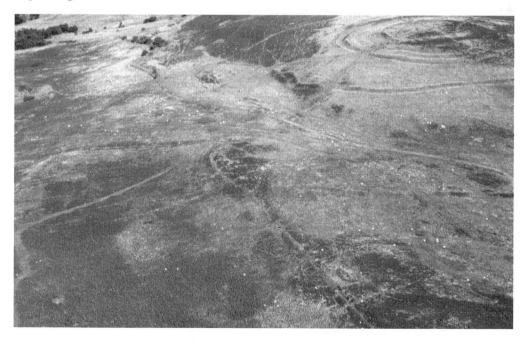

2 The Lordenshaw rock in its landscape setting at the centre of the picture

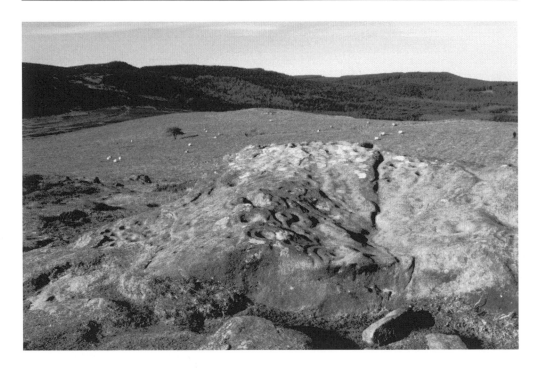

3 The panel, with the Simonside Hills in the background, in strong, low sunlight

Among the ancient markings is a piece of modern graffiti: a cup and two rings with 'Rock Map' pecked on it with a hammer and nail or punch. Some of the ancient decoration has been sliced through by the assault of quarrymen, for the evidence remains in the wedge slots, used to create a line of weakness to prise off a piece of freestone. On the ground is a piece that has been removed, with cup marks on it. The rock's status is established by an old Ministry of Works sign, not too obtrusive, and itself an ancient monument.

It is possible that when you first look at this rock you may find it is not easy to see all that is displayed on it. My photographs and drawings will help you. Most drawings flatten the picture, and have to be seen alongside photographic images. What do they tell us?

The rock is divided by a natural shallow channel. There are cracks, lumps and depressions that have been followed when designs largely in the shape of concentric circles were added to it. Some markings are fainter than others and are invisible unless seen in strong natural or artificial light. This has followed visits to the rock over a number of years, in all weathers and seasons, during which time my perceptions of the rock have changed slightly. Hopefully, I have now recorded all that is on it. By itself, it is an intriguing rock. If it were the only one of its kind we would only be able to say that the decoration on it (except the modern part) looks old. We would know that quarrying had removed some of it, and that the decoration must mean something. We would have no idea who made the symbols and why, or what they mean. We might be tempted to relate the rock surface to a valley because of the dip in the middle, and think that it might represent the distant

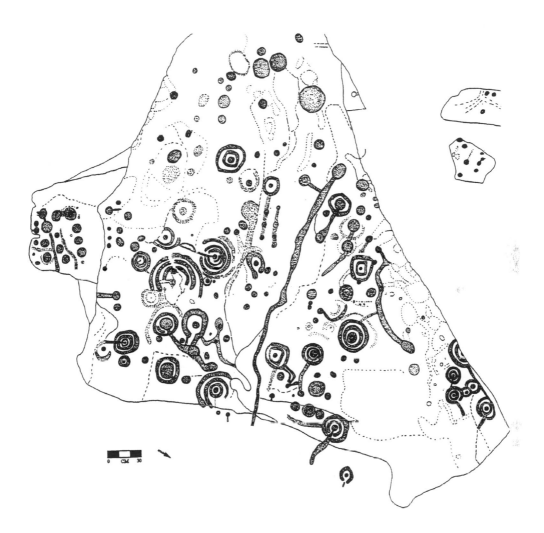

4 *The Lordenshaw rock*

river. We might look at the circular ditches and walls of the nearby hill fort and think that it might be a map. We might visit it at night and link it with star patterns. All this would remain in a world of possibility, waiting for corroboration.

What are these symbols? The beginning of interest is based on the patterns on the rock, but the search for meaning depends on finding other rocks decorated in the same way. Not just isolated rocks, though, but where they are in relationship to other things. Look at the aerial photograph again. The landscape is basically what was laid down in geological times, but people have used it and modified it. Parts of the hill fort ditches have been erased and a large earth and stone wall built there. You will see many such divisions. You will see signs of rig and furrow ploughing, of small house sites and hollow ways made by beasts and carts.

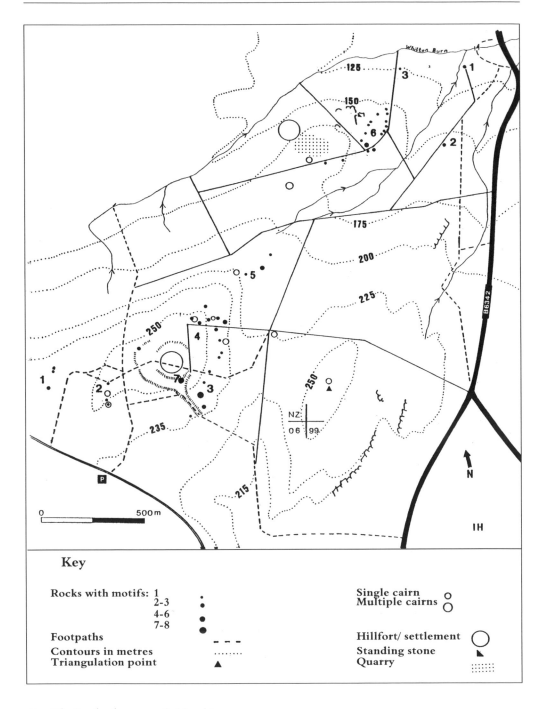

Key

Rocks with motifs: 1
2-3
4-6
7-8

Footpaths

Contours in metres

Triangulation point

Single cairn

Multiple cairns

Hillfort/ settlement

Standing stone

Quarry

5 *The Lordenshaw area*. I. Hewitt

These features are transferred onto maps. We must walk over the whole area if we are looking for the information that may explain what our rock is doing there. We begin to appreciate the number of changes that have taken place: cairns of stones that have been dug out to reveal stone-lined boxes called cists, more panels of rock art, an association between burials and rock art, and quite different designs that have been used to decorate rock out-crops. As we learn more by looking, we try to find any other parts of the county where the same things appear, and then look beyond the county boundaries.

This book is about the research into rock art in its wider setting. In putting it before the readers I have a problem. For most people the illustrations are going to be the most important part of the book rather than a technical description of the rock markings; rock art is a visual experience. As an archaeologist I have to write precisely but at length about what others and I have found. For example, each panel of rock art needs to be described by using a specialised vocabulary that might be a turn-off for many, even with the pictures to go with it. My compromise solution is to offer an extra text, an Archive, to institutes that require such information. That leaves me with a book that includes every piece of rock art ever discovered in Northumberland in its 'context', with some detail taken out but not discarded. It also allows me to share my thoughts about the part that rock art has played in our history, what threats there are to its preservation and how it should be presented. It was not long ago that cattle walked over all the rock art on Lordenshaw, until an agreement was reached between the landowner and the Northumberland National Park.

If at the end of the book you feel frustrated that many of your questions have not been answered, you are not alone. When the object of our curiosity turns out to be some of the earliest marks made by human beings, it is no wonder that what is left is only a small part of what used to be. To enter into the mind of someone who lived four or five thousand years ago is almost impossible.

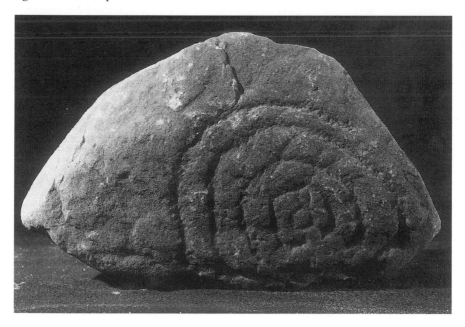

Definitions

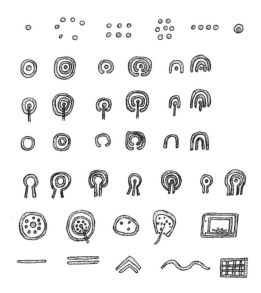

We now go straight to the heart of the study of rock art. The term *rock art* is all embracing. Four or five thousand years ago, people whose lifestyle was probably mainly nomadic pecked indentations into rock surfaces with a hard stone chisel or pick. Motifs known as *cup and ring marks* were formed, based on symbols. Some of the results can give aesthetic pleasure today, and the way in which the rock shape and its surface are used in designing the way these motifs are applied may in some cases be described as artistic.

The most common element is the *cup*, a small, shallow circular depression. It can be on its own, in a random scatter with others, arranged in a pattern with other

6 *The main elements in rock art*

cups (for example, as a rosette or domino form), or part of a design that includes grooves.

A *groove* can be straight, curved or wavy (serpentine). Grooves are pecked onto the rock in the same way as cups; a common device is to guide grooves to form a more or less circular enclosure or an arc. A cup generally lies at the centre of a ring or concentric rings, with a groove leading out of the cup (a *duct*). *Motifs* are formed by incorporating one or more basic symbols. The way these motifs appear on the rock can be determined by the shape of the rock, its surface irregularities and slope, but it does not explain why some parts of a large rock were used and not the whole surface.

Where rock art is found

1 On outcrop and earthfast rocks

Outcrops are rock formations that have been laid down in geological times as part of a general series. All outcrops used in Northumberland for designs are of sandstone; they are soft enough to mark with a hard stone pick or chisel and mallet. 'Earthfast' means that rock has become a generally immovable part of the landscape, having been brought there by such forces as ice and water. Stones that have been erected are also regarded as earthfast, but will be dealt with separately.

2 In monuments

A monument can be a natural feature used in some way to commemorate an event or to mark the significance of a place, or a specially erected cairn, standing stone or group of standing stones. At Morwick, for example, a cliff face was used for elaborate designs at the fording place of the River Coquet. Some rock shelters are used as monuments, with motifs and/or burials.

3 Taken from its original place

Where monuments and outcrops have been destroyed, for example by quarrying or field clearance, fragments are transferred elsewhere. They appear in field walls, piles of field clearance and rockeries. Some are built into house walls, transferred to museums and kept in private collections. Two decorated cobbles have been cemented into the foundations of Paines Bridge at Wallington. Collectively, these stones are known as 'portables', and we do not know where they came from originally.

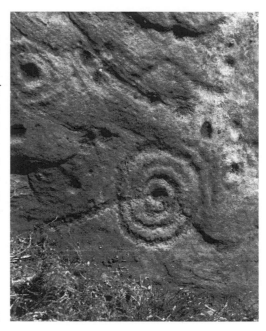

How the patterns were made

Where rock art has been recently uncovered or has resisted erosion particularly well, individual pick marks that produce cups and rings are visible, especially in low light. The

7 Pick marks (Hunterheugh)

size of the 'picking' or 'pecking' shows that a variety of tools was used, some with a fine nail-like point and others with a broad chisel, with other varieties in between.

The basic requirement is that the pick should be made of a rock harder than the surface being decorated, such as whinstone or andesite. Although it is possible to use a sharp pointed piece of andesite held in the hand, it is more likely that a mallet was used to impact the tool against the rock. So far no definite tool has been found; the nearest we have come to it is at a recent Dod Law excavation, where the pick was found close to peck marks on rock subsequently covered over by building in the Iron Age.

To make a cup, the outside edge had to be wider than the lower excavated area, making it cone-shaped. Usually the cups were not ground out and smoothed afterwards, and the edges are uneven. To make a long groove, the outline was sometimes made by pecking cups in a line and joining them together. The ring was sometimes made by joining cups together with straight grooves, making the rings distinctly angular.

Some designs may have been smoothed out, although it is not always possible to tell because erosion can have the same effect. So far there is no evidence that the motifs were coloured in. Any 'colour' produced would have come from the contrast made by the removal of flakes from the weathered surface of the parent rock. This has been demonstrated recently.

The discovery of cups on rock other than sandstone has now been made in the Cheviots, at only three locations.

Past explorations and present problems

Northumberland was one of the first areas where rock art was discovered, as long ago as the 1820s, when John Charles Langlands of Old Bewick recognised the significance of markings on two large earthfast rocks on the dip slope of the Old Bewick scarp. Local clergy, such as the vicar of Doddington and people like the ubiquitous Canon Greenwell from Durham, made other discoveries and popularised them. The theme was taken up by local antiquarian societies, and by people supported

8 D.J. Collingwood Bruce's lithograph of Dod Law

by the Duke of Northumberland, so that an impressive archive was built up. The monopoly earned by enthusiastic amateurs and independent archaeologists was not challenged by universities. It is only within the past decade that the balance has changed, with more professional archaeologists becoming involved.

There has been a change in emphasis; the first task was to produce accurate recordings, such as the fine lithographs of Mr J. Collingwood Bruce and George Tate's drawings. Although accurate representation of what is on the rocks, now helped by laser scanning and digital photography, remains essential, we are more concerned now about their position in the landscape as a whole and their relationship to other prehistoric finds. We ask the same questions that were asked over a hundred years ago, and although we have yet to reach many satisfactory answers, we have learnt considerably more. Not only have we discovered more sites, we have many more points of reference to rock art in Britain and in the world as a whole.

Building on past studies, we now ask questions like these: Is there logic to the siting of the marked rocks? Why was one rock chosen for this treatment and not another? Are marked rocks inter-visible? What can be seen from a marked rock? How close do you have to be to see that a rock is marked? Were there trees in the way to obscure the view of it or from it in prehistoric times? Is there a reason why some designs are complex (using many concentric rings, for example) and others have just random cup marks? Do the patterns convey different information? Why do some designs appear on standing stones, in rock overhangs and in burials? How did the symbols originate, when were they used, what did they mean to the people who made them, and why are some symbols common in many parts of the world?

We can perfect our recording techniques to give us a firm basis for our speculations, but this does not mean to say that we are going to have our questions answered. That may be frustrating for some, it may be an invitation to wild speculation to others, but I have long accepted that some questions will remain unanswerable.

9 George Tate's drawing of Dod Law main rock

Where do we stand?

Not long ago it was assumed that all rock art belonged to the Bronze Age (from *c.*2000 BC onward). We now know that it had a much longer lifespan, beginning in the Neolithic (New Stone Age, *c.*3500BC), but still being used in the early Bronze Age. This is a period when people were no longer dependent on hunting and gathering, but had farming that included the growth of crops and the domestication of animals. Hunting continued. Animals were still very important in sustaining human life, and were moved about from one grazing area to another. Farming made life more settled, and boundaries in the form of stone and earth dump walls and fences grew around the farm buildings. Hunting and herding animals would have favoured the 'marginal' lands, where the soil was thinner and poorer than in the valleys, and where there would have been tracks, clearings, springs and water holes for the beasts. Such areas overlook valleys in Northumberland, and it is here where the main outcrop rock art is to be found. Rock art, though, is more likely to survive in such marginal areas, and to be removed in lowland areas when more land is brought into cultivation by people who do not recognise the significance of rock art. We must be aware always that what is left may be only a very small part of what was there originally.

Because the marginal areas are high up, many command extensive views. The importance of these viewpoints has been long recognised, but now what is actually visible and over what distance is measured. Today the views from these rocks are very impressive and exhilarating, but what if they were covered with trees in prehistoric times?

If this was all we had to go on, we would not understand much of the significance of rock art, but the fact that the same patterns occur in a 'context' gives us more to work on. It is their presence in mounds built for the dead that gives them a special quality. Although cairns with incorporated rock art are a tiny proportion of the rest, the use of marked rocks in their structure is significant, and perhaps in the past some excavators did not look carefully enough at every rock in the cairns. In Northumberland and in other parts of Britain in the nineteenth century the discovery of some decorated slabs in or near disturbed graves led to all of them being regarded as the same age as the burials, mostly early Bronze Age. However,

some of the slabs showed signs of being exposed for many years before they were incorporated with the burials; some appeared to have been broken off outcrops. Recent excavations have revealed purpose-marked cobbles and slabs within the mound structures, so the motifs are contemporary with the mound building. In whatever period the marked rocks were put there, it means that they changed their function from being face-up in the open air to being concealed in the mound. Their use and significance changed. Their ritual use is also seen on standing stones, of which Northumberland has a few. Northumberland is unique in the rock-shelters that it has with cup and ring markings made *in* the overhang or on the floor, two of them with burials.

There is another element in this story: evidence of a slab of marked outcrop being removed and a fresh design being pecked onto that new surface as though to 're-sanctify' it. In this case we may speculate that the removed slab was then used for something else, perhaps in a burial. It is hardly likely that decorated stones placed in graves had no serious purpose, so we are not looking at idle graffiti or pure decoration.

Why almost all the images (all but one in Northumberland) should be abstract symbols rather than pictures is not known. How the symbols originated we do not know. It is unlikely that the people who used the images knew how they originated, but they would have understood their significance. They also used a limited symbolism inventively to produce surprisingly varied designs.

I have often asked myself awkward questions to which I can give no answer. Among them is this: if the marks had been made on rocks in woodland or even on cleared land, the designs would soon become covered up and overgrown. We see this happening now. So, for how long would they have been visible, or did people periodically clean them? Many can only be seen from a few metres away, so people must have known where to look for them. The problem becomes more acute when you realise that these marks can be made over a span of hundreds of years, and we have no idea of the relationship in time between one panel and another. If they were exposed for so long, many would have eroded considerably, yet many of those we see today are quite fresh or even pristine.

Some questions may be answered if we can excavate sites sealed in since the marks were made, and examine pollen and carbon to assess what the vegetation was like at the time and when, but this will not be easy.

Rock art: a survey

The simplified map of the underlying geology of Northumberland shows that the southern part is largely coal, millstone grit and carboniferous limestone, with dolerite intrusions. The north has a scarp ridge of Fell sandstone, cementstone and a central dome of volcanic rocks that form the Cheviot Hills. Only three sites in the Cheviots have rock art on volcanic rock; the favoured surface is sandstone. The scenery is varied and spectacular in parts, especially from the scarps. Wide viewpoints are extensive. The land varies from rich agricultural soils to the thin soils of the high moorland.

Many parts of the county have few people living there today; the coastal plain to the south, where the main industries were based on coal, is still the most populous, and open-

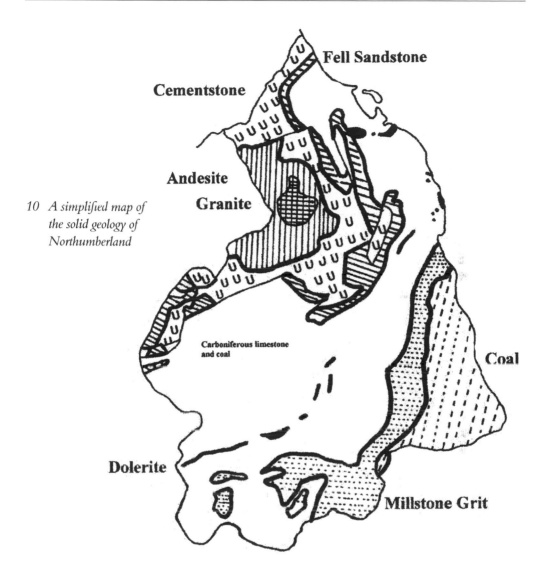

Fell Sandstone

Cementstone

Andesite

Granite

10 A simplified map of the solid geology of Northumberland

Carboniferous limestone and coal

Coal

Dolerite

Millstone Grit

cast workings continue north to Amble. Sandstone has been the most favoured build-ing material before the coalfields produced bricks in great quantities for housing, and the quarrying of sandstone has removed some rock art. It survives when people do not wish to exploit the land where it lies; this also affects the survival rates of such things as enclosures and burial cairns. River valleys play an important part in the distribution of rock art, and the main rivers flow from the west to the North Sea. The River Till is an important excep-tion.

The amount of information available for rock art in Northumberland is great, and would fill many volumes. The material has therefore been selected and arranged so that you will be able to see where rock art occurs and what its significance might be, under headings that enable me to deal with the most important elements in its distribution: Art in the landscape; Art in monuments; Portable and reused stone.

2 Art in the landscape

Sandstone is almost exclusively the rock chosen for marking, particularly the Fell sandstone that makes up scarps. Outcrops form the high ground overlooking stream and river valleys. Soil in these areas tends to be thin and unproductive, supporting heather, scrub, light woodland and pasture. It is not good quality arable land of the kind that is concentrated on the coastal plain, lowlands and in valleys. Although the *sites* of decorated rocks can be seen from considerable distances, the rocks themselves cannot; most are near-horizontal, whereas natural features such as cliffs and overhangs are far more likely to act as highly-visible markers in a pristine prehistoric wilderness. Many of the sites are inter-visible across valleys; the Weetwood and Fowberry sites, for example, can be seen from the west-facing scarp across the valley from major sites such as Buttony, Chatton Park Hill, Amerside Law Moor and Old Bewick, all of which overlook the major river valley of the Breamish/Till. It is the *sites* that can be seen, not the individual panels. Add to that the different vegetation in prehistoric times and I wonder how much marked rock could have been seen about 5000 years ago unless you knew where to look and approached within a few metres of it. Perhaps the rocks were in clearings and were linked with paths, for both are necessary to hunters and herdsmen using the landscape as a source of food. Geology determines where the outcrops are; people can influence what kinds of things grow there. Mobility was an essential part of the life of hunter-gatherers and herdsmen; such mobility may have been seasonal, when some areas were more used than others.

Not all of the high outcrops attracted rock art. Few of the places attracted significant settlements. However, most were used for the burial of the dead. It is essential to take a holistic view of landscape in order to understand what part rock played in the life of its people. How could it possibly have been used?

As Northumberland has some of the most extensive landscapes that include rock art, there is a good chance that understanding may result from our analysis if it. We begin in the north, gradually working southward as we examine the positions of, and the motifs on, these outcrops.

Each site, whether it has a single marked stone or many panels of outcrop, has a name, a Grid reference, and a national database number (HELICS) devised by Ian Hewitt. This information is also fed into the SMR (Sites and Monuments Record). Northumberland County Council has this information.

Readers can find details of discoveries in the Bibliography and Archive. The drawings sometimes depict the total rock surface on which the marks are made; in some cases where there is very little marked on the rock the motifs are drawn in isolation.

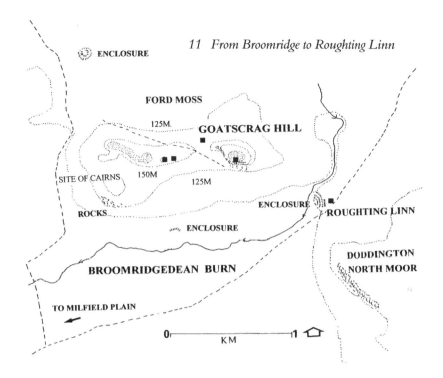

11 *From Broomridge to Roughting Linn*

Broomridge to High Chesters

The distribution of cup and ring marked rock sites along Broomridge, prehistoric buri-als under the Goatscrag Hill overhangs, and the massive marked sandstone whaleback at Roughting Linn provide us with an area that focuses much of our thinking on rock art in the landscape. It is also one of the most interesting walks in the area, with a public right of way along the ridge, an outcrop of sandstone sandwiched between the sunken area of Ford Moss to the north and the valley of the Broomridgedean Burn to the south. To the south-west the land falls away to the Milfield Plain, and as it swings east again below Broom Ridge there is a series of massive, colourful sandstone outcrops that have eroded into dra-matic shapes at Dovehole Crag, at present protruding from planted forest, and visible from the road to the south. If you travel from the *Maelmin henge* site at Milfield to Kimmerston and Roughting Linn you will be on an ancient route, part of which is 'sunken'. This road skirts Broomridge on the south, so you can see the whole ridge from Dovehole Crags to the top of Goatscrag Hill from there. This cluster of naturally-sculpted outcrop must have provided a well-known and memorable reference point to any groups of people moving through the land, but the ridge above gives a much wider view of the landscape for many miles, not only to the south, but also to the North Sea.

The area between the ridge and the Dovehole Crags was used by prehistoric people for building burial cairns; an early excavation report shows that one contained Neolithic pottery. Nothing has survived; the cairns have been cleared away. Good viewpoints, not necessarily at the top of the ridge, are common to the siting of burial cairns; the distribu-tion of the rock art on top of the ridge to Goatscrag chooses the highest points.

12 Broomridge: from the west to Goatscrag Hill

At Goatscrag Hill on the floor of the overhangs were interments of cremations in pots, and it would seem that there is a coincidence of burial and rock art along this ridge; although the two cannot be linked chronologically they share the same special places. As usual, we are dealing with fragments of the picture, as the whole of this ridge has been scraped clean by rig and furrow ploughing, which is just visible under the coarse grass and bracken. Burial cairns would hardly have survived this process, but fortunately there are relatively unscathed marked outcrops that have defied quarrying and ploughing.

Broomridge became an important freestone quarry, and overlooking the abandoned coalfield are workings connected with the mine at Ford Moss, where there is an abandoned crane *in situ*. If there had been any rock art to the north on the ridge, some of it at least would have been broken off. We must stick to what we can see: four locations on top of the ridge, with some of the finest views in the county. The first two sets of motifs are on rock outcrop at the edge of the scarp, both domed. They are not the only exposed sandstones. If you follow a path from the west, it will take you through the abandoned coalfield of Ford Moss, with the foundations of miners' houses and their gardens still visible, as well as the wagonway, a chimney that produced steam power for the mines, and many other traces of this small-scale industry. The path reaches the top of the ridge by a wall on the right, and with the wall behind you, you will see the outcrops on the south edge.

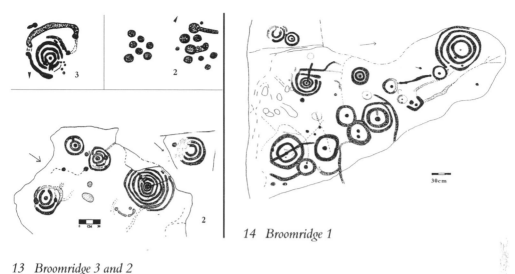

14 *Broomridge 1*

13 *Broomridge 3 and 2*

Broomridge
Broomridge 3 H00405 NT 9703 3708
On the north slope of the outcrop is a cup with three irregular concentric rings, traces of a fourth, and a large arc surrounding much of this central motif. It is very difficult to locate, faint, and usually grass-covered. It is not surprising that it was the last to be found.
Broomridge 2 H00404 NT 9719 3778
Visible from 3, further east along the outcrop line is a large dome of rock that has two distinct sets of markings: one is the outline and various stages of excavation of large millstones at the east end of the rock, and cups and rings elsewhere. Today, two kinds of motifs are to be seen: to the west are cups, some isolated and scattered, but there are two impressive cup clusters, one group having two linked cups and a cup with a tail, with the pick marks of their making still clear.

The other motifs include multiple concentric circles. Seven concentric circles is a large number for any British site, and although some features of this motif are faint, it can be seen that the 'circles' are made by rather angular lines joined together. Two grooves, one very faint, radiate from a circle around the central cup, but not directly from it. The remaining motifs appear incomplete — not something to be accounted for by erosion alone. The disturbance of the surrounding area by ploughing and its covering with grass and bracken can still allow something of the past to surface: we found a splendid orange and white flint flake close to this rock on a path.
Broomridge 1 H00403 NT 9736 3718
The next rock east, hard to find in high bracken, is north of the scarp edge and the public footpath. A flat quarried outcrop rises above the field level; a central area, elongated from north to south, has many motifs visible from the north. The whole ridge can be seen to the east and west from the rock, which also commands extensive views to the south and north.

South-east of this rock is a wall that separates the bulk of Goatscrag Hill from this field, and a small gate gives access through the wall to the top of the hill, where the next motifs are.

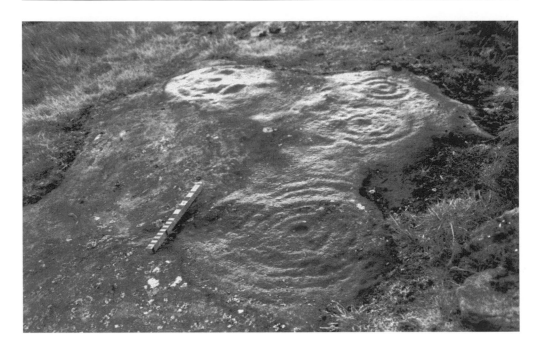

15 Broomridge 2: a horizontal marked outcrop also used for millstone quarrying

Goatscrag H00407 NT 976 371

The name 'Goatscrag' could refer to wild goats; the alternative name for Broomridge is 'Hunters' Moor'. The discovery of animal carvings on the wall of one of the rock over-hangs (H00412 NT 977 370) is the first instance of anything other than abstract motifs, but they were not regarded with certainty as prehistoric. However, the rock overhangs were certainly used for temporary shelter and for the burial of the dead in prehistoric times, as excavations have demonstrated, and the discovery of linked cups above the rock overhangs, or shelters, may be more than their being an accidental juxtaposition. This was indeed a special place.

The animals that are illustrated here are on the vertical face of the rock overhang on a good smooth surface that faces south. They may be prehistoric. The overhang catches the best of the sun, and the rock glows with attractive colours. On top of the rock outcrop is a series of two cups linked by curved grooves, giving the appearance of horseshoes. It is rare to find linked cups, and a cluster of ten and two other cups on the rock is unique. Their position places them precariously close to the edge of a big drop, and they overlook many kilometres of land that includes much of the county. It is possible that Roughting Linn rock was visible from here, but it depends on the vegetation cover.

From here the sandstone outcrop drops east sharply to the little valley of Broomridge-dean Burn, a tributary of the River Till. Flowing in from the north, it drops to Roughting Linn, then moves south-west in a valley south of Broomridge.

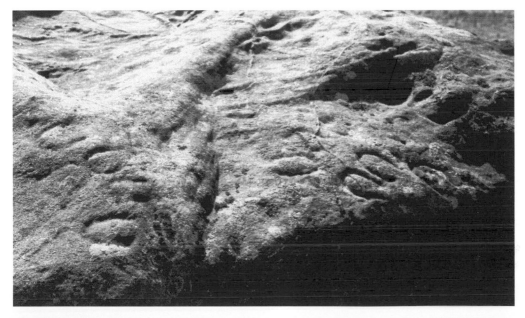

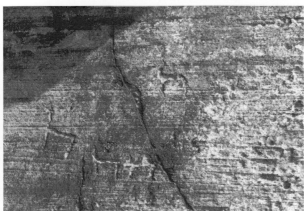

16 *Goatscrag. Clockwise from top: 'Horseshoe' type markings; linked cups on top of the overhang; one of the buried urns in the overhang floor; animal figures on the vertical face inside the overhang*

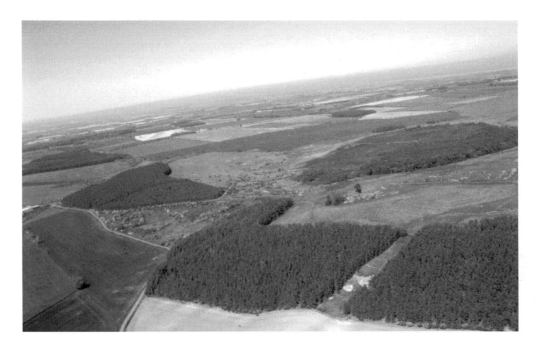

17 From Ford Moss eastwards (left to right)

Roughting Linn **H00406 NT 983 367**

Roughting Linn is named after a nearby small waterfall, the two elements being 'linn', a pool, and 'roughting', a bellowing noise. This is a huge, natural, whaleback shape of sandstone outcrop, an elongated domed ridge, 20m long and 12m wide (60ft x 40ft). It is slightly higher than the land to the north-west that flattens out before plunging into a gully formed by two small streams that join before flowing towards the Milfield Plain. In the area between the outcrop and the gully are the multiple ramparts and ditches of an enclosure that cuts off the promontory to the north-west. The small waterfall is formed by the Broomridgedean Burn falling over a ledge. Where it falls into a pond is a place both sheltered and beautiful, with small cliffs rising on either side, one with an overhang. To any group of people who regarded water as an object of veneration, this could well have been a special place. Despite the narrow road that cuts the triangular promontory at its base, the area has a lingering timelessness. The rock, the enclosure and the burn look west to the valley that leads to the Milfield Plain. To the east the views are impeded by higher ground; to the south-east the land rises to Doddington North Moor. Goatscrag Hill may have been visible, as it is partly today, from the rock. Just before the water tumbles over the ledge to cascade into the pool, there is some substantial outcrop covered by grass, and it would be interesting to see if this is marked in any way.

Roughting Linn is the largest decorated rock in northern England, and perhaps the most famous. The western part has been quarried away, before 1850, and a large slab has been removed across its width. There is still one cup and multiple circle motif on a surviving part to the west; although the south is gouged with mainly natural grooves, there are

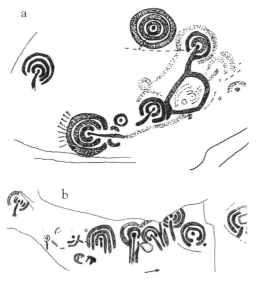

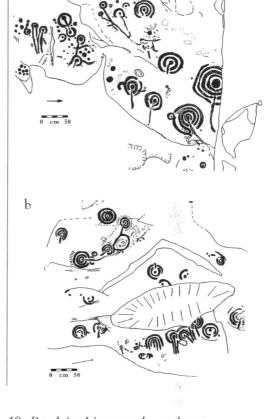

18 *Roughting Linn a south east ; b east edge*

19 *Roughting Linn a north east; b east*

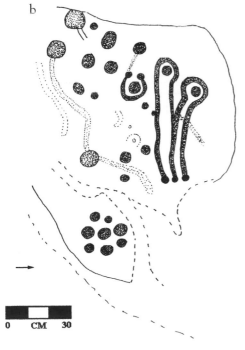

20 *Roughting Linn a north; b detail of motifs on the east*

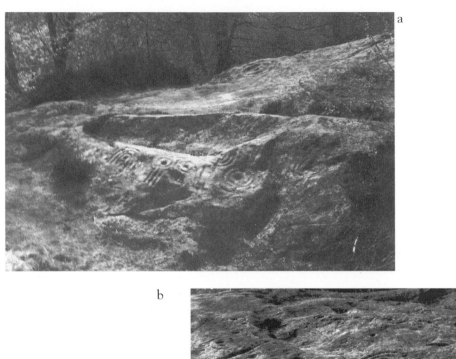

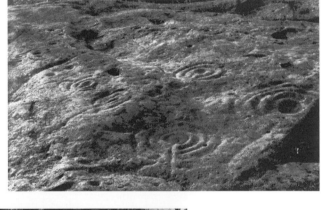

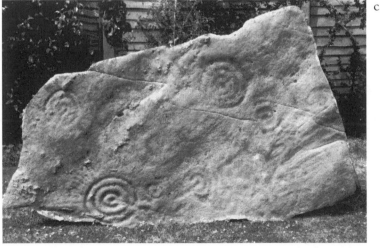

21 Roughting Linn a east; b south east; c a replica of the eroded south surface made by English Heritage

cups and rings there too. Apart from its size and the fact that it just happened to be there, natural erosion on the southern part may have attracted artificial additions, a factor seen also at sites like Old Bewick. The decorated kerb concept is one shared with Irish Passage Grave art, although the circumstances are different, for this is undisturbed outcrop rock and not panels arranged in an artificial structure.

Much of the art is of the cup and ring type, quite deeply pecked, especially on the circumference; what is also so interesting about the way this rock has been used is that there is such a variety of motifs. Near the top of the dome slope are flower-like stems with heads made of a cup surrounded by a ring. Some of these grooves join each other, and some end in small cups. There are clusters of cups enclosed by grooves, interconnecting with other enclosed cups. There are, uniquely, nine radiates springing from the outer of two penannulars around a cup, itself connected to other figures. The south-east slope includes concentric inverted arcs, and a variation of the cup and ring theme is the use of parallel grooves, six in the case of two linked figures. Erosion has taken its toll in a hollow to the south-east, but it has been possible to trace the nature of these figures. Slightly higher up the rock, above these, is by contrast a heavily-picked pair of concentric penannulars with a row of cups above that. The concentric grooves have been made by joining together separately-made cups; the divisions between these cups are still clear.

At first sight, the cups and rings look similar, but closer inspection shows some interesting differences. To the south-east of the quarried gash the ends of two penannulars are joined, and in the space between are three tiny cups in a row. Attached to the outside penannular of another is a hook-like groove. To the north, two grooves run uphill from the circles, and one group of four concentric circles has a diametric groove through the central cup.

The drawings, checked many times in different lights, show some figures fainter than others, not necessarily a result of erosion, but of being put on faintly originally, and perhaps unfinished.

A big problem with this site, one of the most important panels in the world was its aged and irrelevant notice board, an ugly fence, tree roots close to the rock that were breaking it up, and no pointer to help people find the site. The latter is still the case but the other ugly or dangerous features have now been removed, after a great deal of pressure. It should have a board to explain and locate the motifs, so that people don't trample all over the surface looking for the motifs, and which should educate them to understand its importance.

Access to the marked rocks is by public rights of way. Should you wish to examine the rock overhangs at Goatscrag Hill, it is a courtesy to ask permission at Roughting Linn Farm. You may approach from the Ford Moss site to the west or from Roughting Linn on the east. The OS *Explorer* series gives details of paths, but not of the marked rocks.

The position at Roughting Linn is pivotal in the area, lying as it does at the head of the Broomridgedean valley, whose burn flows past the towering north scarp with its overhangs, burials, and the trail of rock art across the top of the ridge, to the now-removed round barrow cemetery at its west end before the Milfield Plain begins. It is linked with the next group of rock art at Hare Law; this site today does not evoke such aesthetic pleasure, for it lies in a different kind of landscape: more levelled out as it moves east towards the sea.

Hare Law Crags
H00408-411, 416 NU 013335-012335

The Hare Law Crag sites may be reached on the minor road to Wrangham, just east of the Berwick-Wooler road (A6111), but as they are on private land permission must be sought to view them at Wrangham Farm. The field approach is through pasture, which after rain and animal activity can be thick black mud.

The area has been extensively quarried and mined, but is now pasture and used for timber plantations; much archaeology may have been removed or buried. The rock art has survived on an elongated outcrop ridge aligned roughly south-east to north-west, partly tree-covered, highest at its south-east end. The view from the ridge is widest and furthest towards Dod

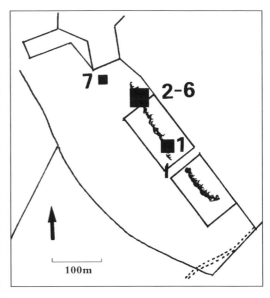

22 Hare Law crags: location of rock art

Law, an area of major rock art that rises from a valley between it and the Hare Law land, although the view of the Doddington Dean valley is obscured by land that rises to 130m. The view to the west is limited by the ridge of Doddington North Moor. To the east lies the Devil's Causeway, a major Roman road, but the view from the marked rocks to the east is blocked by a slight rise in the outcrop ridge. To the north the fields rise gently, and include the site of the English camp at Barmoor before the Battle of Flodden in 1513. To the north-west is Roughting Linn, and to the north-east the sea is reached via some undulating ground. This north to north-east landscape is extensive, and today is mainly pasture. The whole of the Hare Law Crags is probably marked at intervals, for three more major panels of rock art have come to light since recent clearing of woodland.

There are three areas of plantation, aligned north-west to south-east. The south-east enclosed rectangle has not revealed any markings yet. The second rectangle has been shortened: the fence now excludes all but Hare Law Crags 1 from the wood.

Hare Law Crags 1 (H00408 NU 013 354) is the most south-easterly, and lies close to the forest ride (unplanted area). It is part of a broken-up sheet of outcrop, and the figures illustrated include an 'occulus' (eye-shaped) — two cups surrounded by two concentric ovals. The central panel has a rosette type of design: two concentric oval grooves surrounding a central cup, itself at the centre of a circle of cups. These motifs are rare variations on the cup and ring theme. Quarrying may have destroyed others before 1860, with stone taken off the scarp edge.

At *Hare Law Crags 2* the concentric rings are faint, and not easy to see; the rings are somewhat angular, and 28 metres of outcrop contain the motifs of rocks 2-6.

Hare Law Crags 3 (H00409 NU 0127 3554) is on a smooth outcrop inside the former plantation at the north-west end, and used to be covered with vegetation. Timber clearance has now exposed the rock to its southern edge. Cracks follow the slope of the rock, and smaller

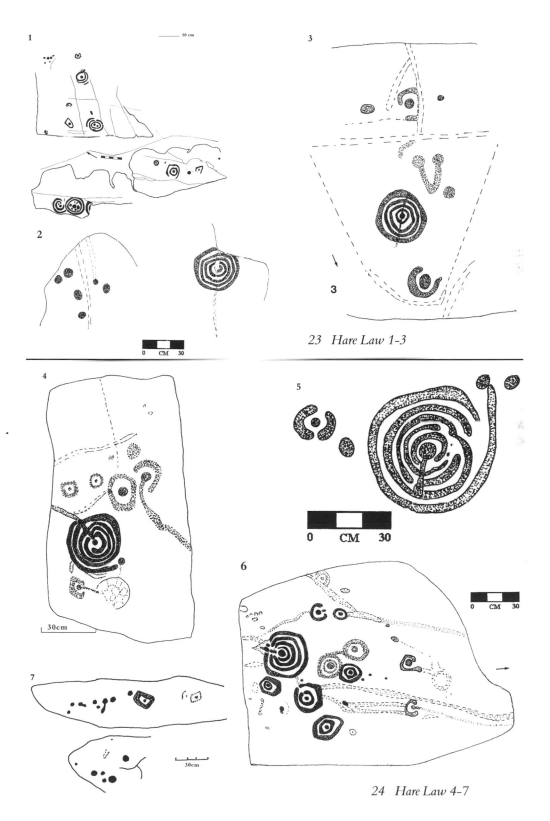

23 Hare Law 1-3

24 Hare Law 4-7

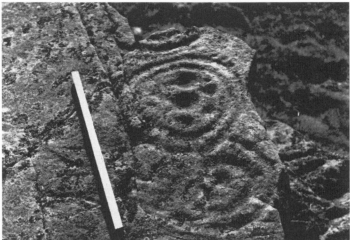

25 *Hare Law. Top: rosettes on site 1; bottom: rings on the horizontal outcrop 6*

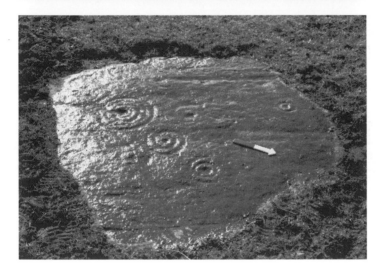

ones cut across the rock horizontally. Cracks mark off a triangular area with its apex to the north, and it is within this area that the two main figures have been pecked.

At *Hare Law Crags 4* cracks in the outcrop sheet form a rectangular block that contains the motifs.

Hare Law Crags 5 (H00416) was found just inside the wood, when a new fence, now removed, was being erected. It is an outcrop slab with a design that has been well-preserved and executed deeply.

Hare Law Crags 6 (H00410 NU 0128 3552) is a piece of decorated flat outcrop in grass that used to be outside the previous plantation fence. It lies to the north of the raised outcrop, and has the last of the complex motifs that follow the 'crag'. To the west of it is a gate in a wire fence, a convenient reference point.

Hare Law Crags 7 (H00411 NU 0120 3554) is an outcrop flush with the grass, in two parts, that has 13 cups and an angular groove surrounding a cup.

26 High Chesters. Nineteenth-century
drawing by Collingwood Bruce

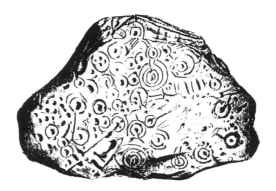

High Chesters (Cairnheads) *H00421 NU 0015 3349*

No one has seen this rock recently, as it is buried, so we have to rely mainly on the drawings made by Mr Bruce and Mr Tate. Half a mile north of Doddington village just east of the A6111 road Miss Procter discovered the stone in 1859.

Mr Bruce said that the Rev William Procter

> observed traces of burial which escaped the ordinary observer . . . groups of large stones, and beneath the cultivated soil, a fair quantity of fatty matter, apparently animal. The field had evidently been an ancient graveyard.

It was re-excavated in 1933, left exposed for three days, and has been covered ever since.

Its position is at a high viewpoint (at 100m) that overlooks the valley of the Doddington Dean Burn to the massif of Doddington Moor; the valley flows into the Milfield Plain, so the site overlooks the access to the Plain. It is densely packed with motifs, and occupies an important site in the landscape. There may be others still buried there.

The position of this and the Hare Law Crag site is significant, for the marked rocks are on land that slopes towards a tributary of the River Till. Unlike the Broomridge marked rocks, the Hare Crags group does not lie along the scarp edge facing the Milfield Plain; the Cairn Heads site overlooks both the Doddington Dean and the Till valley.

Doddington and Horton Moors

Bounded by the Roman road (the Devil's Causeway) on the east, Doddington and Horton Moors lie on the Fell sandstone ridge that overlooks the Milfield Plain to the west. The Doddington Dean lies to the north, the Till to the south (as it makes its right-angled bend), and the Horton Burn to the east, a minor tributary of the Till.

On three sides, this natural block of high ground presents a scarp edge, and rolls more gently on its dip slope to the east. It has not only one of the greatest concentrations of rock art in the country, but includes hill forts, a small stone setting, destroyed burial cairns, and has been a source of many finds by generations of collectors. It is a homogeneous region in one sense, but it is useful for this account to subdivide it into smaller areas where the rock art occurs, to make it easier for those who want to visit the sites.

Doddington Moor

The west to south-west-facing scarp, rising from the flat Milfield Plain, extends from Doddington village to Weetwood Bridge. 'Dodd' has two meanings: a hill, or the Old English personal name, 'Dodda'. To the north, a large quarry, now only occasionally used, gives a crosssection of the underlying high quality sandstone. On the whole the soil is thin, and good only for pasture and moorland today, but there are signs of rig and furrow ploughing for arable in the past. A golf course occupies part of one of the most important archaeological sites on the moor, where there is a cluster of three prehistoric enclosures. The most westerly has been investigated in various ways, not all skilfully. It is a defensive site at the scarp edge, with an added enclosure, the walls of which overlie rock art. This at least shows that the rock art pre-dates the Iron Age structures, and recent ex-cava-

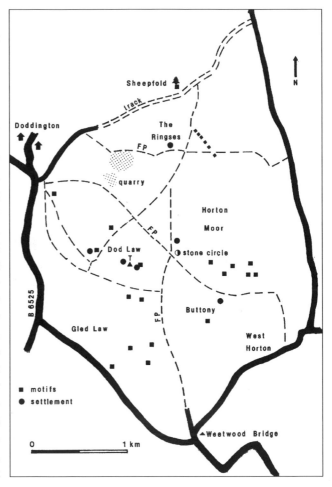

27 *From Sheepfold to Weetwood Bridge.* Ian Hewitt

tion of the enclosures indicates that more outcrop with motifs may still lie buried. The two other roughly circular enclosures are univallate (one wall, one ditch), and could have been used as stock enclosures. Their relationship with the hill fort has not been investigated.

Doddington Sheepfold H00424 NU 0145 3336

The private site is a well-positioned viewpoint on a crag overlooking the Doddington Dean. Much of it has been planted; the patches of outcrop rock that have motifs are scattered, and the motifs are simple.

Doddington North H00425 NU 0012 3230

One rock among many other outcrops is not easy to find. This lies east of the public footpath that begins at the minor road from Doddington to the Golf Club. A small piece of the rock has been quarried away. There is a clear view of the Milfield Plain and of the Doddington Burn, a place that overlooks the exit of the valley to the plain.

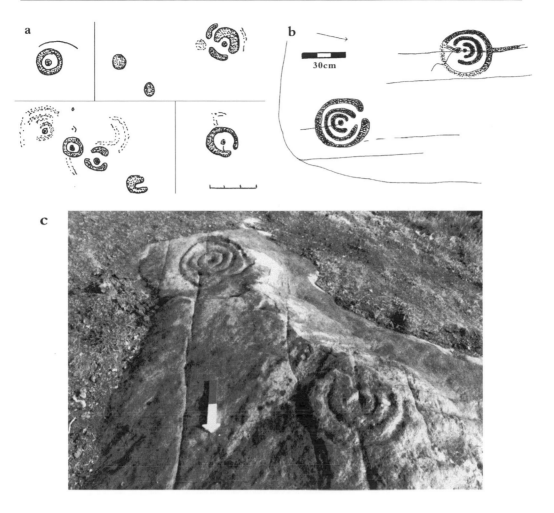

28 a Sheepfold; b Dod Law north; c Dod Law north rock

Dod Law excavation site H00426-8/433-40 NU 0041 3178

Before the selective excavations of the hill fort by Newcastle University, motifs on two outcrops of sandstone had been recorded. The rock art comes from the periphery of the main fort, and its building may have destroyed some. Outside the fort and its extensions are some flat outcrops that have unique motifs.

The Main Rock H00429 NU 0049 3173

This is one of the most impressive and outstanding panels of rock art in Europe. Although people playing golf have legal access to it, this and the hill fort are on private land. Mr Tate and Mr Bruce drew the rock, and it is clear that part of it has been removed since then. The main difference from what we see today is that some of the western motifs have gone. Another important observation is that there are three levels of the rock surface, and that the main motifs occupy the lowest level, well preserved by peat and turf, and deeply pecked into the rock. The right-hand corner of the drawing shows that some cups and partial

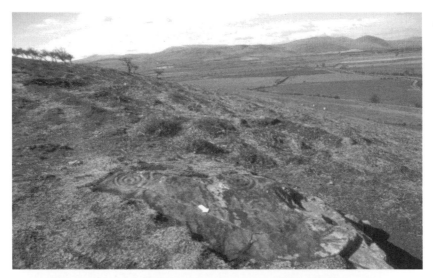

29 Dod Law north to Cheviots

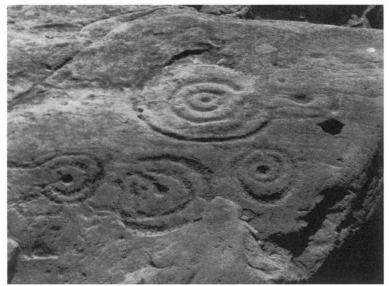

30 Dod law: motifs on outcrop that is overlain by Iron Age structures

rings have eroded considerably, or were pecked on lightly. A possible explanation for this is that some rock with older motifs was removed, and new motifs put on at a lower level in prehistoric times; perhaps it was deliberately removed for incorporation in a monument. This important, elaborate rock art panel, viewed from the east to appreciate its designs, gives only a limited view of the Milfield Plain, although the Cheviots and scarp edge are in sight. It occupies a place that has all-round views of the landscape.

The other small pieces of marked outcrop in the same series are less obvious. The outcrop rock of which all these are part is horizontal at ground level, unlike those in the fort area which stand higher, and the outcrop to the immediate south-east which has not been marked. The predominant view from these flat outcrops is down the slope towards the Doddington Dean.

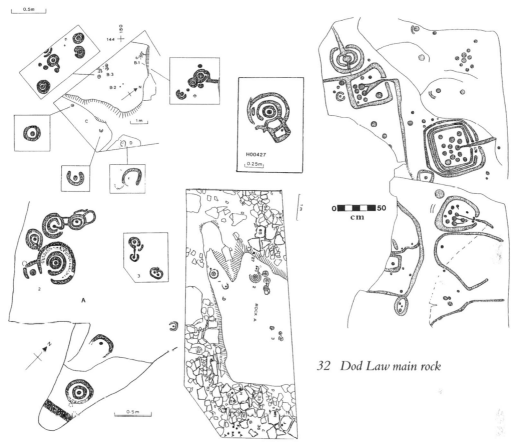

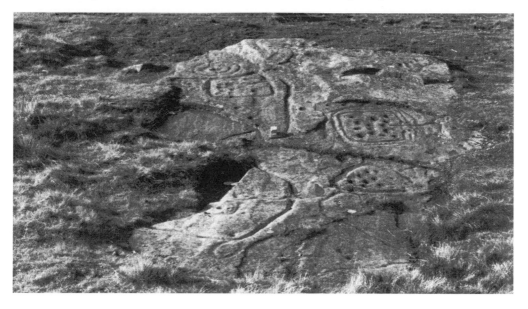

31 Dod Law excavation site drawings and plan.
University of Newcastle

32 Dod Law main rock

33 (below) Dod Law main rock

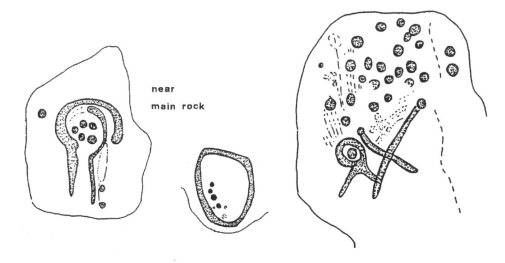

near

main rock

34 *Motifs on small pieces of detached outcrop*

35 *Above: Enclosure site; below: motifs on outcrop on which a cairn has been built*

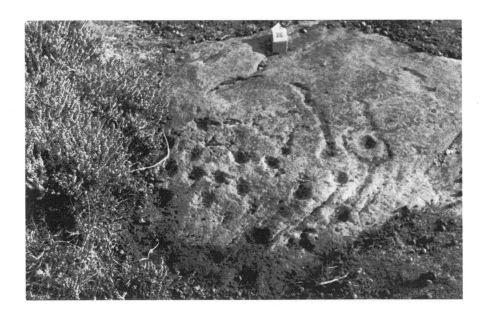

Enclosure site H00431 NU 007 3165

At 200m, east and south-east of the Main Rock are two enclosures of unknown date. The furthest one, beyond the triangulation pillar, is roughly circular. An outcrop or earthfast rock with motifs is not easy to find in the long bracken. It is at the centre of a destroyed cairn, which makes it doubly important, for its position in the landscape, with views of many kilometres east and towards the Till before it breaks through the scarp to the plain, has a Neolithic and possible early Bronze Age significance. There are other cairns built over rocks with motifs in Northumberland, to be seen later in this survey.

36 Dod Law Quarry site

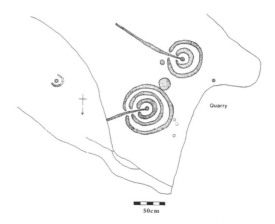

50cm

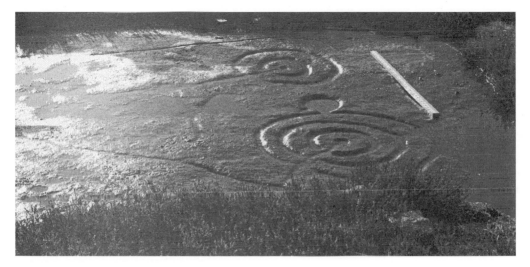

Quarry site H00432 NU 0078 3199

Between the public footpath from Buttony and Kitty's Plantation with a wire fence to the west of it, looking north-east towards the quarry is a flat, sloping outcrop exposed in the heather, that has very well made motifs. What is special about the motifs is that the grooves are so well spaced and finished. The choice of such an even surface and the width and spacing of grooves make the design particularly impressive. It is not easy to find among other outcrops that are similarly encroached on by heather, but it is well worth the search.

At 150m the focus of the viewpoints is away from Dod Law, which blocks the view west and south-west. It looks towards the Horton Burn and the high ground beyond.

Gled Law H00441-6 NU 010 306-006006 005

Gled Law is the continuation of the Dod Law scarp south-west, with a similar view across the Till valley to the west, and sight of the river as it breaks through the scarp from the east to Weetwood Bridge. The sites lie on a wide ridge overlooking the river valley, divided from the Buttony sites to the east by a small stream and valley. The panels of rock that can still be seen are illustrated, beginning at the south-west end of Gled Law.

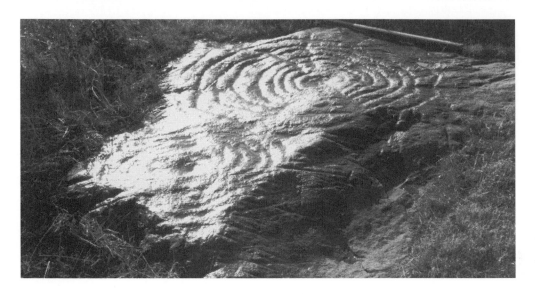

37 Gled Law 2a: one of Britain's largest number of concentric circles, with radial grooves

Most are in a cluster of horizontal outcrop at the west edge of the scarp overlooking the Till valley. No. 3 is on a raised horizontal outcrop to the east, and to the north on rising outcrop towards Dod Law are scattered, unspectacular motifs. No. 6 was discovered embedded in a wall below the scarp on the west. A piece of decorated stone, now at Weetwood Bridge Farm, has most likely been cut from outcrop, and is included in the drawings.

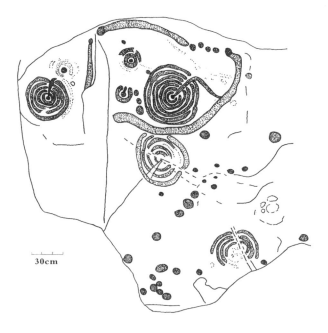

30cm

38 Gled Law 3

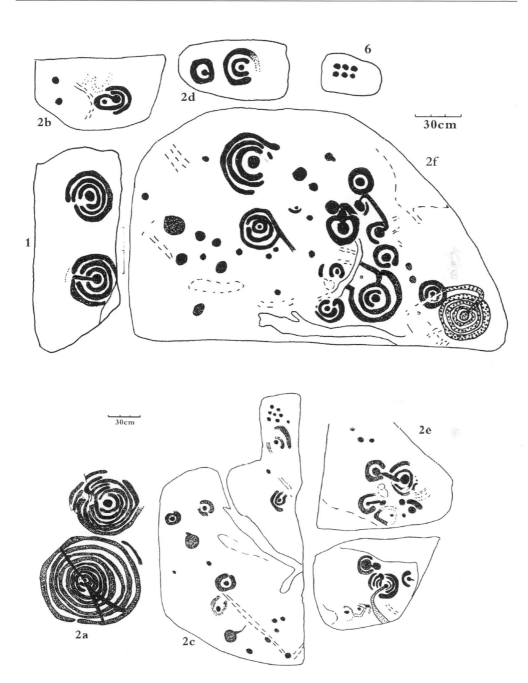

30cm

30cm

39 Gled Law 1-2c

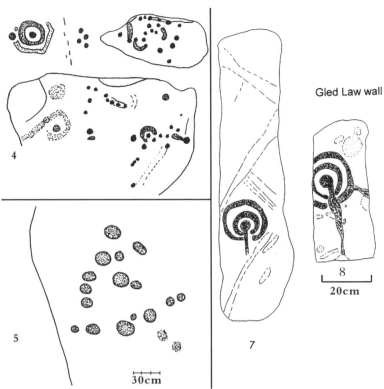

40 Gled law 4, 5, 7, 8
Below: the Cheviot Hills and Milfield Plain west from Gled Law

Gled Law wall

4

5

7

8

20cm

30cm

Buttony

The main Fell Sandstone scarp that includes Gled Law and Doddington Moor is broken by the River Till, and rises again to Clavering and Weetwood Moor, forming a steep-sided and very attractive valley, spanned by the Weetwood bridge. Overlooking this gap, and bounded on the west by a small stream valley, and to the east by the Horton Burn, is a small hill at 152m below the summit of which at 140m is an outcrop rock that overlooks the whole of the Till valley, and from which the Milfield Basin and Cheviots can be seen.

A field boundary runs to the north of this outcrop, cutting through a circular enclosure that has been ploughed out quite recently on the pasture side (north) and planted with trees on the other. Sadly, the planting has been allowed to take place to obscure some outstanding rock art, although the motifs are 'safe', unless the acid in pine needles takes its toll.

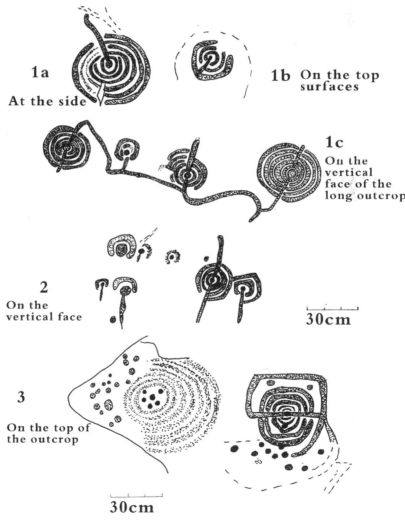

41 *Buttony. 1-3*

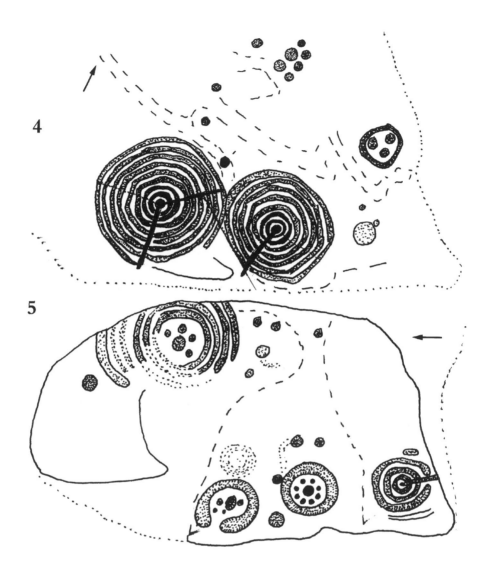

42a Buttony 4: There are domino cups, three cups in a ring, multiple concentric rings that are largely angular with deep grooves from the central cup, and other radials. 5: The emphasis here is on a rosette patterns of cups, enclosed by grooves

Buttony H00446 NU 01710 31030

A pillbox at the south-west end lies close to the site (NU 01600 31600, 152m). A ridge of outcrop, lying roughly north-east to south-west, is broken into six sections where the motifs occur, and although another outcrop is revealed to the north-east there are no motifs there. This decorated outcrop gives the best view of the place where the Till meets the Plain, and overlooks the site of another, forested enclosure. The motifs are on two levels of the outcrop: some on the top surface, and others on the steeper south-east face.

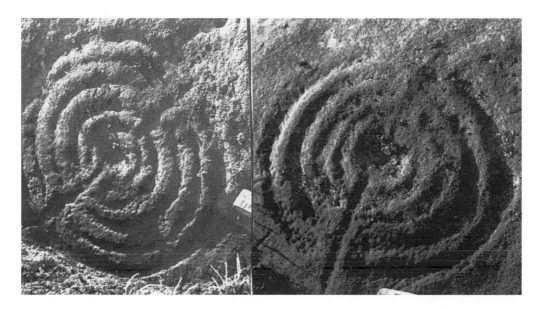

42b Buttony 1c

42c Buttony 7. Cups in the outer ring may be guides for the completion of the ring. Photograph M. Van Hoek

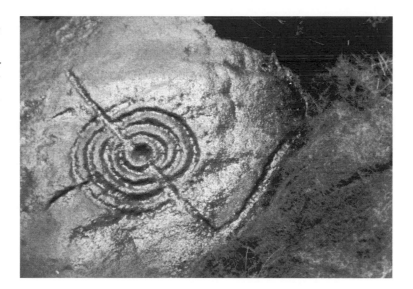

There is a difference in the clarity of the motifs, those on the upper rock surface appearing to be either worn or more tentative, and those on the more vertical surface showing all the pick marks, especially where they dip into the turf at the rock base. There is also a variety of motifs, with radial and diametric grooves, angular and circular concentric grooves, and rosette arrangements of cups.

The Buttony group, although having characteristics that can be seen elsewhere, is particularly important for the number of rosettes, the multiple concentric circles, and the contrast between pristine and eroded or tentative motifs.

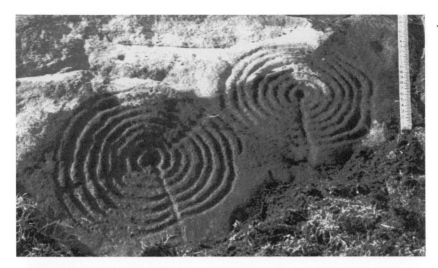

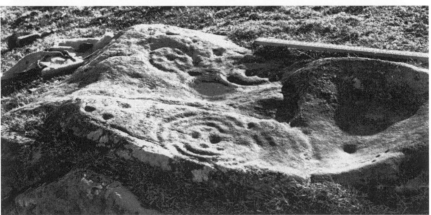

West Horton
West Horton 1 H00447 NU 0216 3149

North-east of Buttony, in the next large field, at 122m is a linear outcrop of sandstone that marks the south-east limit of the marked rocks in this area. The outcrop is visible from the Devil's Causeway, and has viewpoints that encompass the Till valley, the Horton Burn, and the scarps to the east. The outcrop dips to the north, and it is at the lower level of this slope where the motifs have been best preserved. Familiarity with this rock leads me to believe that this is a planned design and not a random collection of symbols. There is a unity and a fluidity in it that is aesthetically pleasing.

A second outcrop lies a few metres away, on different levels. The upper, southern surface has most motifs, but they are faint. Among different-sized cups are four motifs. To the north at a lower level is a pristine design, and it could be that the upper surface of the rock has been removed to make way for it. We have seen this feature at the Main Rock at Dod Law. The design, although using familiar symbols, is unique, quite sophisticated, and very well executed and preserved. There are three other groups of motifs around the main rocks.

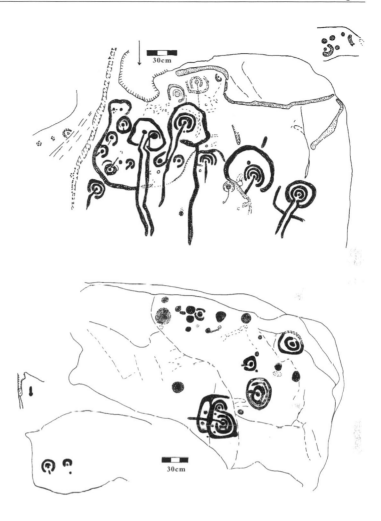

44 Top: Horton 1a;
bottom: Horton 1b

West Horton 2 H00448 NU 0220 3165 122m (Plantation Site)
A stone wall runs to the north of the site just described, and just over the wall are horizontal rocks that are now tree-covered or in coarse grass. Among the designs is one particularly sensitive to the shape and form of the rock surface.

West Horton 3 H00449 NU 02145 31565 120m
This outcrop lies about 3m north of 2; the motifs are on two levels, scattered over the rock.

West Horton 4 H00450 NU 01950 31580 130m
West of 2 are more extensive sheets of outcrop, sloping north-east to a small stream that joins the Horton Burn.

West Horton 5 H00451 (a-c) NU 0160 3170 145m
West Horton 9 H00455 NU 0160 3170 140m
This rock is at site 5, but has been given a separate number. In grass, it lies about 60m north of 5 on a slight slope near a small stream. Usually the motifs are grass-covered: three or four worn sets of circles around a central cup and a complete ring from which a spiral groove runs. On another outcrop is a well-made cup.

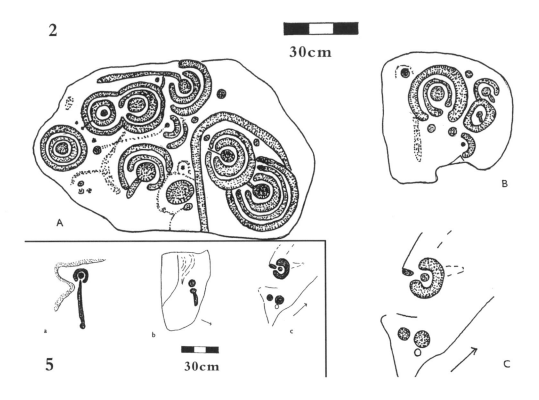

45 *Horton 2 and 5*

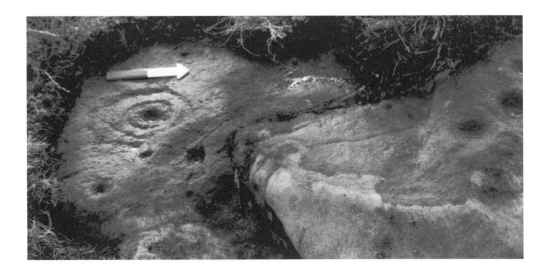

46a Horton 3

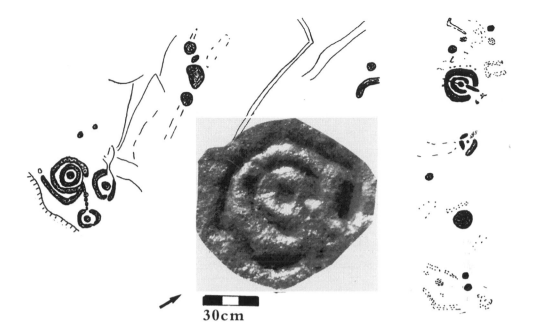

30cm

46h Horton 3

To the west of these sites, the public footpath runs north via a stone setting and an enclosure with external hut circles, to Kitty's Plantation and the Sheepfold. This path is crossed from east to west by another footpath from the quarry to the Devil's Causeway, and to the north of it lie the Ringses hill fort and a field bounded by a wall to the north that has the next group of motifs: the Ringses site.

The Ringses

Between the 137-130m contours on the eastern flank of Doddington and Horton Moors there is a line of rocks running roughly north-west to south-east above an area of marshy land where the Horton Burn flows in its early stages. It is probable that the ridge of outcrop marked the easiest route across the moor, avoiding the marsh. The marked rocks are numbered from the north boundary stone wall. Along the ridge, some piles of stones, presumably from field clearance in the pasture, have been dumped.

Ringses 1 H00461 NU 01632 32881 135m

There is a standing stone built into the drystone wall north of this sheet of outcrop. Part of the outcrop was uncovered at the time when Tate and Bruce made their recordings, but the continuous presence of cattle in recent times on the site has exposed other motifs that are fresh and unusual. What was not noted before is that there is a low cairn of earth spread over the north part of the outcrop.

The rock surface slopes eastward, and at the top of the exposed part are fresh motifs that cluster together in a way that suggests that they were to flow into each other rather than stand separately on the rock. The drawing best shows this relationship,

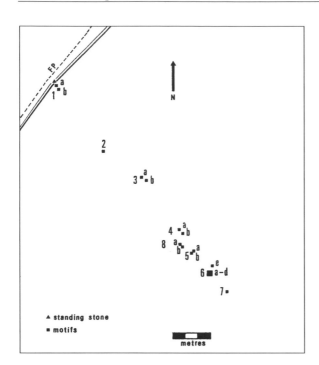

47 Left: The Ringses sites; below: Ringses 1b. I. Hewitt

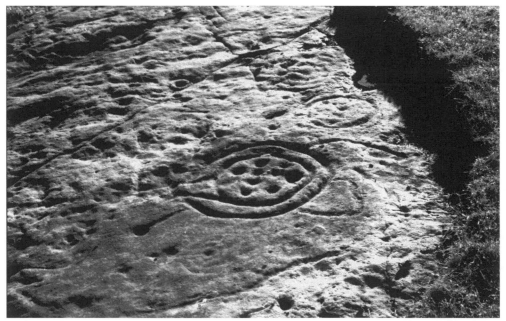

where pick-marked figures include a scatter of cups, pick marks where motifs were not completed, and cups at the centre of rings, penannulars and arcs. A fault separates them from other distinct motifs on the rock to the east, and two just above this slight change of level have the ends of penannulars looped together (a rare feature seen also at Roughting Linn and Hunterheugh).

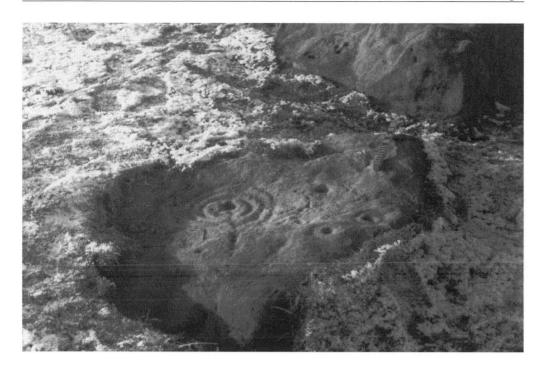

48 Ringses 5b and c

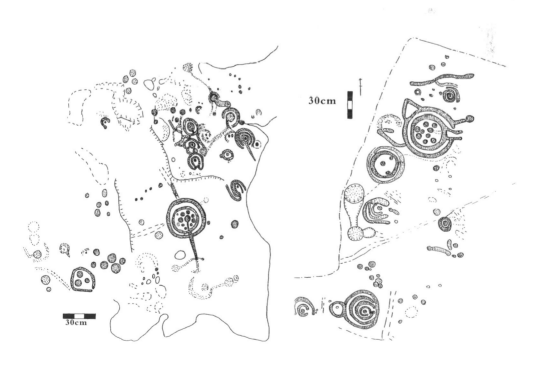

49 Ringses 1a (left) and 1b (right)

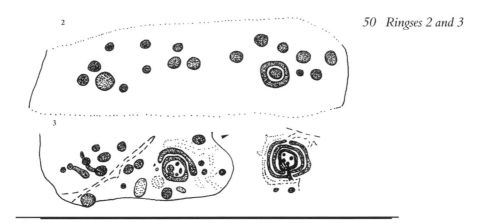

50 Ringses 2 and 3

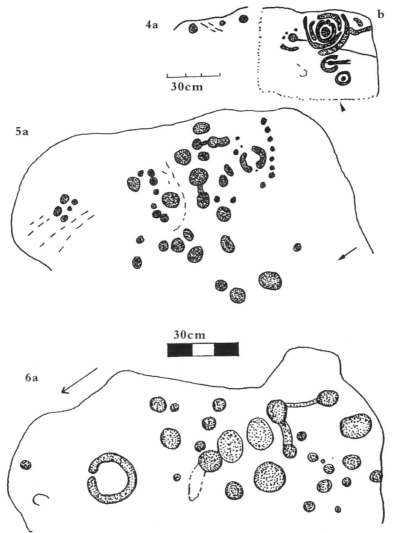

*51 Ringses 4a, 4b,
5a and 6a*

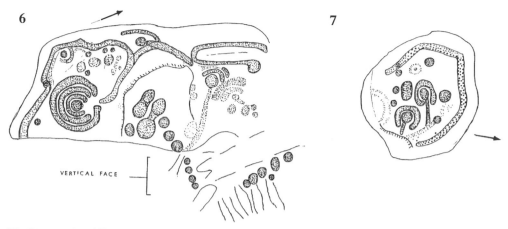

6 7

VERTICAL FACE

52 Ringses 6 and 7

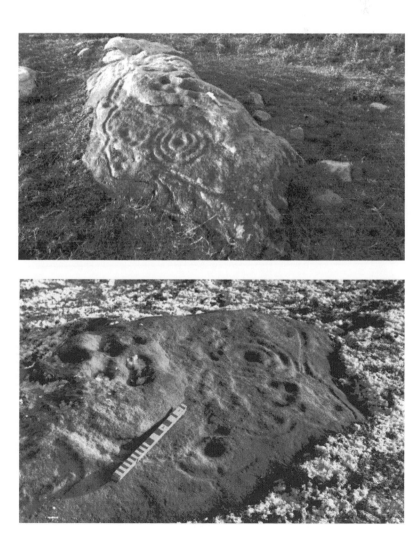

53 Ringses 6

Further east a rosette motif dominates. This rare form has a central cup, ten cups around it, and two concentric rings around the rosette. A duct leads from the central cup and flows down the rock beyond the concentric circles to a cup. There are faint grooves, some curved, and distinct cups of various sizes. At the lower end are three cups enclosed by an angular groove. A second part of the exposed outcrop lies to the south, close by. These motifs are on sheet outcrop; it is not easy to tell, but some of the other marked rocks may be earthfast rather than outcrop close by to the south, a continuation of the outcrop.

The other parts of marked outcrop or earthfast surfaces are drawn from north to south.

Ringses 2 H00462 NU 01634 32874

Ringses 3 H00463 NU 0175 3280

Ringses 4 H00464 NU 0180 3278

Ringses 5 H00465 NU 0181 3276

Sadly, and very regrettably, two of the rocks in this group were removed, presumably by farming, between April 1983 and April 1984, along with three others, and quantities of field clearance material were also taken away. 5a is the survivor, about 3m south of Ringses 4. It is an irregularly-shaped outcrop, slightly domed, covered away from the edges with many varied-sized cups. There is a curved line of eight small cups beside two arcs that face inward to each other, and two sets of linked cups. There are six small 'dominoes' and 32 other cups.

5b, now missing, is photographed, and I sketched it pre-1983. Tate and Bruce also sketched it. A horizontal outcrop, dipping gently into the ground on the south, has on the west a cup and duct with three penannulars, the duct running on to the edge of the rock. Around the cup, inside the first penannular, are three cups in a curve as though to form a rosette. All the pick marks are clear, as they are in tentative groove outlines on the rest of the rock. Two cups have faint single rings, and two others have well-defined rings. There are five other cups.

5c protrudes from the ground north-west of b, with its steepest slope facing b.

Ringses 6 H00466 NU1085 3274

There are three separate rocks in this group. One has a fairly flat top surface; it drops steeply to the east, and all the surfaces have been marked. Below the vertical line of cups on the east face is a line of six cups. A parallel to this is at Old Bewick, which is on a much larger scale.

Ringses 7 H00467 NU 01780 32698

This, the most southerly rock, stands apart from the broken outcrop that forms the ridge 10m to the north. It is at ground level, has a smooth horizontal surface, and is roughly circular.

To the north is the Sheepfold site, and this brings the survey of the area to a close. Eastwards, the land falls to the Hetton Burn, rises to the West Lyham-Holburn road, then more steeply to the outcrop scarps of Raven's Crag, Bowden Doors and Cockenheugh, further east of which is the descent to the coastal plain and the North Sea. Very few pieces of rock art have been found in this large area, none is on outcrop, but there are sufficient examples to allow some speculation that motifs played a part in the life of prehistoric people.

Weetwood and Fowberry

The River Till cuts into the Fell sandstone scarp as it flows to the Milfield Plain, and the Clavering/Weetwood scarp thus formed looks north to Gled Law and Buttony. The town of Wooler commands another gap from the south to the plain. The Haugh, now a place for caravans, is flat land beside the water. The moorland is skirted by rivers and streams, and juts out from the main scarp that continues as Chatton Hill, Amerside, Chillingham and Ros Castle onwards. It is an outlier that shares the same kind of moorland landscape as the main scarp. The soil is thin, not very fertile, and supports heather, pasture and planted woods. The fertile soils lie at a lower level. At Wooler Cricket Ground a buried henge ditch, visible from the air, marks the place where the southern valley enters the fertile plain that lies between the sandstone moorland and the volcanic Cheviot range. South towards Lilburn and Powburn from the Wooler gap, the land undulates gently where ice sheets have deposited moraines that are in places rich soils for arable farming. Survival of monuments on the moorland is quite good, and the flatter areas, farmed for generations, reveal their history mainly from the air, or from occasional ploughed-out remains and artefacts. Although named as the 'wet wood', the moor is well drained today. It is a mixture of heather, planted trees, and grass — the latter being quite recent, and not wholly suc-

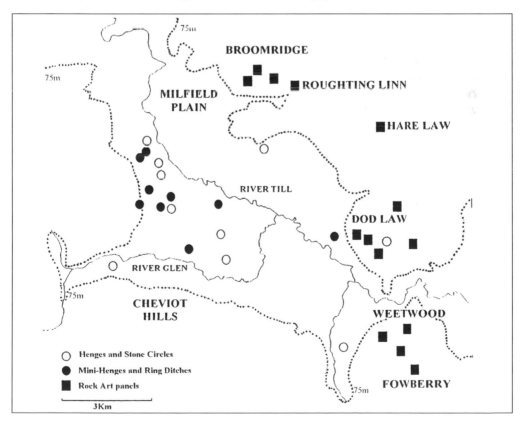

54 The disposition of rock art and henges around the Milfield Plain

55 The Weetwood bridge gap, where the Till breaks through to the Milfield basin

cessful as coarse bent grows with it. It is a hangover of subsidised agriculture that ruined a perfectly good stretch of heather moorland.

The boundary between Weetwood and Fowberry is an artificial one, beginning with a tree-flanked road towards the triangulation pillar that cuts off the moor from the Fowberry Farm grounds, which are pasture, ploughland, woods and a little moorland with minor quarries. Fowberry continues the slope down to the south and south-east, and from it the whole scarp range that includes Old Bewick is visible. It is convenient to examine the area in two parts, despite the artificial nature of the boundary.

Recent discoveries of motifs on small patches of outcrop towards Clavering among small plantations indicate that more sites may be hidden. There is, however, an extensive outcrop that is open to the public and that has a good spread of motifs. The site is a raised, slightly sloping plateau of rock flanked by pasture, a public footpath, and a cairn, to the south and south-west. It is reached just north of a metalled road that leaves the bend of the Wooler-Chatton road west past North Plantation by a cattle grid. The outcrops, many ridged and twisted during deposition, are very close to the surface, and on the edges they have been quarried. The hill has extensive views over many kilometres that do not extend to the north edge of the Weetwood-Clavering scarp, but overlook all the scarp edge sites from Gled Law, Buttony, Chatton Park Hill, Old Bewick, and onward to Alnwick. Most of the major rock art sites are intervisible.

The map locates the rock art in groups, beginning with the edge of a small quarry, looking towards the road and cattle grid. Group 3 includes one of the most spectacular designs in Britain; the rocks in other groups lead up to it on the slope, where it holds a

56 *From Weetwood to*
 Lilburn

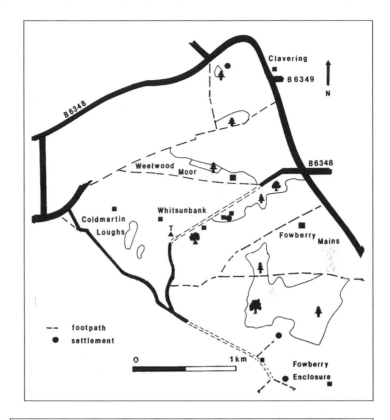

57 *Sites 1-7 (excluding*
 6), Weetwood Moor.
 I. Hewitt

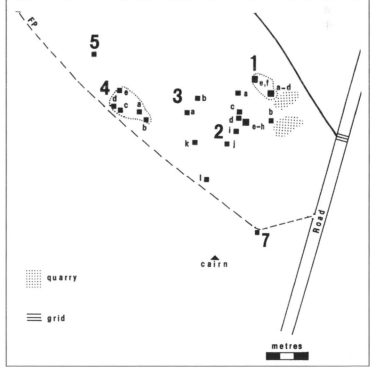

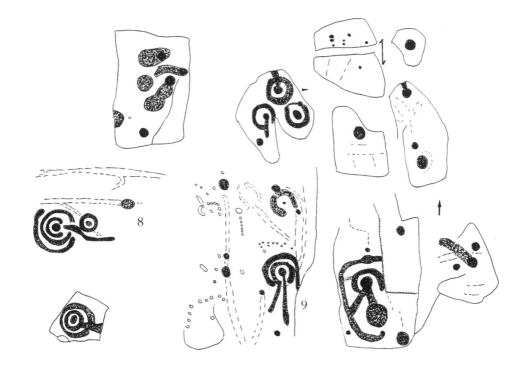

58 Weetwood north; the drawings include all rock art found in this area: outcrop, earthfast and displaced parts of a cairn that lie against the decorated outcrop.

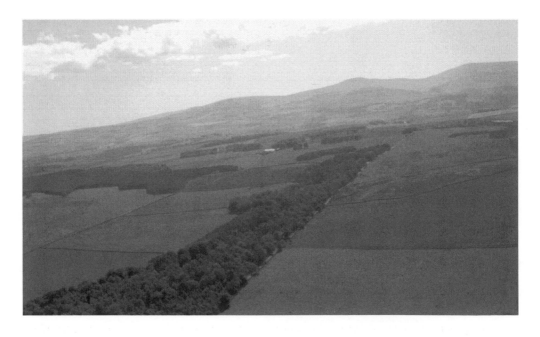

59 Weetwood and Fowberry from the east. The central wood is North Plantation

60 *Weetwood 1 and 2*

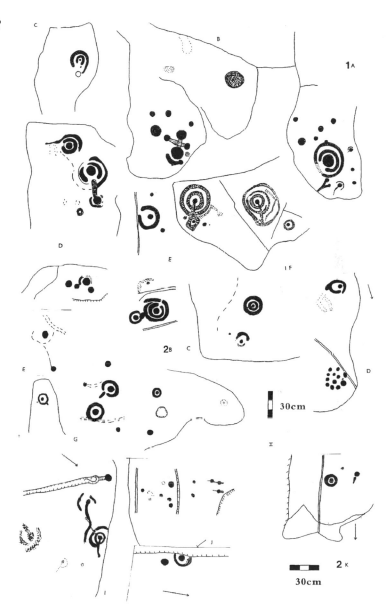

central position on a horizontal, relatively smooth outcrop. This is a well-executed design; although it has been exposed for at least one hundred years the pick markings are clear. There is a strong sense of fluidity, of interconnection, in the arrangement of the motifs, and to the modern eye it is impressive.

In group 5 is an outcrop patch known as 'The Gorse Bush Rock' because the rock is almost covered with it; this isolated near-horizontal outcrop has some elaborate motifs, including pear-shaped grooves of the type that also appear at Coldmartin (below).

The rock outcrop rises gently to the north and drops sharply away, forming an edge, now covered with planted trees. There are small walled enclosures, and access to the

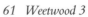

61 Weetwood 3

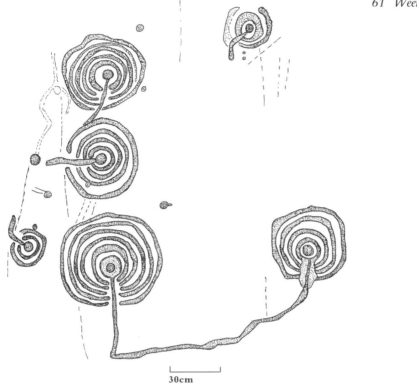

30cm

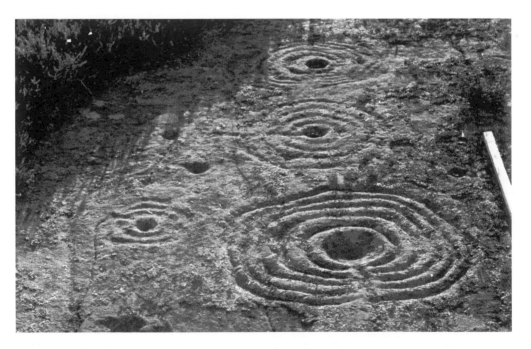

62 A photograph of Weetwood 3 taken 30 years ago; the outcrop was still largely covered with heather

63 Weetwood 4

64 Weetwood 5

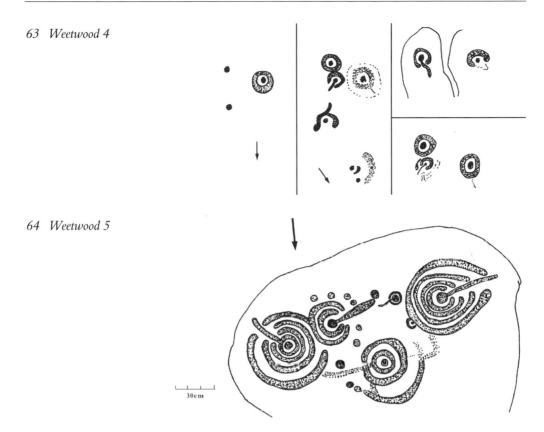

30cm

marked rock 6 is by a gate. A smooth outcrop sloping away from the edge to the east has some very fine cup and ring motifs. The rock is sheltered by the wood, but the shedding of needles, although offering some protection, could be producing acid and obscures the motifs from inspection. The little wood has a wire fence that limits access.

Stone 7 is reached by returning towards the road along the public footpath, next to which it stands out on the south side. It is an outcrop block, horizontal at ground level, and has two cups with complete rings, a cup and faint ring, and seven other cups. It marks the limit of the marked outcrops to the south.

This low hill, that has so many marked rocks, is a dominant viewpoint. To the west is a small valley before the land rises again to Whitsunbank 2, where the outcrop has been superficially quarried, possibly for wall-building. Surviving on a high part are motifs that include an extraordinary design that echoes that on the kerb of the Weetwood Mound (see page 128).

A central cup with three concentric rings has three radial grooves, a motif repeated at Buttony. Further west, north-west of a triangulation pillar at the end of the hard surface track that runs from the B6348 is a recently-cleared field, the base of which is outcrop rock above thin grass, and on which field clearance stones have been dumped. Beyond that field is a fence with a small gate, to the left of which, south-west, over the fence, are some outcrops that face north-west, overlooking the dip in the expanse of moorland, a slope upwards to the communication discs, and to Coldmartin Loughs. The tops of the Cheviot

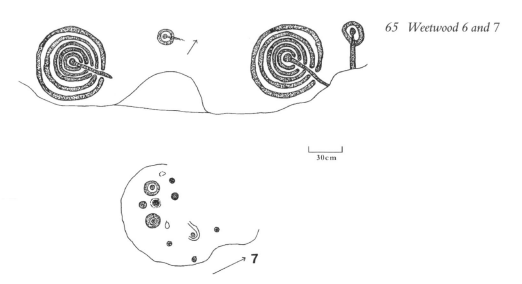

30cm

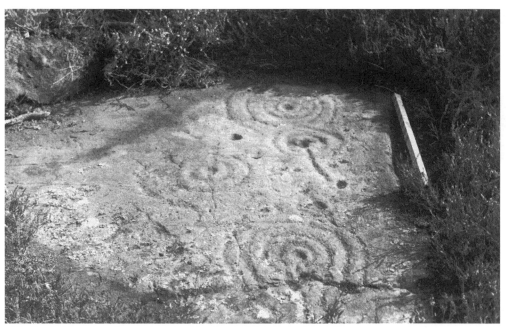

66 Weetwood 5

Hills are visible. The two marked outcrops overlook the lower ground and loughs that may have encouraged a supply of game.

One is a large sheet of outcrop, aligned north to south, with a view to the south ending at the ridge on which the triangulation pillar is now situated, and with views to the edge of the Weetwood Moor scarp, and to the Dod Law-Broomridge scarp on the horizon. In a sense the view from the rock is focused on the slight depression and the loughs. There are

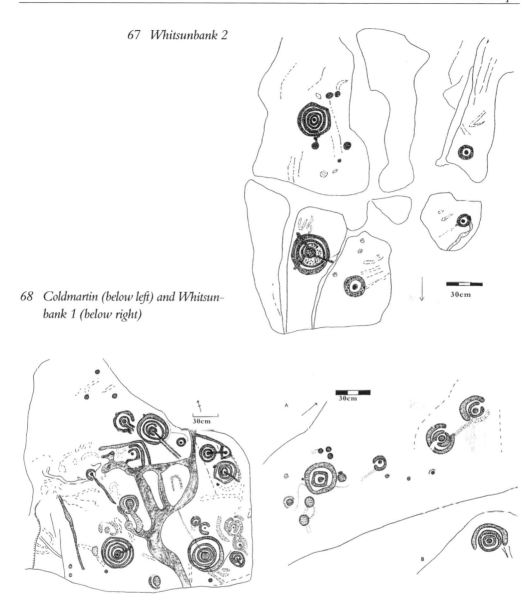

67 *Whitsunbank 2*

68 *Coldmartin (below left) and Whitsun-
bank 1 (below right)*

two sets of motifs, separated only by a metre. The second outcrop, much smaller, lies a few metres inside the fence.

From Whitsunbank a ridge of sandstone is visible, with the tops of the Cheviots beyond. Nothing of archaeological significance has been found in this flattish area between the two sandstone ridges until we reach a marked rock at Coldmartin, which means the farm near the pool. This has some complex motifs, in which the structure of the rock plays a part. There is also some nineteenth-century vandalism, where initials and dates have been incised (HCR 1834, for example). The rock slopes southwards and there are two levels. The ridge that forms the division has a number of erosion channels that have been enhanced as branching wide grooves. One of the interesting things about this rock is

the way in which its natural surface irregularities and its slope have been incorporated into the design. Its position overlooks what must have been a valuable source of food in and around the lough. The shallow valleys have been scraped clear of loose stone and surface archaeology. A large boulder (NU 0095 2785), 180 yards east of the communication tower, has recently been found to have cups and a cup and two broken rings on its top surface.

Fowberry

Fowberry is not topographically separate from Weetwood, except by land ownership. Both areas have a mixture of moorland, planted trees and pasture. Both have prehistoric enclosures: at Clavering, North Plantation, Deershed Plantation and Trickley. Fowberry means the fortification of the foal. For the purposes of this section, the Way to Wooler, an old road, skirts the south-west of both areas. The artificial division between the two areas is the metalled road that runs from the bend on the Chatton-Wooler B6348 road.

In one corner of North Plantation, where the road to Fowberrymoor Farm follows a high stone wall that runs partly on the top of the outer earth and stone prehistoric enclosure wall, is an outcrop by a small gate leading into the private wood. This is the first of two marked outcrops, named *North Plantation* (H00521 NU 0207 2782).

The more westerly rock is a sloping outcrop that has a large cluster of cups near the west edge and a large cup from which a groove runs along the edge. Among the motifs on the east is an occulus: two small cups with arcs and a figure-of-eight groove around them.

The more easterly rock is longer than it is wide. The most interesting feature is where a rectangular piece of outcrop has been removed from the surface, possibly with cup and ring designs. The space left by this removal, a flat base, has been pecked with a pristine cup that has a bending groove leading from it down the stepped rock into the earth, with concentric angular grooves, square with slightly rounded corners around the cup. Every pick mark is visible, as though it had been made yesterday. We have seen this phenomenon at Dod Law and West Horton.

In 1933-4 Mr Davidson described another rock built into the rampart, its flattish sides packed at varying points with flat stone slabs, particularly on the east side. The rock was re-covered after men with crowbars had tilted it. He said that it was not in its original position; his drawing shows a series of four concentric penannulars around a cup and other cups, with the crowbars in position. It has either been removed, or remains covered up in the wood. Whether this, like some of the other slabs in the area, was broken from outcrop for the building of the enclosure is not known.

The Fowberry Excavation Site's major importance lies not only in the use of the outcrop for a rich variety of motifs, but for a mound containing decorated cobbles built on it; this will be considered in detail in chapter 3. Suffice it to say that the outcrop occupies a position higher than the North Plantation rocks, sharing views to Ros Castle and Old Bewick in the far distance, and having a very important ritual connotation.

Fowberry Mains/Fowberry Park *H00525 NU 0282 2773*

The land that runs from Deershed Plantation north-east includes the moorland of Fowberry Park/Mains. Along the outcrop edge to the north bounded by a small burn is some unique rock art. The area to the south of this, known as Trickley Wood, has been the site

69　*North Plantation*

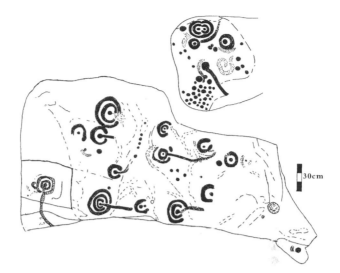

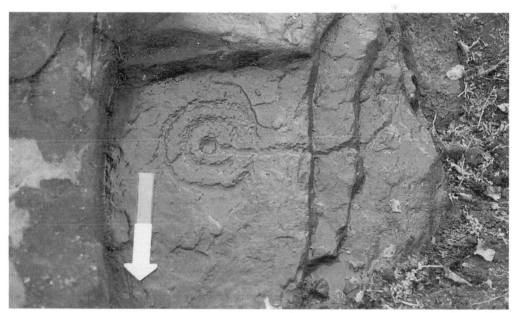

70　*North Plantation: a slab of rock was removed in prehistoric times and a new motif picked on its place*

of prehistoric finds, including a destroyed tumulus from which an urn was taken. The site of the rock art is at the edge of a quarry that has taken away much stone. There are four areas of marked rock, including some unique motifs. An outstanding one is a very long rectangle made entirely of very small cups. One end has a straight line of cups; the other almost closes on three pairs of cups pecked below it. There are two larger cups above this figure.

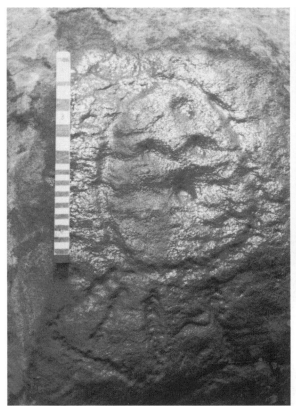

71 *Fowberry Mains a and b*

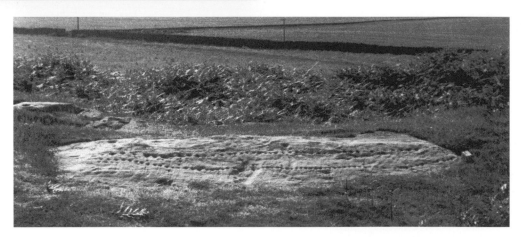

There is on this outcrop an exclusive repertoire of motifs, given the limited marked surface. There is nothing else in the immediate area with which to associate the marked rocks, but the direction of the outcrop is leading uphill towards the Fowberry Excavation site; the motifs have their grooves drawn down to the south-east. If North Plantation were not covered with trees, the Weetwood sites would also be visible from here to the north. There is a good view all the way round from the outcrop to the Till valley and uphill to Trickley Wood.

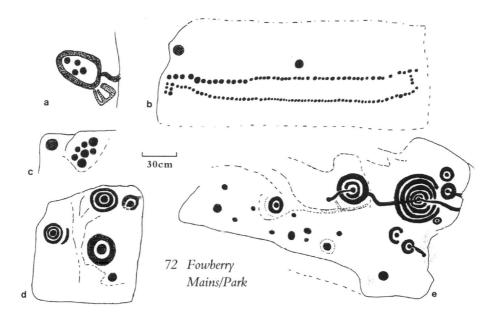

72 *Fowberry
Mains/Park*

The old trackway from Newtown to Wooler divides the rougher moorland from enclosed fields and plantations to the south-west. William Gunn in 1881 discovered a marked outcrop block to the west of the trackway when he was completing a geological survey.

The horizontal outcrop to the east of the track lies close to another enclosure. The rocks are partly plough or harrow scratched and appear through thin soil and grass. Two areas of markings are illustrated:

Fowberry Enclosure 1 H00526 NU 0290 2612

The repertoire here includes a very unusual grid pattern. This has been pecked out by making a series of parallel grooves that divide a square into 20 small squares. A serpentine groove runs from one corner of the square to a beautifully executed symmetrical cup, on either side of which are two antithetical motifs; one is a clearly pecked cup with a groove running from it through a ring. The other has two concentric rings that have left a space at the centre instead of a cup, which is unusual for this area. Included in this group are two other cups.

Fowberry Enclosure 2 H00526

Split by a crack that forms a straight edge to a wedge-shaped outcrop, the west part is dominated by a pristine deeply pecked cup at the centre of four concentric rings.

Scratches on all these rocks are from ploughing and harrowing. Despite this, it has been possible to get a good idea of what motifs have been pecked into the horizontal surface.

There is another important rock art site somewhere in the Lilburn-Newtown area waiting to be rediscovered. A report says that the Cairn-fauld's field east to the old grass on Chillingham-Newton ground is backed by a fir plantation from which there is a wide view of Chillingham. Here there are many 'flat rocks, with markings', some of which are sketched in the article. They are most likely to be a continuation of the outcrops to the north.

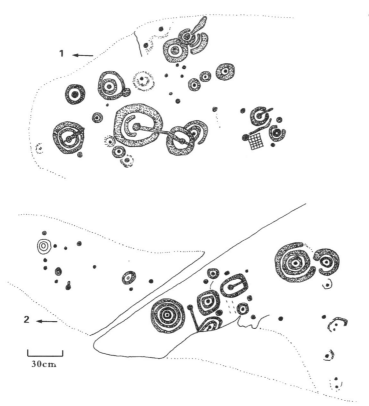

73 *Fowberry enclosure,*
 1 and 2

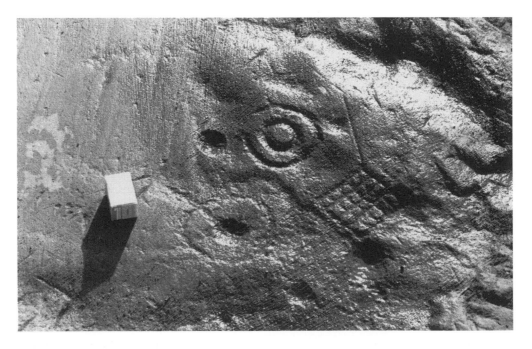

74a Fowberry enclosure 1

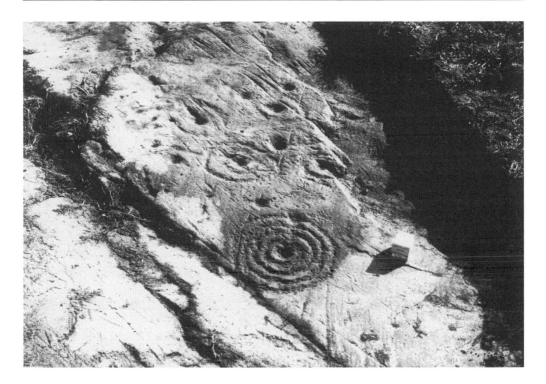

74b Fowberry enclosure 2

Chatton Park Hill to Old Bewick

Chatton Park Hill

Chatton Park Hill is part of the Fell sandstone scarp that faces west, with its dipslope to the east. The highest part of the hill is marked with a triangulation pillar at 180m. It is separated from the scarpland south of it, Amerside Law Moor, by the Mill Burn, which flows north-west to join the River Till. The Lyham Burn marks the edge of the hill to the north. To the east the land shelves more gently away from the hill to more even ground at Linkey Law, where industrial spoil is visible.

Park Plantation, on the west-facing scarp, is visible for miles around. Above this stands extensive outcrop on a south-facing spur, on which is one of the finest rock art panels in Europe. From the highest point, the views to all but the north are extensive, taking in most of the major rock art sites in this region. It is just to the north-west of the hill that the River Till, having risen as the River Breamish, runs through the Ingram valley and turns to flow roughly north past the major rock art sites of Beanley, Old Bewick and Amerside Law before it turns west to cut through the parallel scarps of Weetwood Moor, Gled Law and Doddington. Here it enters the Milfield Plain via the south-facing scarp edges of Horton and Buttony overlooking that valley.

Some of the finest and largest concentrations of rock art in north Northumberland are found overlooking the river valleys from the high Fell sandstone scarplands. The river

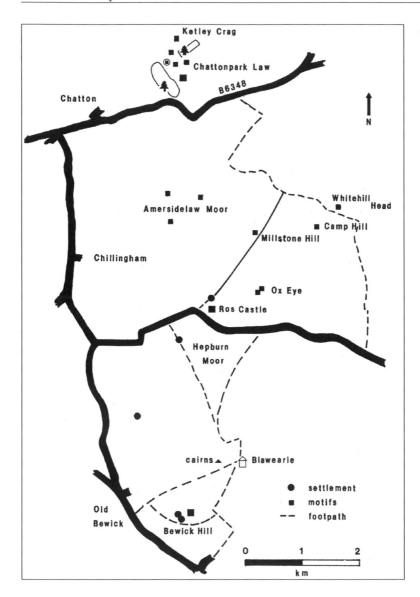

75 Chatton to Old Bewick. I. Hewitt

valleys provide good agricultural land that in prehistoric times would also have been good hunting and fishing ground. The higher Fell sandstone scarplands, with their thinner, poorer soils would have provided good ground for hunting and for seasonal pasture.

Chatton Park Hill was singled out for a prehistoric enclosure at its highest point, which circles outcrop rock that is cup and ring marked. On this hill there is evidence of clearing for arable agriculture, where the land is now used for permanent pasture. Some land to the east has been enclosed, such as the rectangular field of Northmoor Plantation. The field south of it, also enclosed, includes a natural ridge facing north-east that has been added to by field clearance stones. There is on the north side an outcrop of sandstone forming a line of low crags; under one of the overhangs is a unique decorated floor. The marked rocks are illustrated, and some major features are singled out below.

76 *Chatton Park Hill 1 and 2*

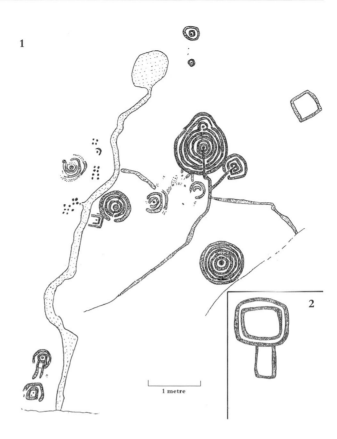

Chatton 1 *H00541 NU0757 2906*

The finest rock art here is often marred by mud and cow dung, as cattle roam freely. The soil is churned up. The part where the outcrop is has little agricultural value; in the recent past it has been quarried both on the top of the outcrop and on its edges of the slopes leading up to it. There are motifs on the crown of the rock in the form of parallel serpentine grooves, cups, and simple cups and rings. From the west edge there is an uninterrupted view across the Till valley and the Weetwood and Fowberry sites to the tops of the Cheviot Hills.

The main natural feature of the rock is a large irregularly shaped basin from which a channel snakes its way down the slope eastward. This feature seems to have been enhanced. To the south of the channel are groups of domino cups and other motifs of two kinds: roughly circular grooves and more angular grooves. To the north of the main channel, close to it, is another box-like figure with a small cup enclosed, but this is faint compared with the cup at the centre of three deeply pecked concentric rings. The cup has a small duct leading from it down the rock, the line of which is extended faintly up the rock as a radius to reach the outer ring. Other faint figures, unattached grooves and incomplete concentric rings lead to the most distinct design of all. This is a cup from which a long groove runs down the rock, almost meeting the channel. Around the cups are three concentric rings and a penannular. Then an unusual variation on the cup and ring theme appears: a small cup above the central one has its own ring that is attached to the fourth

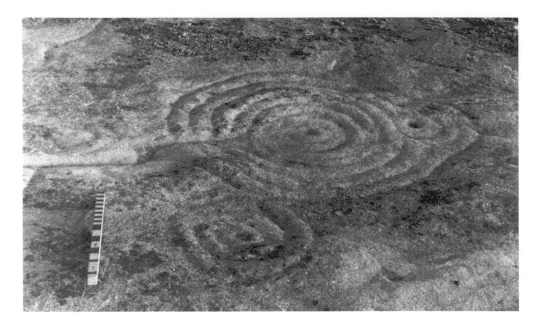

77 *Chatton 1*

penannular around the main central cup. The next two concentric rings follow that pattern, giving the seven concentric rings a distinct crown.

A sense of space, the use of the natural basin and channel and the interconnection of many of the motifs are all important parts of the design. Unfortunately, the nineteenth century saw people trying to lay claim to cheap immortality by bringing up tools to carve their names and the date on the rock.

Chatton 2 H00542 NU 0747 2909

On a slab of outcrop is a figure known to us as 'the television set', on account of its shape.

Chatton 3 H00543 NU 0757 2909

There are some incomplete cup and ring motifs scattered over a large area of rock. Whether they are eroded or incomplete is not clear, but the latter is more likely.

Chatton 4 H00545 NU 0723 2939

On the highest part of the outcrop within the hilltop enclosure where quarrymen have been at work (leaving their wedge marks in the rock) is an occulus. At the centre are two discrete cups with two concentric rings enclosed by an arc that follows their curved shape. To the left is a serpentine groove that provides another partial enclosure for the occulus. Above this is a shallow basin on the scalp of the rock that may be partly natural, but which has cup and ring added to its centre.

Chatton 5 H00455 NU 0738 2941

200m east of the enclosure is an outcrop that lies above the stream. On the west side of this outcrop is a small settlement that includes at least two enclosures. The more northerly takes advantage of a scoop out of the hillside, and is walled. The other enclosure has a pronounced earth and stone wall. The site is sheltered from the east by the outcrop.

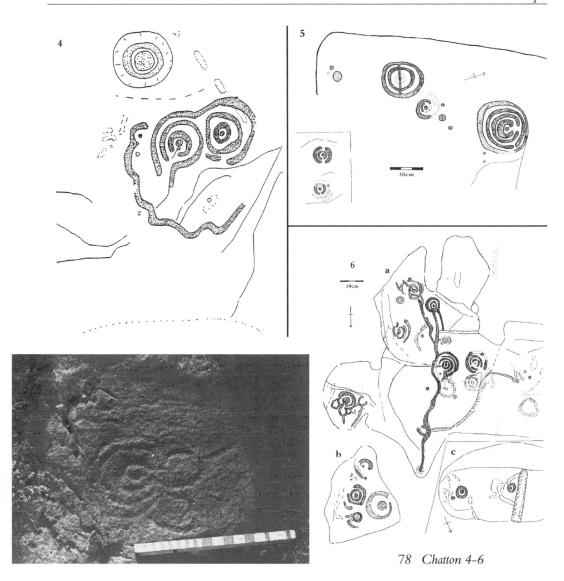

78 Chatton 4-6

On the top of the outcrop are signs of extensive quarrying for stone. This extends to the edges, but luckily the most prominent part of this outcrop, visible for miles from the south and east, still has markings. The top surface is marked. An unusual feature is that two motifs are pecked onto the downward, almost vertical slope: a cup at the centre of two precisely gapped rings and a cup and penannular with other faint signs of pecking. The main outcrop rocks 1-3 are clearly visible from the top of this rock, and so is the ridge to the east where there are other motifs.

Chatton 6 *H00546 NU 0742 2960*

There are motifs on three parts of the same outcrop, which occupies a site of extensive views reaching many miles to the north, east and west. The most impressive aspect of this site at the edge of the North Moor Plantation is the range of view. To the west the

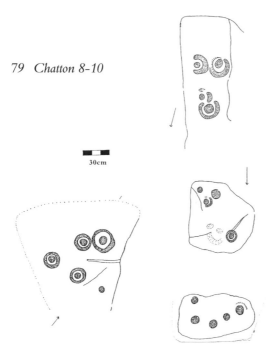

79 Chatton 8-10

30cm

land drops away to a small burn, then rises to the enclosure. To the north-west there is an uninterrupted view of the Horton to Dod Law sites, Weet-wood and the Cheviots.

Ketley Crag H00553 NU 0743 2978

A rock outcrop on the descent north from site 6 to the Lyham Burn is fa-voured by badgers; they exposed part of the floor of a rock overhang that is cov-ered with motifs. At the time of the dis-covery only the part nearest the rear wall had been exposed, and this is how I drew it at the time. Since then someone un-known stripped the rest of the turf cover off it; it had been our wish to excavate it carefully, as Corby's Crags and Goat-scrag Hill had revealed pre-historic buri-als in the floor. At Ketley Crag this was a long shot, as the dip of the outcrop made it unlikely for the turf to be supported by more than a very thin soil.

The site is at the far east of the crag, low down the slope. (With North Plantation behind you, line up with the hedged field boundary and its gate to the north). I recorded the whole floor area at a visit in January 2001. The quality of the decoration is stunning, and this is one of the most sensitive uses of the shape and variations of any rock panel that I know. The slight variations in slope have determined the direction of grooves running from cups that are central to concentric rings. One long groove is drawn across the sur-face parallel to the width of the floor. Another long groove runs from this centrally to the downward edge of the rock. A third long groove completes the way in which the surface is zoned into three areas, each packed with cups and rings. At the lowest part of the rock, which naturally comes to a point, the small triangle has become a focus of a most elaborate treatment where packed motifs flow into one another. The largest figure here of cup and four concentric rings is intersected diametrically by a long groove that originates at the centre of a smaller cup and two-ringed figure above it. To the east of the long dividing groove are four large motifs of three and two well-spaced rings united by the grooves from the central cups as they flow down the rock. There is a distinct design element; in any age this would be the work of an artist.

The way the motifs flow into each other, taking every advantage of the natural slopes and irregularities of the rock surface is similar to the concept on the main rock on Old Bewick Hill. Fluidity and interconnection, the spacing of grooves, and the use of what the rock had to offer in the first place must make this one of the world's greatest sites.

What significance the rock shelter had for the people who decorated it in this way is not known. The absence of anything funerary today does not preclude it from having been used in that way, but we cannot speculate any further. What we can admire is the great wide stretch

80 Ketley Crag rockshelter floor

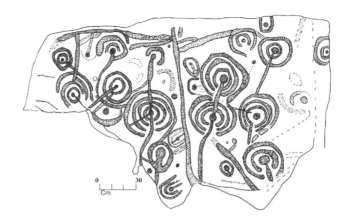

81 Ketley

of landscape that this site dominates. It is truly a significant viewpoint. The crag outcrops continue to the west on two levels, and all have been examined without disturbance. For me, a great feature of the recording, as I spent about three hours on my knees under the overhang, was the continuous noise of the badgers from the other side of the wall. They sounded as though they were having a vigorous spring cleaning of their homes!

Chatton 7-10 H00547-550 NU 0783 2941

These sites lie between the North Moor Plantation and the main Chatton-Belford road, on either side of the wire fence that divides enclosed fields from rougher, uncultivated ground. Most have been found on the low ridge that the field wall follows.

Amerside Law Moor

Amerside Law Moor H00556-8 NU 075 276-081 271

The Fell sandstone outcrop at Chatton Park Hill continues along Amerside Law Moor through Kay Hill and Achnacarry Plantation once the Mill Burn has been crossed. The highest part is at 220m. The view west extends across the Till valley.

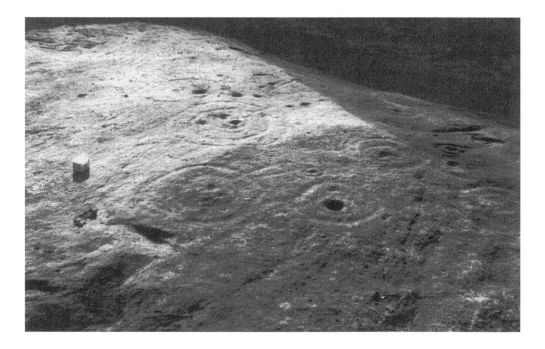

83 Amerside

The story of how I encountered this site is unusual. I was invited to talk to members of the Chatton Leek Club in the village hall about the local area, so I took slides and projector, to find the hall packed with people of all ages. It was quite an occasion for all of us. Among the audience was Jim Robson, who at that time did his shepherding on horseback.

He showed me photographs of rock art that I had not seen before and took me to see it. There is a scatter of marked rocks on the little plateau bounded on the south by the wall of Achnacarry Plantation, including a large and impressive panel.

One rock is a good example of how basic symbols used all over the county can be arranged in such a way that an individual result is produced.

It seems that some cups had been made before the main motifs were applied, and were incorporated in them. On the extension of this ridge north are two motifs: a cup and ring with an outside cup, and a cup with a groove at the centre of two rings. There is a small Christian cross carved on the ridge with a metal tool.

The third outcrop patch has a rectangle within a rectangle enclosing a number of cups, further east away from the scarp edge. Four cups in the inner rectangle are all linked. There are three small cups between the rectangles, and one outside. Nearby is an oval containing a cup with two radiates that meet the ring. Close by is an open oval or heart-shape enclosing four cups that are linked with grooves.

The obvious parallel for the rectangular grooves with linked cups and the heart-shaped/ oval groove with linked cups is Dod Law Main Rock. The almost square-shaped enclosures elsewhere are echoed at Chatton Park Hill and Buttony, so one may ask if there was a contact between the people who made them.

In 1982 the area was ploughed and trees planted, but these rocks were fortunately avoided (at least one of the workers knew the value of rock art). By that time the site was well known and reported. The site has always been difficult of access, not only because it is private. Now it may not be worth a visit, as the patterns on the rocks are almost totally obscured, even if you know where to look for them.

Ros Castle H00568-72 NU 0798 2510

Continuing further south along the scarp, the next prominent viewpoint is Ros Castle, a prehistoric enclosure that commands enormously wide views. Rock art here has not been found at the highest point, but on the slope leading up to it from the Hepburn road. The position must say something of its significance, in this case marking a path.

The motifs are simple, which again may mean something, such as being in a subsidiary role to some now-destroyed monument or large rock panel. All the markings are on outcrop.

The area to the east of the scarp edges, though not nearly so productive of rock art, has given us a few small finds that extend its range and significance. There is a great expanse of moorland and pasture, not the most fertile of land, before the coastal plain is reached, that includes the extension of Amerside Law Moor eastwards to Brownridge, Whitehill Head and Chatton Sandyford Moor. Although this area has revealed hundreds of barrows and many flint artefacts it is strangely lacking in other signs of habitation.

Ox Eye H00564 NU 0951 0541

East of Ros Castle in a planted area is a natural outcrop boundary marker; between this and a long cairn are two cup marked outcrops that are usually buried in deep heather. The question that arises is whether the long mound could be a Neolithic long barrow, for this might explain why two ritual traditions exist at the same site. One slab has scattered cup marks, most of them in a cluster at one end. The other has a scatter of 28 cups; some might be seen in pairs like those at Ros Castle, but their apparent pairing could be coincidental.

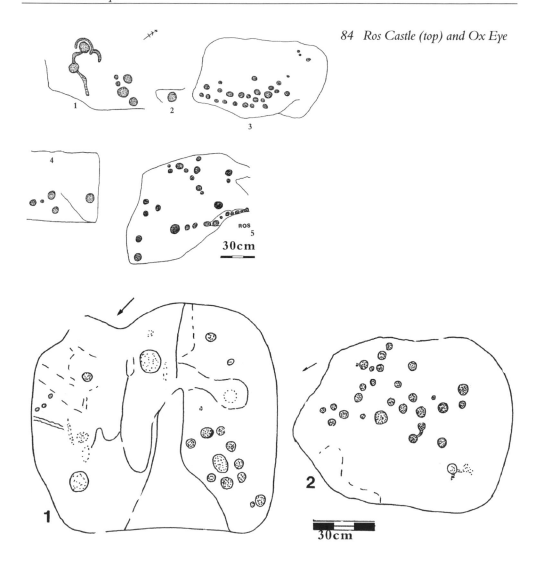

84 Ros Castle (top) and Ox Eye

Millstone Hill *H00565 NU 0885 2650*

On Millstone Hill there is a sloping outcrop with linked cups, discovered during the last 10 years. On the outcrop are cups joined together like strings of beads. The largest string has its largest cups at either end with five smaller cups in between. Parallel to this are four joined cups and a thinner groove that ends with a cup; the head of the groove has four cups pecked in an arc. To the right of this is an arc of four cups, which appears as though they were also due to be linked with a groove. The motif of linked cups is rare, but can be seen at Gayles Moor (Richmondshire) and Barningham Moor (Co. Durham), for example.

Wandylaw *H00625 NU 137 251*

There is an upstanding earthfast block of sandstone, tilted on its top surface, lying near a stream. A flow of grooves leads down the slope from cups, and there is a small boulder in the stream with a small cup and groove at the centre of it.

*85 Millstone Hill (left)
and Wandylaw*

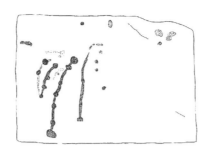

30cm

Old Bewick to Midstead

Old Bewick

Old Bewick Moor has a prime place in British rock art, for it was here that the first panel was recognised as such. John Charles Langlands dismissed his first reaction in the 1820s that the marks on top of this massive table-like lump of rock were the work of an idle shepherd when he found more. He realised that they were ancient. It is difficult to believe that it took so long for people to become aware of the phenomenon, but we do tend to find what we are looking for.

Old Bewick Moor begins at the scarp overlooking the River Till and the Cheviot Hills, marked by a large double hill fort shaped like a pair of half-moon spectacles. Its dip slope includes a long field cleared of heather only in the past 30 years and converted to pasture, and within this field are panels of rock art, some obvious and others almost hidden. So recent are our discoveries that maps used to include only three marked rocks. We begin with Mr Langland's first discovery.

Old Bewick 1a H00581a NU 0781 2158

This mini-car-sized block is earthfast, brought here by ice. To one side is some field clearance, but there are also two smaller but similarly deposited earthfast blocks, one with a single cup. We were able to establish that they did not rest in pits, but flat on the sub-surface.

What we see on the tilted surface of this block is a design that takes into account what was already there before people began to get to work on it with their hard stone picks. At the top end there are many natural craters or depressions. Looming large among them, near the top edge, is a large scoured basin. This was almost certainly a natural feature, but the edges have been worked on and the basin shaped to make it a feature. There are similar signs that other depressions have been pecked or scoured, and as we follow these indentations down the slope, the edges of the naturally eroded part give way to cups and cups and rings. The slope had already produced erosion channels from water running down lines of weakness and hollows. These were exploited further. The main central groove that almost reaches the end of a triangular part of the edge begins as a cup from which a groove runs to a similar sized cup. Around it are two penannulars. Higher up the rock a similar motif is linked to the ring edge by the central curved groove. This leads right down the rock to an offshoot groove that runs to the inner circle of four concentric rings around a cup, with an arc outside. The main groove curves slightly to run concentrically to these rings before it reaches the rock edge.

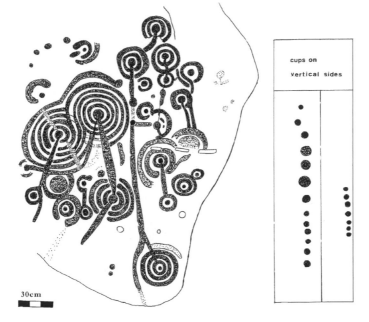

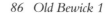

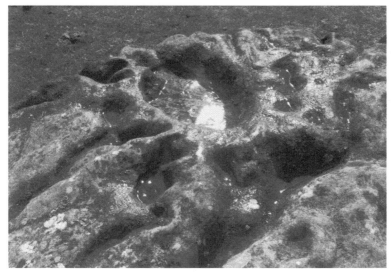

87 Natural erosion and enhancement at the top of Old Bewick 1

This long groove divides the rock in two. To the right are cups and rings with grooves running from central cups and surrounding rings, all linked together. Some cups do not have grooves running from them.

Although the left-hand design is based on a similar arrangement of cups surrounded by rings and by long grooves running from cups at the centre of rings, there is a unique variation in design that has produced what looks like a figure-of-eight. A cup from which a long groove leads down the rock is at the centre of five rings, three of which are made to flow into a similar motif to the left. This has a cup and groove at the centre of five penannulars. A large serpentine groove arcs over the top rings of both motifs to unite

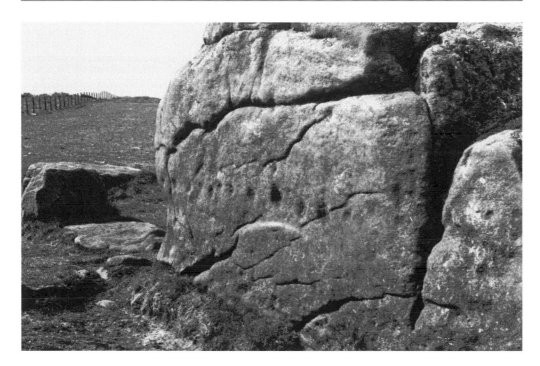

88 *Old Bewick: the vertical face*

them into one, and an extra radial groove from the centre of the right-hand figure curves into the outer arc of the second. Two faint additional radial grooves run to the outer ring of the left-hand motif.

The right-hand design completes its movement down the rock when the groove from the central cup reaches a cup at the centre of three broken rings; the groove continues down the rock from that cup. The left-hand figure has a crowd of motifs below it; one cup and ring connects to the main groove from the central cup. An arc at the centre of a large cup touches the outer ring, and is itself touched by the outer penannular of a cup and ring motif. This in turn is touched by a cup and ring linked by a groove above it to a cup and arc. Above the main motifs are some apparently incomplete motifs. Wedge marks appear on the surface and iron pick marks on the edge of the rock to show just how close we were to losing this rock to quarrying.

There is another feature that distinguishes this block as one of the most interesting ever found: horizontal lines of cups at the tallest end of the rock on its vertical face. This line turns the corner to extend the line east.

The block is not at the highest point of the hill. It was chosen because it was there and it was big. Its viewpoints are limited only by the rise to the hill fort; it overlooks Hepburn ridge, Blawearie cairns and the Corby Crags hill fort.

If you move away from this large block downhill towards the public bridleway from the village to Blawearie house you will encounter more rock art scattered across the pasture on small earthfast boulders. Before the field drops away further there is a small deco-

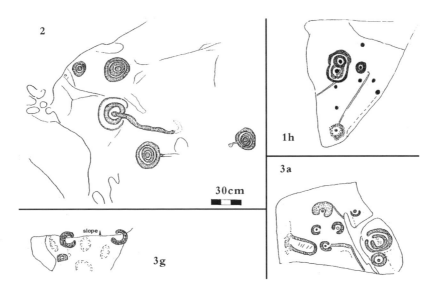

89 Old Bewick 2, 1h, 3a and 3g

rated piece of outcrop (1h) protruding at grass level. The final ridge before the path is reached is a quarried edge with some markings including a piece of stone taken from the quarry spoil. The rocks in the field before the quarry edge is reached vary from single cups to more complex marks. North of these marked isolated outcrops and boulders in the pasture the ground slopes down towards the bridlepath, passing a massive stone and earth dump field wall. The edge of the outcrop here has been quarried, and the next series of decorated rocks follows this line. The ridge has an extensive view to the Cheviot Hills and Hepburn moor, and is designated as Old Bewick Quarry site. A block cut from outcrop rock, found in the quarry, has been decorated on two levels; a cup at the centre of a ring that has been cut through, and below that on the next level two cups with grooves at the centre of penannulars both cut through. It is a fine example of the technique used to create it, for every pick mark is deeply made. It is impossible to guess what its original context was.

We return up the hill towards and beyond the large table-like block of marked rock (1) and over the wire fence to its near neighbour (2). Unlike the pasture field, the land here remains rough before it plunges down the slope to the Harehope valley. It leads to the sites of a number of burial cairns situated away from the rock art.

The table-like block is a smaller version of its neighbour. Its naturally uneven surface has been followed to place five motifs on the rock surface. A cup and ring and three motifs each with a cup at the centre of two rings lie on either side of a cup and serpentine groove that is the centre of a ring set in a natural hollow.

The hill fort outer wall has many marked boulders, which may have been displaced to build the wall. Two are illustrated here (3a, 3g).

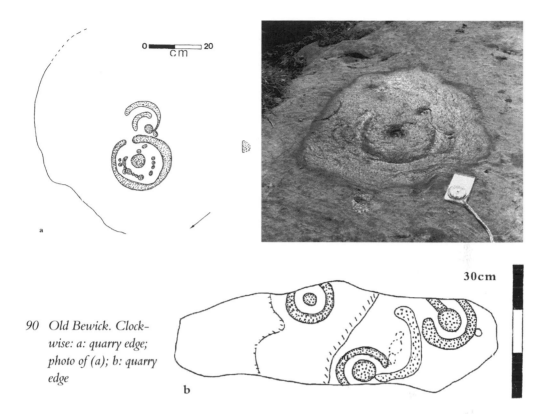

90 Old Bewick. Clock-
 wise: a: quarry edge;
 photo of (a); b: quarry
 edge

Beanley Moor to Midstead

The Old Bewick scarp continues south-east to Harehope Hill, where cairns are recorded, thus continuing the line of cairns from Hepburn through Blawearie and Tick Law. Above Harehope Farm a hillfort is recorded.

Beanley Moor

South of Old Bewick the sandstone moorland continues at Beanley Moor; an area of heather, bracken, coarse grass and planted forest has a fine surviving prehistoric landscape, and a management agreement gives the public access to it.

A many-walled hill fort known as The Ringses occupies a central place at its north end; it is one of many enclosures presumed to be of the pre-Roman period. There are many ancient field walls denoting land ownership and division of the landscape for various farming activities. Today it is difficult to equate this with arable agriculture as the soil seems so poor. There has been some quarrying, otherwise there has been little major interference. There are faint and unspectacular markings on a domed outcrop to the east of the fort (H00593 NU 1015 1855). As a viewpoint, with a range over many miles, including Old Bewick and Hepburn, its position is more impressive. To the west of the fort is a recently discovered slab embedded in the ground horizontally, with cups, single rings and grooves. This has yet to be investigated; the rock is in the vicinity of some low stone dump walls and mounds, which through excavation makes it possible to place the rock in a context.

81

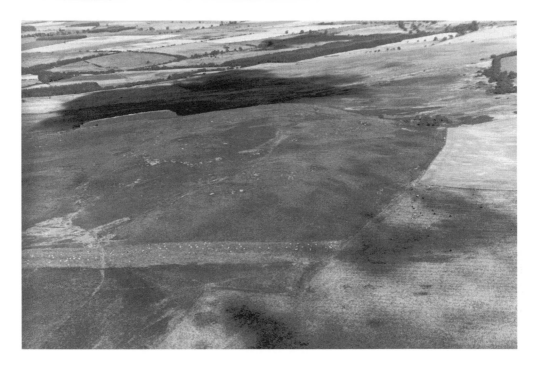

91 Hunterheugh. The marked rocks lie at the centre of the moorland above the gas pipeline scar

Hunterheugh *H00594-6 NU 117 168*

The south-east part of Beanley Moor slopes down to the Titlington Burn at Hunterheugh Crags. The view from the crags is extensive, particularly down the valley of the Eglingham Burn on its way to join the River Aln at Alnwick. Hunterheugh Crags are the north-east extension of the Titlington Pike scarp, which includes a large defensive earthwork and cairns. To the south-west of the Crags are two unexplored enclosures and the site of mill-stone extraction. The site is now bounded on the west by a straight gas pipe excavation, running roughly from north to south, that makes a dramatic feature in the landscape. The marked rocks all occupy a ridge that slopes gently to the south and south-east towards a widening valley at distinct viewpoints. Cairns built upon some of them makes a ritual significance likely.

The southern outcrop (1) has motifs on exposed patches. These include a very unusual marked surface on outcrop that is placed within the kerb of a greatly disturbed cairn (1d). A serpentine groove presumably continues to run under the cairn kerb although this has not been excavated or disturbed. The groove bends into itself around a cup. Below this is an oval with a small cup inside, and three small cups. At the centre of the outcrop is a 'keyhole' entrance to the cupped centre of a figure made up of three concentric rings with an outer arc ending in a very large cup that is partly natural. The outer arc is linked to the keyhole groove by a straight groove. This motif is rare, as is the technique of linking pen-annulars so that they are closed. The pick marks are fresh. To the south are cups with faint rings.

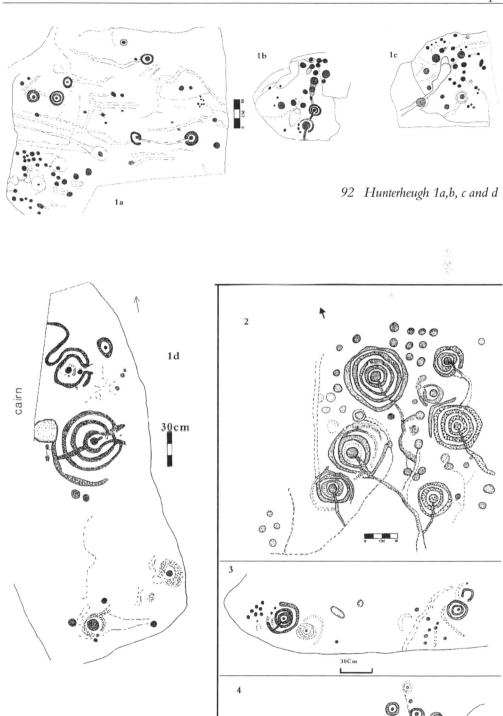

92 Hunterheugh 1a,b, c and d

cairn

1d

30cm

93 Hunterheugh 2, 3 and 4

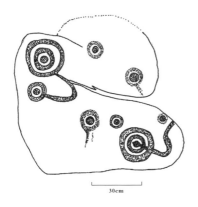

94 Midstead

Higher up the hillslope to the north, the outcrop has been covered with cairn material, and the freshness of the pecking suggests that much of the outcrop has been covered since the motifs were made (2). The drawing shows the difference in depth, freshness and erosion of the motifs. All the grooves from these motifs follow the slope of the rock southwards, and those at the east end are fresher than the rest. Another part of the same outcrop has much fainter motifs (3).

The most westerly part of the cliff outcrop, on the south-easterly edge, has three cups with single rings in a line; there are two other cups, one with a faint ring (4).

The presence of disturbed cairns on the outcrop links it with others at Fowberry, Dod Law, Lordenshaw and Cartington, all of which are built on marked outcrop rock and some of which have marked stones in their kerbs and the mound filling.

Midstead H00641 NU 1243 1546

South of Hunterheugh and Titlington across the Titlington Burn is a sandstone hill bounded on the south by the River Aln known as Jenny's Lantern. On it are two prehistoric enclosures with hut circles, to the east of which is a marked horizontal slab named after a now-destroyed house called Midstead. The rock is located by keeping the fence east of the site of the house as you walk 50 yards (115.8m) north of the road up the hill.

The Cheviot Hills to Morwick

Scrainwood, Alnham H00726 NT 9984 0986

There is a large piece of earthfast or outcrop sandstone that has a distinctive and clearly picked design covering the whole of the panel. At one end is a cup at the centre of two penannulars, the ends of which are marked by four large cups. Four smaller cups are con-

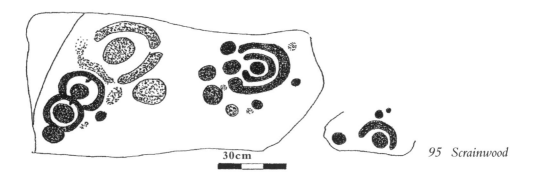

95 Scrainwood

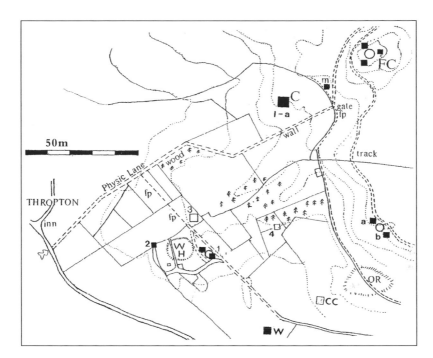

96 *Sites north of Rothbury. The map shows the area north of the Coquet, with West Hills (WH),*
 Chirnells (C), Football Cairn (FC), Westcliffe (W), Cartington Cove(CC) and the Carriage-
 way. OR is Old Rothbury enclosure. Cairns are marked with a circle, sites as a black square
 and sites that are now destroyed or overgrown with a hollow square

centric to the outer penannular. At the other end of the rock are two motifs pecked on with
different strengths. One is a large cup with a broken ring, flanked by a large circular cup
and a faint oval. The second figure, very well executed, has interlocked motifs rather like a
figure of eight or occulus: a large cup at the centre of a ring with a large cup touching that
ring is joined by another ringed cup. A cup of the same depth lies to one side. Either the
fainter motif was tentative and unfinished, or made at a different time, or both.

North of Rothbury

The River Coquet flows from the region of Alwinton to Harbottle, then on to Caistron
and Rothbury. The valley is wide, and an important line of communication for the whole
area. At Rothbury the river valley narrows, with ridges of sandstone on either bank that
have become the places chosen for a number of pre-Roman hill forts.

To the north of the village is the high moorland known as Cartington Moor. In parts
the land has been cleared and forests planted. Further east it is part of the Cragside estate,
a new man-made landscape that contrasts with some of the surrounding area. There has
been considerable quarrying activity.

There is still plenty of evidence of prehistory in the survival of enclosures, burial
cairns and artefacts. There are also rock shelters, one of which containing rock art was

85

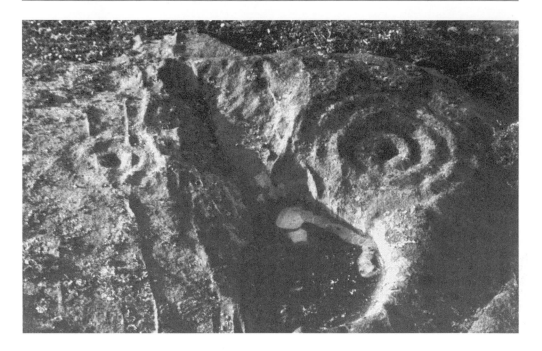

97 *Rock art in the Football Cairn area*

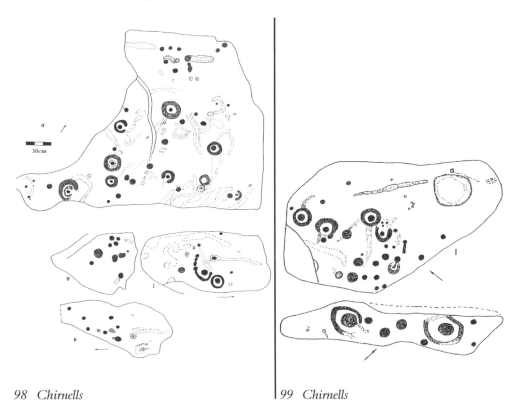

98 *Chirnells*

99 *Chirnells*

blown up by quarrying. Another, deep in a wood, produced some flint implements, found by a local shepherd. The rock art is widespread but fragmentary.

Chirnells Moor

H00663 NU 0418 0275

One access to Chirnells Moor is from Thropton village. Physic Lane, a green road, gives access to the western part. When you have almost reached the wall that divides pasture from heather, a band of this outcrop rock shows through the grass on a slope to the left, with gorse above it. There are motifs on ten patches of sloping outcrop that protrude from the grass.

Football Cairn

H00665 NU 0459 0303

Football Cairn was built on the outcrop that is reached through a gate at the end of Physic Lane (turn left) to the north-east. The name is given to a dilapidated large burial mound with a massive cist at its centre. 16.5m to the east on the slope of the outcrop on which it stands is a range of faint motifs that is very difficult to see. 23m west of this rock is a triangular-shaped boulder 66cm high with a large deep cup. To the south-west are two outcrops with faint markings. North-east of the cairn on the edge of the high ground are two other marked rocks: H00665e has concentric circle motifs on either side of an natural basin that has been artificially enhanced; the other, H00665f, has 11 cups on a boulder.

Crocky's Heugh

H00672 NU 052 039

This rock lies 50m west of the gravel road that leads from the Thropton-Cartington Castle road before it joins the Cartington carriageway. The outcrop is an extensive viewpoint over the valley to the north and east. At the time of recording it was covered with very thick heather, which accounts for it being so difficult to find. The slab of marked rock has large cups, some smaller ones, and two cups with a penannular each. There are two cups on one edge.

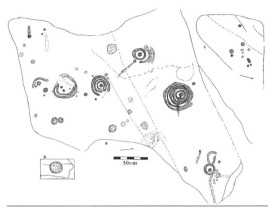

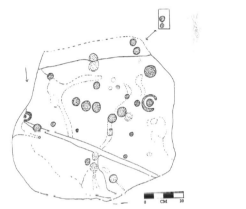

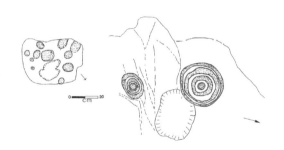

100 Football Cairn (top), and Crocky's Heugh (middle) and two rocks close to Football Cairn (below)

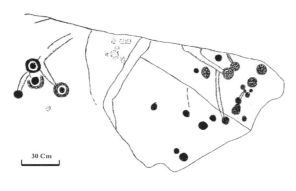

101 Westcliffe House

Westcliffe House
H00666 NU 0423 0173

The house and grounds are private, and permission is essential to view the sandstone outcrops. One is a large thin slab with large and small cups, three linked together, and two sets of cups touching. On the same outcrop is a natural crack that has been used to link two cups with single rings, a cup and a cup with a faint arc. On another piece of outcrop is a small cup and ring and a cup.

Lordenshaw

The sandstone promontory on which Lordenshaw stands is to the north-east of the Simonside-Dove Crags range of hills. Its north-west and south-east flanks drop respectively to Whitton Dean, a tributary of the Coquet, and to a narrow glaciated valley overlooked to the east by another outlying sandstone hill that rises to the same height as Lordenshaw. There is a rise to the hill fort from the south-west, then the land slopes away to the north-east, finger-like, to the Whitton Burn. This raised, prominent extension of the Simonside Hills reaches 268m OD, and is made up of outcrop Fell sandstone, with only a thin layer of acidic soil. There are patches of bright orange soil thrown up by rabbits and a dark grey soil elsewhere.

The name 'Lordenshaw' (also Lordinshaw) is not clear in its origin, but may come from *heavy* (Old French *lourdin*), *ridge* (Old English *hou*, which occurs as 'hoe', as in Prudhoe or Swinhoe, for example). The other meaning of 'shaw' is a wood. If the first derivation is correct it means that the ridge was unproductive, for 'heavy' was used as a term of complaint. The whole area has archaeology of many different periods, one of the most recent and most significant being the clearance of much of the land to the east for 'improvement' for the growing of grain on a regular close-running rig and furrow system. This must have destroyed some surface archaeology, and may have resulted in some of the stone heaps that could also be prehistoric burial mounds. Prominent on the hilltop is a 'fort', a ditched Iron Age enclosure that has been reused as a Romano-British settlement. The slope southwards to the modern road and car park has many field walls, some of cobble and soil construction, and others of vertically-set sandstones. Some of these walls cross one another, and represent different episodes in the use of the land.

The oldest features belong to the late Neolithic period, represented by cup and ring marked rocks over a wide area. The motifs vary from simple cups to more complex ringed cups and grooves, but there is a characteristic regional phenomenon of long grooves or channels that follow the slope of the outcrop sheets on the east side of the hill.

It is impossible to date outcrop markings, but in this area three possible early Bronze Age cairns have been built on marked outcrop rock, showing that the latter are either contemporary or earlier, also showing that the sites were already of great importance in the landscape before the cairns were added.

All the marked rocks *in situ* are at prominent viewpoints, some commanding many miles of territory. A few cupped rocks in the hill fort allow the possibility that some marked surfaces may have been destroyed during its construction, and the medieval Deer Park wall may account for others being broken up and reused.

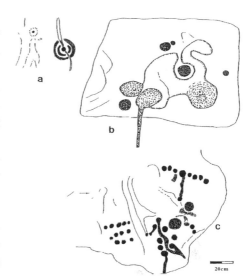

Modern quarrying has certainly taken its toll, especially on the north-west, where masses of freestone have been removed, leaving holes in the ground like bomb craters, and the main block of rock art (2c) bears every sign of the quarrying process. Add to that a network of other walls, including those for shielings (temporary herds' houses and gardens), and it is likely that we have lost a large proportion of rock art. Public access to all the monuments has been assured by a management agreement between National Park, the Duke of Northumberland and the tenant farmer, except for those at the far north (Area 6).

102 Birky Hill a, b and c

What follows now is a division of the area into smaller regions that can be explored one at a time, beginning near the road from which the Birky Hill rocks are easily reached.

West Lordenshaw (Birky Hill) 1 *H00680 NZ 0512 9912*

Birky Hill is the small hill and ridge that marks the western edge of the area of rock motifs before the land drops away to the Whitton Burn. On it there is an artificial structure that may be a disturbed long mound or a small enclosure. On its northern slopes are three marked rocks. The most southerly is a flat slab with a cup and two rings, centred on a cup, and a diametric groove, all faintly marked (a). There is a large box-like block of sandstone with natural erosion on its top surface, added to artificially, and incorporating cups and basins (b).

A sloping outcrop completes this little group, and differs from the others, for here a notable feature is a line of eight cups, one with a groove running down the sloping rock to end in a small cup (c). There are three parallel lines of cups, both vertical and horizontal. The lines begin with five cups at the top, four on the next line, and three on the third, but the largest cups form a square with three rows of three. The other part of the rock has larger cups, some with grooves.

The area to the east of Birky Hill has been cleared, and there are the remains of a rectangular shieling by a solitary hawthorn tree. The hill itself may have escaped clearance. North along the same ridge, commanding views like the others across the Whitton Burn right through to the Cheviot Hills and the Coquet valley, with Simonside close by, is the *Horseshoe Rock*, named many years ago (at NZ 0502 9918). This outcrop block protrudes from a grass-covered cairn that may be a burial mound with this rock as a kerb. Only excavation would show whether the block has been quarried from outcrop. The motifs include a double

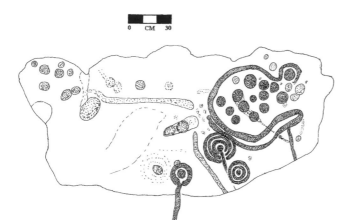

groove enclosing many cups, some linked, and this groove becomes single, culminating in a cup and penannular. There are cups along the top in a line, and a linear groove. Different from all these are one-, two- and three-circled cups, two with grooves running from the cups and the other without. Other grooves, roughly parallel, run to ground. There are at least two episodes in the marking of this rock, as the cups and rings were put there before the double groove.

West Lordenshaw 2a-f H00681 NZ 0524 9916

A well-constructed field wall links the Horseshoe Rock to the next major site on the high ridge to the south-east. The whole of this ridge, an outcrop of freestone, has been quarried, so that any survivals are fortunate. The main rock has already been illustrated.

11m south along the outcrop edge there are cup and ring markings.

East Lordenshaw 3 H00682 NZ 0562 9909

This outcrop ridge, quarried in places, is a dramatic feature of the area, and the exposed rock is grey to white. The exposure of sloping sandstone has led prehistoric people to think of making long grooves and channels, together with large cups and cups and rings — characteristics that extend to the sites overlooking the Whitton Burn as it joins the Coquet, and the old golf course to the north.

The ridge provides a continuous viewpoint not only along the valley itself in both directions, but also to the Cartington-Skirlaw Pike-Longframlington Common ranges. Some of the view south-west is limited by the rising ground to the east, which used to have many cairns on top. The valley has been cleared and cultivated, but it still has an alignment of small standing stones and some cairns that could be either for burial or from agricultural clearance.

The west ridge above these outcrops has burial cairns, one standing on decorated outcrop, and there is a line of stones from the hillfort north-east on the downslope of the ridge. All the marked rocks lie to the east to north-east of this spine. None has been found to the north-west. It is an exhilarating landscape, full of interest. Cragside with its planted acres and Victorian house is prominent, with the high heather moorland beyond, where other survivals of prehistory are found, such as the Debdon Whitefield village of round houses, the cairnfield on Longframlington Common, and more rock art and cairns on Cartington.

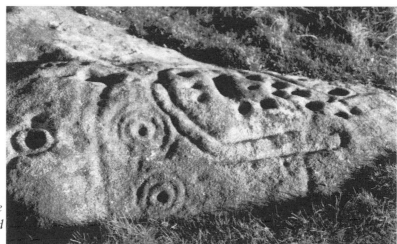

104 The Horseshoe rock, on the edge of an unexplored cairn

105 Large cups and channels, East Lordenshaw, uncovered in the 1930s

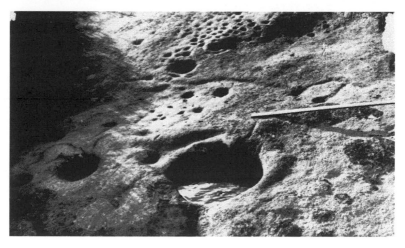

106 Midget cups, an enhanced natural basin and other motifs, East Lordenshaw

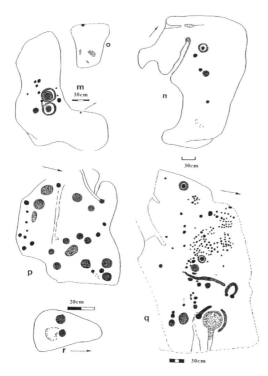

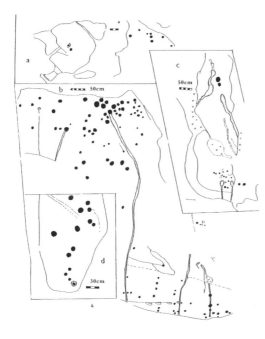

107a *Lordenshaw 3*

107b *Lordenshaw 4*

The rock art begins at the place to the south where two hollow ways diverge. These outcrops have caused much speculation about whether the markings on some of them are natural or not; three rocks on line (roughly north to south) have three giant 'footprints' on them that are natural. At a higher level, are other outcrops where there are artificial cups, five natural basins, and eight small cups. If cups and grooves were so important at these outstanding viewpoints, those that were already there might well have been regarded as part of the art form. The original discoveries about 70 years ago were made by uncovering the rock surfaces.

Further north is a preference for marking long grooves down the rock that continues along the rest of the ridge. Here we are in no doubt that they are artificial, as the channel heads begin with cups, and cups cluster around the heads. There are seven such cups around the central channel, and a faint cup and ring begins another. There are two basins within the channels, and these may have been natural, but enhanced. The outcrop sheet slopes steeply to the east valley. It is just below a ridge. To get at the rocks, antiquarians removed turf and 'one or two of the mounds' were excavated, one having a marked slab at its foot on a steep slope. It was trenched from west to east 'right down to the moor-band', which was undisturbed. The excavators favoured a late eighteenth- to early nineteenth-century origin of the mound for it lies in the 'Old Improvement' on the parish map.

One of the most interesting designs is on almost flat outcrop, lying close to a field wall, that has to the east a large basin that may have been natural originally, but has been worked to produce steep sides and a rounded base, and is almost entirely surrounded by a groove with a groove

leading out of the basin to the rock edge. There are two cups and ungapped rings, two cups linked by a curving groove to form a horseshoe, some large cups and a mass of small cups that produce a stippled effect that is rare in all rock art. All features have weathered well, but it is most likely that they were covered over before the 1930 excavations.

East Lordenshaw 4

H00683 NZ 0569 0038 – 0565 9950

The outcrops so far seen along the ridge prepare us for the massive series to come, spectacular when they are whitened by the sun. The predominant motifs are large cups (or small basins) and long artificial grooves that run down the slopes into the ground. They begin to the north of the wall that joins the Deer Park wall above it. The lowest part ends in marshy ground, and there are signs of a spring here or concentration of water run-off. The cups are either better made than most or better-preserved, and a straight groove crosses the rock obliquely. To the north of this outcrop is another that

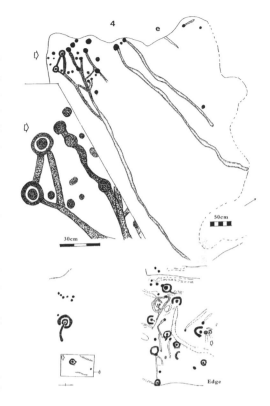

107c Lordenshaw 4a and 5a

by its shape seems to call out for additional marking — but it has not been touched. Why one rock was chosen and not another is a matter of conjecture.

Higher up the slope the outcrop has scatters of cups, three with rings, but the surface lower down has three wavy channels, the head of one being a complex arrangement of linked cups, cups and rings, and grooves. It is very impressive in good light.

A cairn lies on the top of the ridge with obvious digging at its centre, but what went unnoticed at the time was the fact that the cairn stands on cup-marked outcrop, and that one of the kerb stones is also cup-marked. It stands at a high point (NZ 00557 9942) with extensive views, especially to the north and north-east, where the ridge slopes towards the steep-sided valley of the Whitton Burn before it joins the Coquet. Scattered stone down this slope gives the appearance of a marked way, but as there has been quarry disturbance this may not be so, despite its being a natural routeway. Round barrows of the type that we see here usually belong to the early Bronze Age, but because the cairn is built on decorated outcrop, the cairn may be later than the symbols or contemporary with them. A piece of cup-marked stone in the kerb looks unlikely to be quarried outcrop. Whatever the sequence of events, the site was chosen as an important part of the landscape, as a viewpoint and as part of a routeway. The linear outcrop on which the cairn is built, sloping towards the east valley, has about 30 cups spread along it. A step up, and there is the cairn with a kerbstone that has 12 cups pecked onto it. From here the

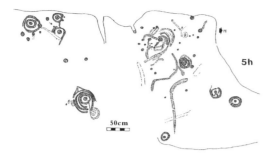

108 East Lordenshaw 5h

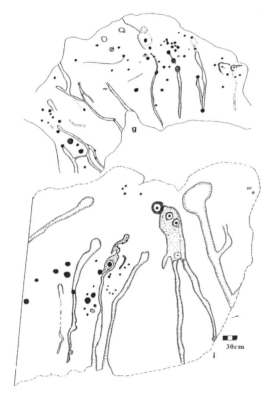

109 East Lordenshaw 6g and i

land slopes down to the Whitton Burn, and there are three faintly marked rocks on the way down.

East Lordenshaw 5
H00684 NZ 0578 9960 - 0586 9969

The descent from the cairn towards the Whitton Burn before an area of fenced pasture is reached is heather-covered, with small protruding rock outcrops, hollow ways associated with recent quarrying, and small quarries. It is also an area of occasional rock art, which is difficult to find and difficult to see. It may be that there has been more erosion here or that the markings were more tentative in the first place. I have found them difficult to record, as some show up on careful rubbings but not with the naked eye.

One marked outcrop lies only 18m (59ft) to the east of two exposed cists in the remains of a large cairn. It is sloping outcrop, with the most well-formed motif on its west side on a natural bulge in the rock surface; there is a cup, groove and two concentric penannulars, with a line of small cups above it. The sheet of rock has an irregular surface, and the more regular part to the south has been less regarded than the undulating downslope. There are many single cups, eight with rings or arcs, and some grooves that may also be artificial.

One horizontal outcrop lower down the slope was described as having 12 plain cups and two cups with plain rings, all considerably weathered, but recently careful recording has revealed that there are more cups and more rings. For years this outcrop sheet has been trampled by sheep and cows. It lies amongst heather, and it is so eroded that it would be better covered over before the motifs completely disappear.

The presence of ringed cups on these rocks links them more with West Lordenshaw than the large cups, ducts and channels of the East.

North Lordenshaw *H00685 NZ0595 9995-0640 0050*
This area is the promontory that slopes north from 200m to 125m bounded to the east and

west by two small streams. Most of the rock art is found between the 175m and 150m contours. Above that, to the south, the land is enclosed by fences from the heather moorland, and is rough pasture. There are quarries and sand pits, cairns, and above the Whitton Burn is an unexplored, presumed prehistoric, enclosure (NZ 0595 0015). The long grooves or channels seen further south on the ridge are repeated: there is a large outcrop sheet with cups either forming the beginnings of long channels or concentrated around the heads of the channels. There is no doubt that the long grooves have been 'directed'. The south-east part of the rock has interconnected grooves as a variation on the theme.

One with channels has cup and ring motifs pecked into the basins themselves. Very dramatic are the northerly large sloping sheets of outcrop with channels. One channel begins with a large basin that has a feeder channel coming into it. This outcrop slopes towards the burn eastwards.

The northern limit of the site N is marked by outcrop sheet that again has large ducts, but there are cups and rings too. One is now covered with grass, but at the time of my recording it proved to be a fine example of three parallel ducts that may extend even further down the rock. Although there are no cups, the grooves appear to be artificial. Another lies on the western outcrop edge, a large cup surrounded by an ungapped ring and the beginnings of another.

110 East Lordenshaw 6p .

There are other surface irregularities on other rocks, some of which may be artificial. As the site was part of an old golf course, one has to be careful about interpreting some of the ground features.

The Whitton Burn sites

These sites are a continuation of those just described, and can best be reached from the Hexham-Rothbury road, where there is parking space by a gate that leads to the burn. The modern road to the east skirts the old road, the culvert of which is close to the first marked rocks.

Whitton Burn 1 *H00686 NZ 0660 0045*

These rocks, which may be boulders or outcrop, lie, exceptionally, in a narrow stream valley, on a ridge flanked on the east by a hollow way and west by a feeder of the Whitton Burn. One has three deep cups, or basins, and nine smaller ones, lying on rocks under trees.

The other is a single detached block of sandstone with a single cup opposite amongst other apparently disturbed blocks under a hawthorn tree.

Southwards, the land rises towards Lordenshaw, via a large clump of gorse bushes. A triangle formed by the junction of a wire fence on stone and earth and an earthen wall is where the next site is:

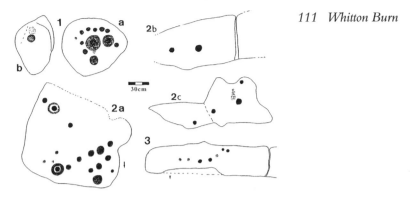

111 Whitton Burn

Whitton Burn 2 *H00687 NZ 0655 0013*

The area has been quarried, and reported burial mounds 'on a little plateau near this rock' have disappeared.

One outcrop has two ringed cups and twelve others, with three small, faint ones; another has two cups; the third has four.

Whitton Burn 3 *H00688 NZ 0640 0042*

The rock is reached from the bridge to a field gate beside the burn. East of an earthen wall is a dome of rock with seven cups, some very faint. Southwards takes us uphill through the valley flanked by Garleigh Moor, back to where we started.

Whitton Burn to Morwick Mill

Millstone Burn and Snook Bank

The Millstone Burn is a valley that links the hills to the north with the low-lying land that leads to the coastal plain. It is an important communication route followed by the course of the Roman road, the Devil's Causeway, and by the Newcastle-Edinburgh coachroad. Today the valley is skirted on the west by the modern A697 to Wooler and Coldstream.

There is a very important cluster of rock art sites on either side of this valley which continues north-east, sporadically, towards Alnwick along the scarp line of the present Alnwick-Rothbury road. The two sites of Millstone Burn and Snook Bank share similar symbols and motifs, but there are some major differences too.

The first marked outcrop rock that led to the discovery of so many others was found on the bend of the A697 near to Milestone 14 above the Millstone Burn at NU 118 054, on the Rural District boundary.

Millstone Burn

The western bank of the Millstone Burn slopes gradually down from the track of the old Newcastle to Glanton coachroad, now a green track, and the Roman road (The Devil's Causeway). On the slope close to the present A697 main road is an old hollow way. The land is divided by a fence that runs north-east to south-west along the line of the Rural District boundary over a spur to the valley. On the north-west side of the fence is heather; to the south east is coarse grass and bent. There are small outcrops of sandstone showing

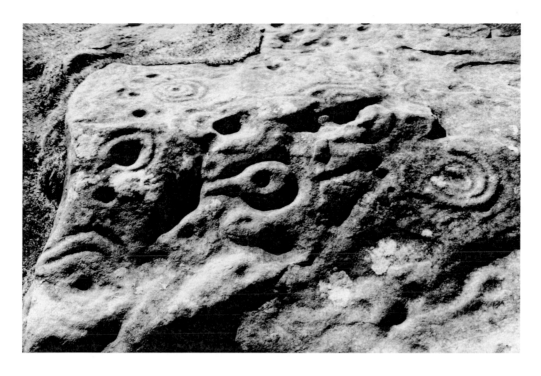

1 Lordenshaw: detail of the natural surface and motifs

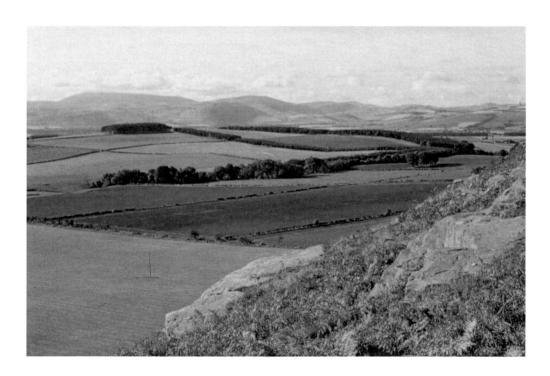

2 Broomridge: the south edge of the ridge to the Cheviot Hills

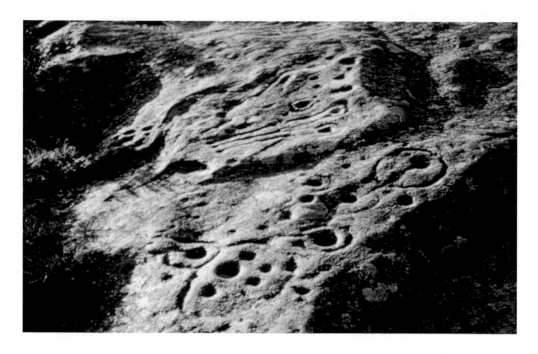

3 *Roughting Linn: delicate motifs on the north-east surface*

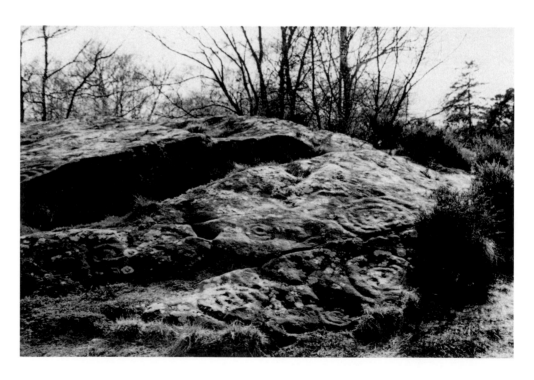

4 *Roughting Linn: the north face and quarry gash*

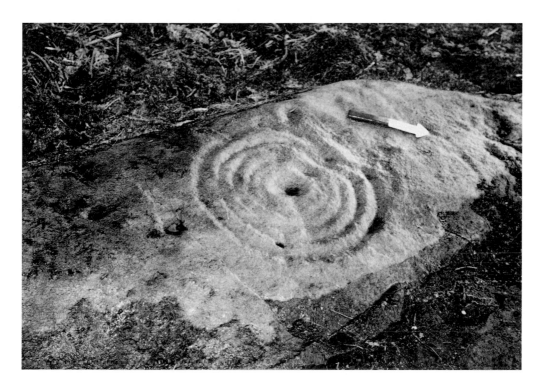

5 Hare Crags 5: part of the crag. The north pointer is 20cm long

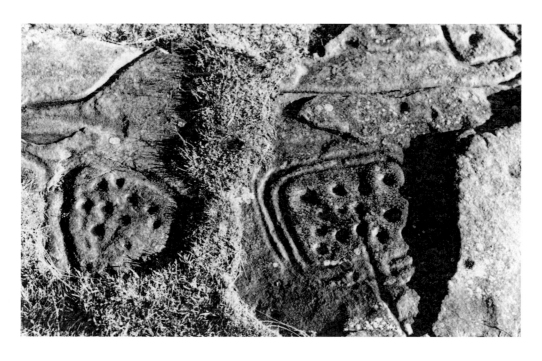

6 Dod Law: detail of the low-level motifs on the main rock

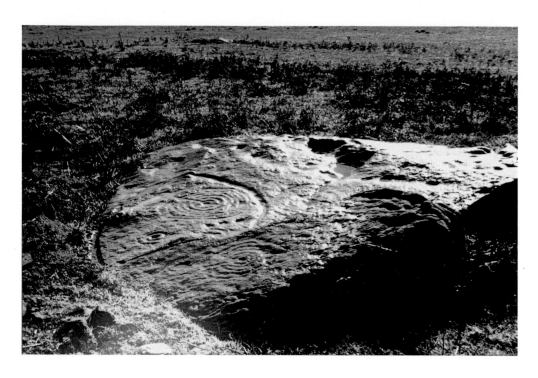

7 *Gled Law 3: the motifs appear on two levels, some fainter than others*

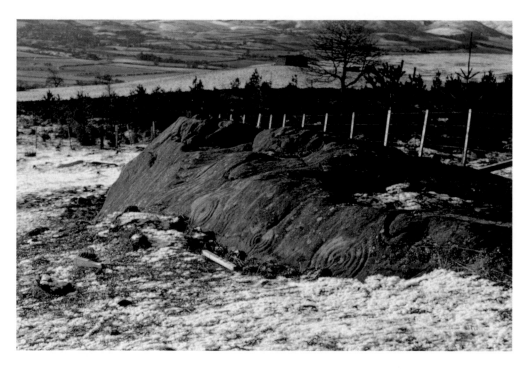

8 *Buttony: a domed outcrop with the best-preserved motifs on the slope. This site was allowed to be planted with trees that now obscure this rock*

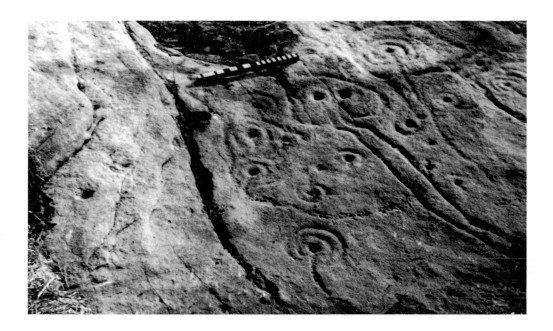

9 Horton 1a: the nearest that we get to anthropomorphic motifs

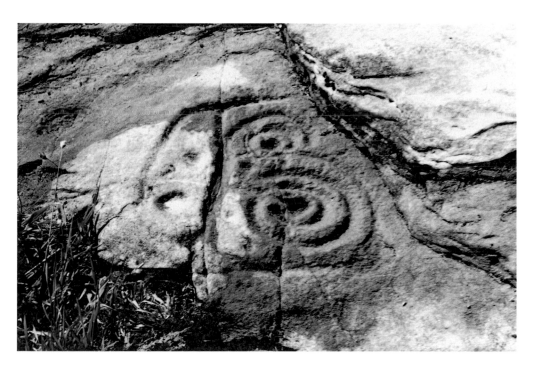

10 Horton 1b: part of the decorated surface has been removed and a very complex motif added

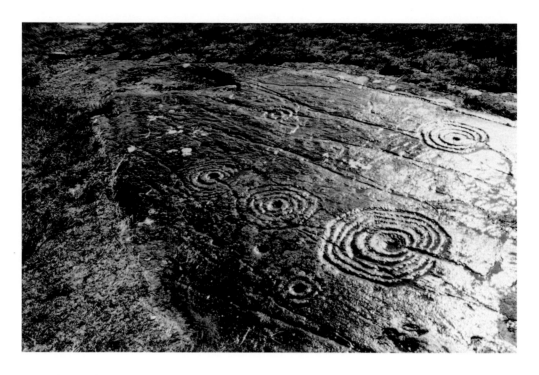

11 Weetwood 3: an outstanding motif that has been exposed for over 100 years

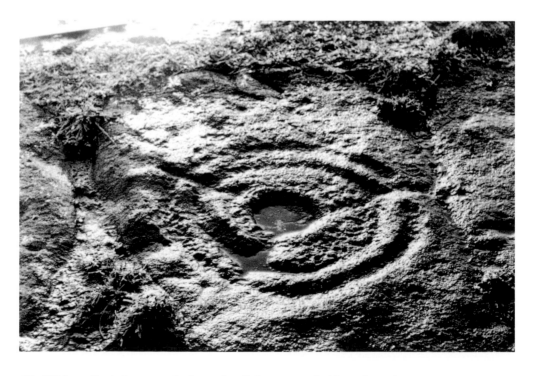

12 Whitsun Bank 2: concentric rings, tri-radial grooves and pick marks at the centre

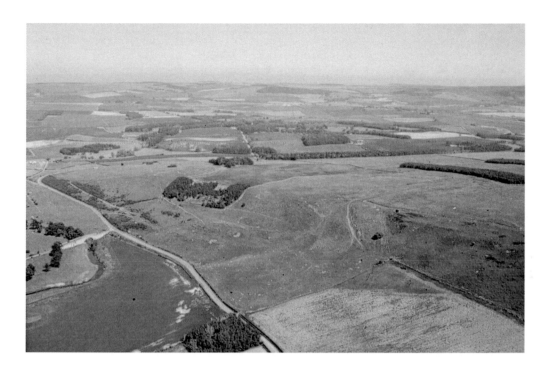

13 The Weetwood bridge gap: here the River Till breaks through the sandstone ridge to reach the Milfield Plain

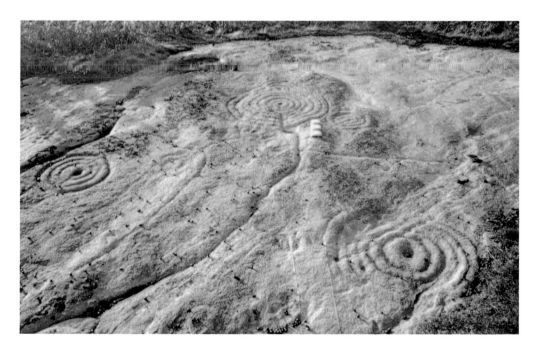

14 Chatton Park Hill 1: an outstanding rock photographed by the late Ronald Morris

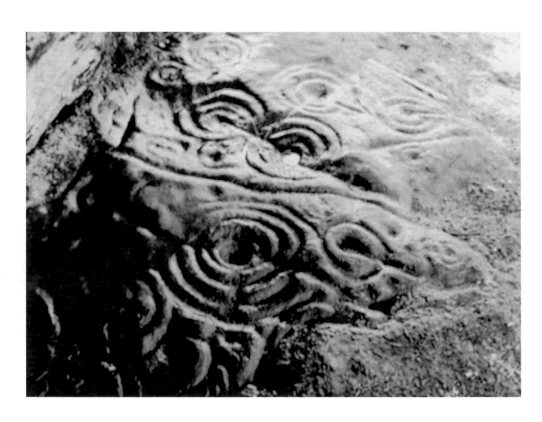

15 Ketley Crag: a unique design on a rockshelter floor. Photographed in 2001

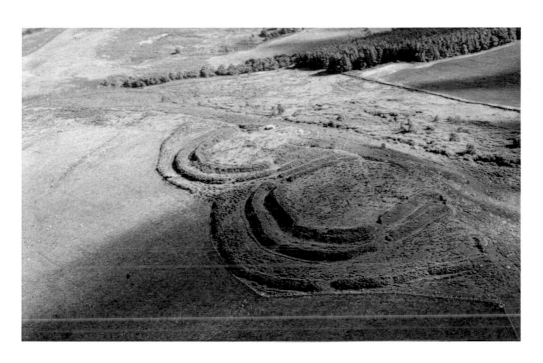

16 Old Bewick Hill. The field to the left of the hillfort has many panels of rock art

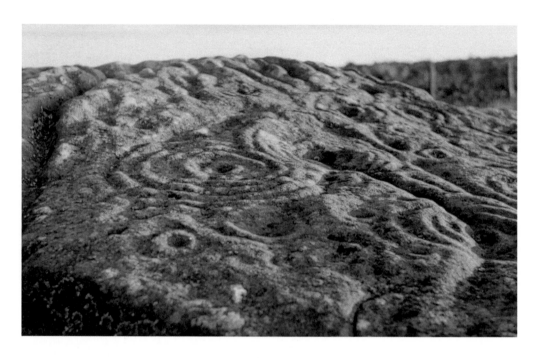

17 Old Bewick 1: the first motifs to be regarded in the 1820s as 'ancient'

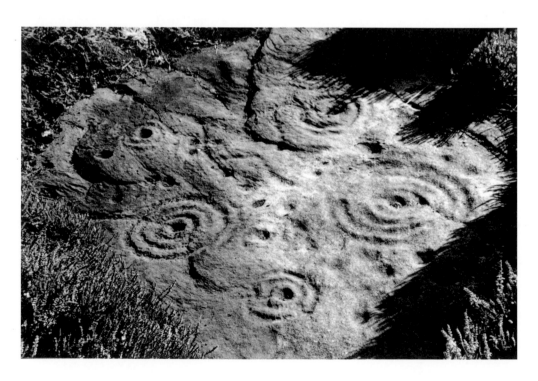

18 Hunterheugh: the largely uneroded motifs lie among cairns

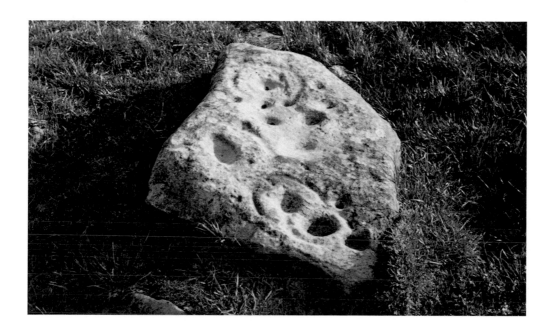

19 Scrainwood: an earthfast boulder at a high place

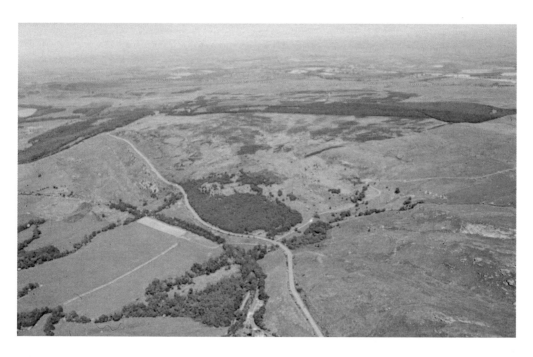

20 The scarp running from Alnwick to Rothbury, at Edlingham, looking north-east

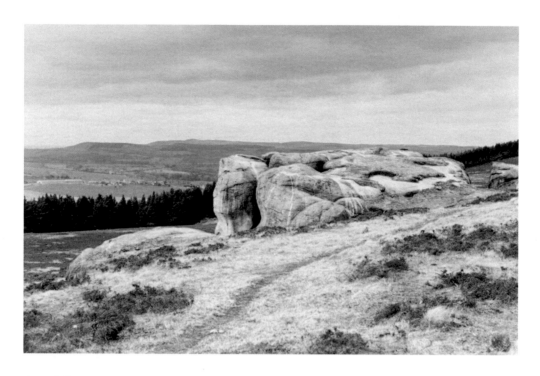

21 Caller Crags: a dramatic line of outcrop cliffs that have cups on the south-facing vertical side

22 Morwick: a vertical cliff with three linked spirals and horned spirals above the River Coquet

23 *Fontburn: part of a 'four poster' that has faint motifs*

24 *Old Deanham, Wallington: decorated cobbles from demolished walls*

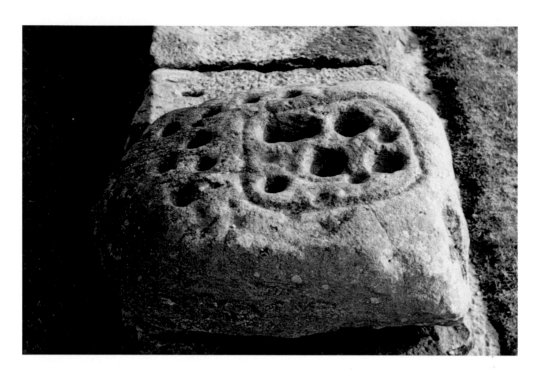

25 Coria (Corbridge): a decorated boulder lying on the foundations of Roman buildings

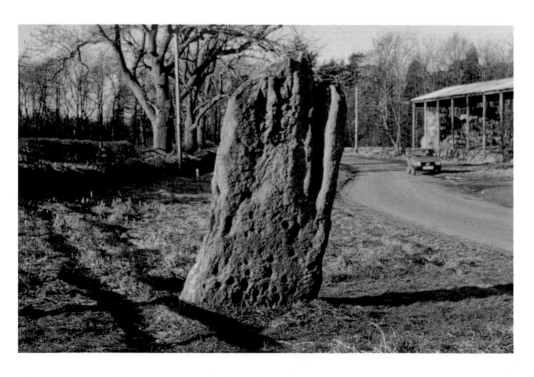

26 Matfen: a standing stone, cup-marked at its base

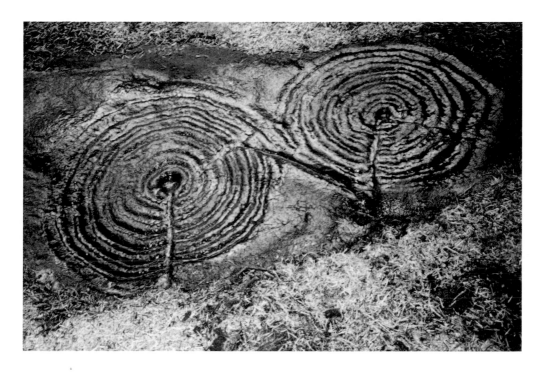

27 *Buttony: very well preserved motifs. (Photographed by a visitor, Jan Brouwer of Holland in 2000)*

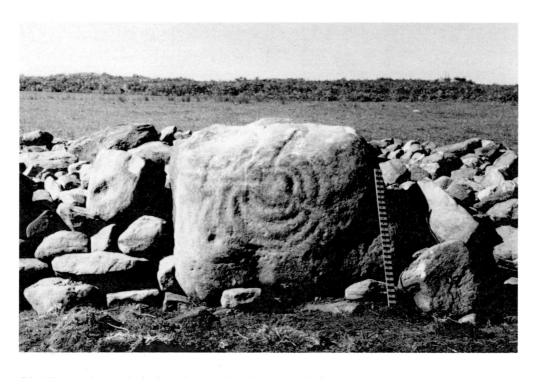

28 *Weetwood mound: the large decorated boulder originally faced inward*

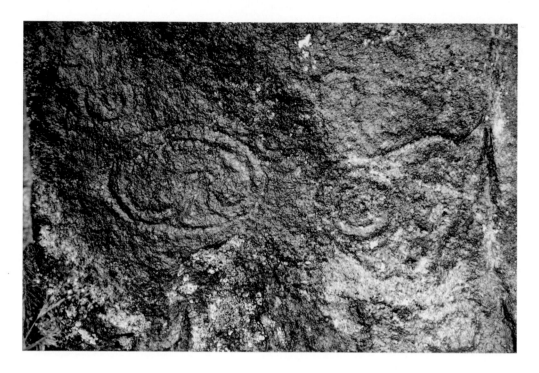

29 Morwick: a unique arrangement of motifs, but the horned spiral has a parallel below

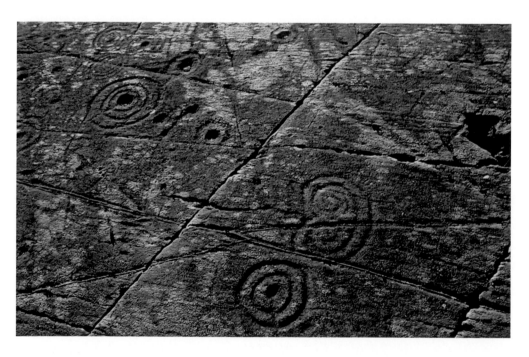

30 Achnabreck: a link with Kilmartin, Argyll. See also the Lilburn gravestone

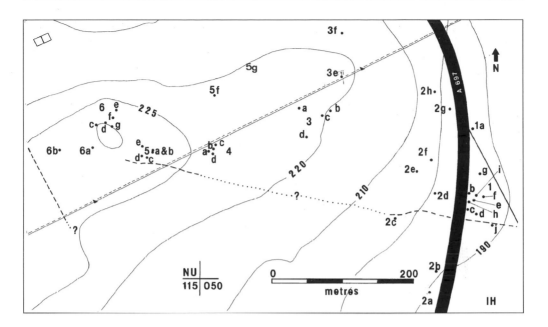

112 Millstone Burn. I. Hewitt

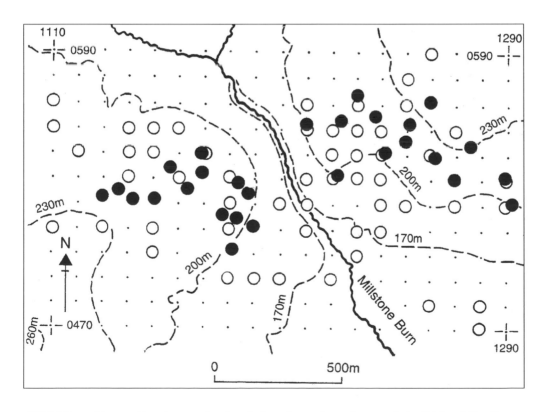

113 Millstone Burn, with rock art as closed symbols and control samples open circles. Richard Bradley

97

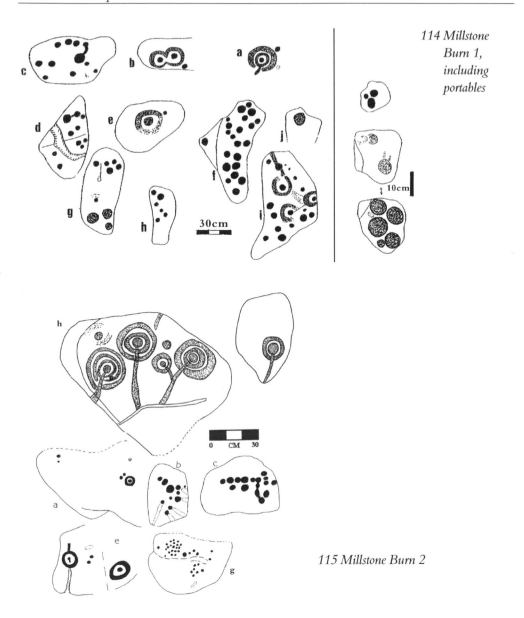

114 Millstone Burn 1, including portables

115 Millstone Burn 2

through the vegetation, some with vertically-quarried edges. The marked rocks are in a band about 2/5 mile wide. Viewpoints are from both sides of the spur and down the slope to the Millstone Burn. The lowest marked rocks in this group stand just above the valley on a platform, with viewpoints to the east and south; the Snook Bank marked outcrop rocks are clearly visible across the burn. There is a hollow way running through these lower marked boulders, and further towards the burn are signs of iron working. The land provides rough grazing, but little else where the rocks are. In places the land has been cleared of all small stone (cobbles). No ancient settlement sites have been found here and no surviving cairns, but forestry clearance across the burn has revealed some flint working. There are clear stretches of Roman road.

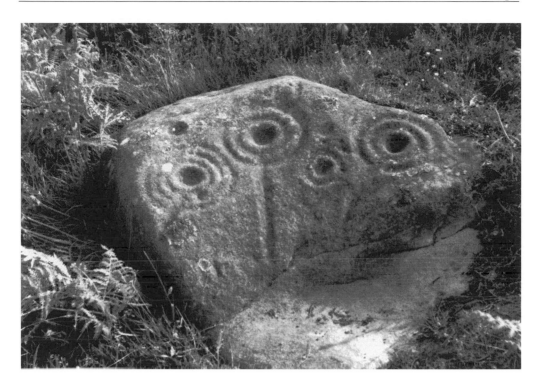

116 Millstone Burn 2h

Richard Bradley's survey with his Reading students used my recordings of the positions of marked rocks, but added control samples of unmarked rocks to determine whether there was a logic to the choice of rocks to decorate. He found that the greatest difference between the two samples was towards the further limits of the views. He noted that the positioning of the marked rocks took into account that the site is at the junction of extensive high ground and the coastal plain, the valley being an obvious choice of route from one to the other. The motifs focus on the entrance to this valley with views in two directions along the axis of the valley rather than on monuments or settlements (almost non-existent here).

As we shall see, the Snook Bank sites do the same, but also lead to the main scarp that runs north-east towards Alnwick, taking in Caller Crags, Corby's Crags rockshelter, Lemmington Hill and Lamp Hill, before they reappear at Midstead and Hunterheugh.

Millstone Burn 1 H00645 *(No. 1 is NU 1189 0521)*

These marked rocks lie in a triangular-shaped field east of the main road. They are mainly boulders rather than outcrop. Two portables found in the area are now in Berwick Museum.

Millstone Burn 2 H00646 *(2h is NU 1184 0525) — eight rocks, a-h*

Although there is a gate leading from the main road to this site, the most convenient approach to all the sites is from the Alnwick-Rothbury road, B6341, at Newmoor crossroads. A gate there leads to a bridle way that is the old coaching road. It passes through a grove of trees and small walled fields where the coaching inn used to be. Eventually the coach road south

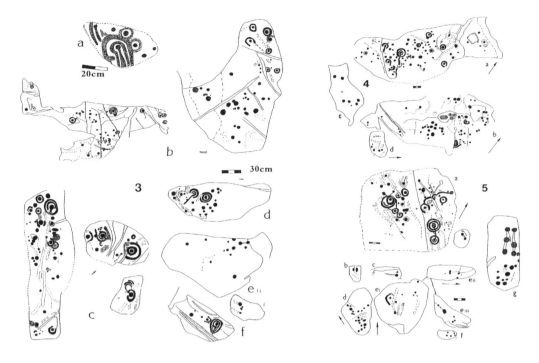

20cm

30cm

b

west

3

d

c

e ii

f

117 Millstone Burn 3

4

a

5

b

c

d

e i

e ii

e iii

f

g

118 Millstone Burn 4 and 5

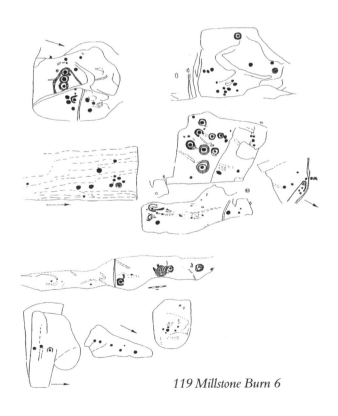

119 Millstone Burn 6

reaches the Rural District boundary, and to the east of this the outcrop rocks descend to the valley. On the west side of the A697 the land begins to rise. A hollow way runs roughly from east to west, and this site includes rocks on either side of it east of the 210m contour, parallel to the course of the main road. The marked rocks are not immediately obvious; they lie low in the ground. Again, some are outcrop and others are earthfast boulders, the result of being moved and dumped there by ice.

On a boulder on the hillslope is the most complex and pleasing design of this entire group (2h). There are three large motifs, two of which are made up of a cup and two rings, with grooves running from the central cups down the rock, almost meeting at the edge. The third motif has a cup and serpentine groove; inside an outer ring are two concentric rings, one running through a cup. The groove from the central cup reaches the edge of the rock. A cup and ring is linked by a groove to the duct of the right-hand motifs; above it is a cup. There is also an incomplete ring around a cup and a long groove. On a detached part of the boulder, separated by grass, is a cup with a straight groove moving to the edge of the rock, with a ring.

Millstone Burn 3 H00647 (3b is NU1160 0523)

Four marked rocks lie roughly at 220m OD just south of the boundary fence, in an area from which much stone has been quarried.

At 3a there is an unusual and very elaborate use of a small indented surface on this small exposure of outcrop among grass. A cup has a widening groove leading to the edge of the rock. Around this is a keyhole-shaped groove, with its grooves parallel. Around this is a wide arc that reaches the edge of the rock, with a large cup inside it. Touching this outer arc (or U-shaped groove) are two rings, probably slightly enhanced natural features, at the centre of cups. There are three cups on this side of the rock; in the opposite corner are two grooves, one running from a cup.

Millstone Burn 4 H00648 NU 1151 0517

Lying just south of the boundary fence, in grass, a thin sloping outcrop has four areas of markings, separated by grass. One has a slot, perhaps for a cross base (medieval?) on the boundary, at the north end, with small cups, the rest having cups spread liberally across the surface, three with a single ring, two with penannulars, two with arcs. A cup with a groove that runs down the rock has a penannular; another has two penannulars, the groove from the latter being continued as a series of joined cups.

Millstone Burn 5 H00 649 NU 1143 0519

There is a scatter of mostly small rocks with markings protruding from the heather on the north side of the boundary fence, just north of the hollow way. It is part of a larger cluster of marked rocks that share a plateau over 225m high, topped by a small knoll. The largest panel in this fragmented group has one of the most complex arrangements of motifs in the area.

Millstone Burn 6 H00650 NU 1142 0528

This group of marked rocks lies at about 230m, the highest of the marked rocks.

Snook Bank

Many of the Snook bank sites are visible to the east of the main road. They begin with prominent outcrops of rock to the east of the Millstone Burn; many are sheared off by quarrying for millstones and building stone. The site name originates as *Shackelzerdesnoke* in 1264, mean-

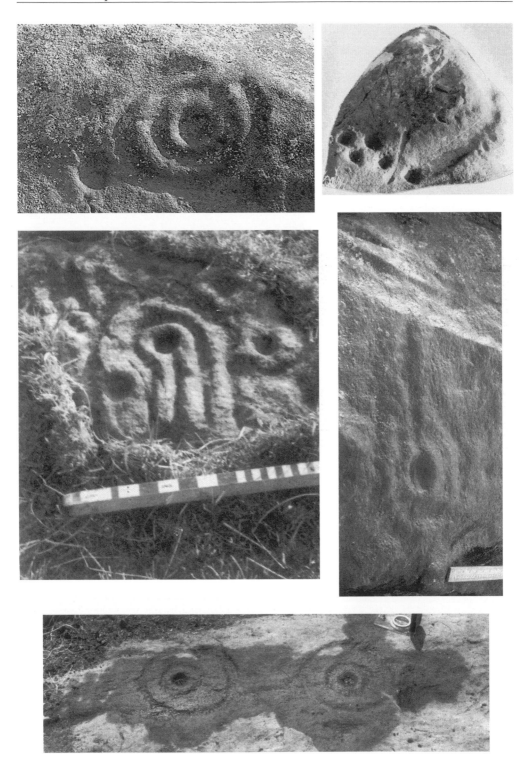

120 Millstone Burn (clockwise from top left) 1a, 1d, 3f, 5a, 3a

ing the projecting piece of land used as a stockyard, a place where the beasts were shackled. The natural outcrops command extensive views to the west and south-west; the land today is enclosed pasture, sloping down to arable land on the south.

The illustrations and map show the distribution and types of motifs on this site. Most are on outcrop, with some scattered earthfast boulders. There are many cairns in the area, some of which are burials (including a cist) and some of which may be field clearance. What follows is a selection of some of the motifs, which have a distinct regional characteristic.

Snook 1-3 H00652-654
Snook 4 H00655 NU 1277 0541
This major rock slopes south. There are two areas of motifs.

The southern slope of the smooth rock has been followed by a long groove that begins at the centre of a cup and ring and runs to the rock edge. Other shorter grooves, parallel to this, are made by joining two and three cups. There are faint/tentative cups and enclosures. To the north (top) of the rock is a cup and ring; a roughly circular groove around two faint cups has three small radiates, one leading into a faint oval. Below this are two faint cups in a faint, roughly oval enclosure, and some cups, with a distinct cup and ring. On either side of the long groove are lines of cups, cups and rings with grooves from either the cup or the ring. All 'flow' down rock in the same direction. The top north east part of the rock has four cups.

121 Snook Bank

122 Snook 1-3

Another motif is echoed only on a newly-found rock further north (5d). On the large downslope three touching sets of cups and rings form a cluster from which a long curved groove follows the slope down for a considerable distance, then returns in a loop, not quite touching the group. Two offshoot straight grooves lead out from two of the rings. Above these motifs is a large pecked enclosure around a cup, with a cup and ring forming part of the enclosure. Outside is a cup.

103

123 Snook 4

A cup and penannular are echoed by a long groove that bends down the slope. There are two other fainter cups and rings, and one begins another angular groove that ends in a horizontal bar.

Snook 5 *H00656 NU126 056 (a-e)*

Until recently, the site of 5, between the 240m contour and a wall, has revealed a cluster of cairns and some scattered cup marks that are now grown over. A cup and ring marked stone that lay at the centre of a disturbed mound cannot now be traced. In 1996 more panels were revealed embedded in coarse grass and bent, at the north end of this site near a very large block of sandstone that forms part of the boundary between pasture and planted forest. The land slopes from the east, and the first marked rock lies to the north of an old quarry. The rest lie to the west of that. Among the four new rocks, one is a large elongated boulder, slightly rounded on top, partly covered with grass.

The second elongated boulder is further proof of the ingenuity of the people who used a limited symbolism to produce unique designs. What is so fascinating about this rock is the way in which the design has taken into account the shape of the rock itself: the motifs are not in a straight line but run with the slight bulge of the western edge. It is hidden today in coarse grass, but the views from it are extensive and aimed at the place where the Millstone Burn breaks through the Fell sandstone to the plain to the south and across the water to the Millstone Burn sites.

Snook 6 *H00657 (a-h) NU 1252 00551*

The group is the most westerly. Lying on the south-west slope from the 215m contour, it is defined on the south by rows of stone blocks marked 'WD' (War Department). It is a large area where small quarries in rough ground give way to pasture before the land falls away to the Millstone Burn. There are six small cairns on the edge of pasture, possible clearance cairns, and one small cairn in it, where the motifs are.

Among the marked rocks a large slab, sloping gently to the west, has motifs that show clearly the pick marks of their making. Long curving grooves link the design with that on other rocks on the site. The entire exposed rock surface has been marked. At the north is

124 Snook 5a and b

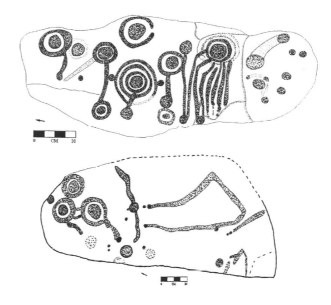

125 Snook 6

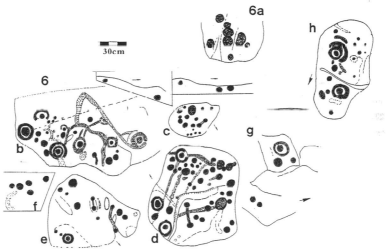

a cup and ring, two cups and arcs, and nine cups, some midgets. A cup and two concentric rings is linked from its outer ring to motifs on the south part of the rock by a long groove that forms a big angular arc that encloses a cup and ring and a cup with a short tail. From the curving groove emerges a near-vertical straight groove that makes a sharp bend down the rock to join a penannular around a cup. This groove cuts a cup and ring that has a thin groove running from it to the cup and ring within the angular arc. Above that groove is a cup; below it is a cup and ring, two large and one small cups.

A large slab lies to the north of three cairns in a line. It has well-made motifs that group on either side of a natural curved crack. What is not clear without excavation is what type of cairns are there. The fact that most are in a row in pasture, from which the marked outcrop appears in patches, makes it likely that they are for clearance within

126 Snook 7

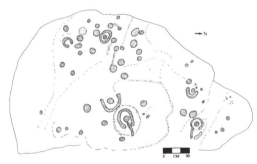

127 Wellhope

an arable field or hayfield. Small stones would have been an encumbrance to scything, for example, and piling up the stones in rows would have been one way of keeping clear of them.

Snook 7 H00658 NU 1264 0434

Promontories of rock facing south-south-west form a millstone quarry on the 230m contour, and include a curious interweaving of serpentine grooves, one beginning at the edge of the rock, curling round a cup and ring, and twisting again to reach another edge of rock. The groove is crossed by a U-shaped groove that runs from a cup and curls round two cups in line (like eyes).

Wellhope NU 115 061

Site 5 at Snook Bank ends at a massive stone on the boundary fence where a wood begins. The path that leads from Snook Bank to Caller Crags runs through the wood as a wide track beyond Wellhope. To the east of the path is a block of outcrop, quarried on its western edge and overgrown with heather and trees on the east. It slopes slightly to the east; the surface is fairly uniform and its irregularities are used in the placing of motifs. There are about 50 cups of various sizes, a cup and enclosing oval groove, two cups with arcs, and an arc. The main motif is a cup and groove with a penannular groove encased in a circular depression that may have been enhanced. There is a cup and broken ring with a groove running from the terminal.

Caller Crag H00651 NU 1150 0695

The continuation of this path north reaches Caller Crag, reached either from here or by a path from the Alnwick-Rothbury road to the north. The whole of the Millstone Burn valley would have been visible from this path only if there had been no trees. To the east of the path disturbances of the surface mainly for forestry have revealed some flint artefacts and burial cairns. Caller Crag is a prominent linear outcrop of Fell sandstone running from north-east to south-west, to the north of which is a narrow flat area that could have been useful for stock holding or settlement. A small cave in the north face of the cliff opens onto this. The rocks have

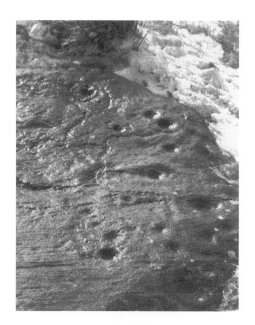

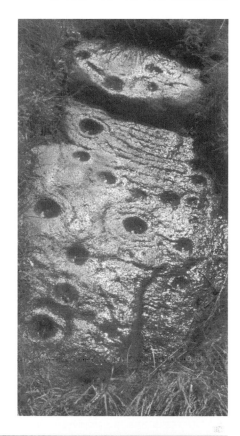

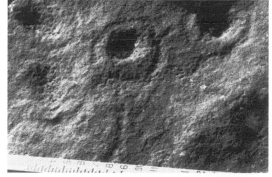

128 Snook Bank (clockwise from top left): 4a, 5a, 4b, 5b, 4a

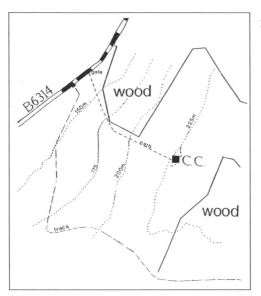

129 Caller Crag sketch map (left) and the vertical face of the rock with cup marks (below)

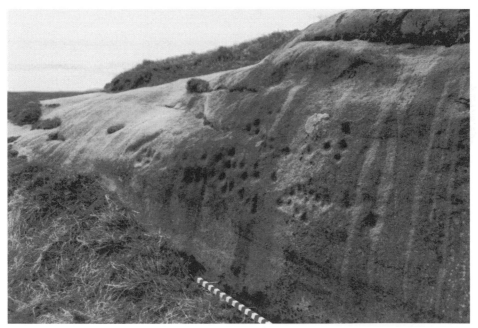

eroded dramatically, with natural grooves and cups formed in the process. As a feature in the landscape this would have been a very striking reference point for people moving through the landscape. The south face of part of this outcrop is vertical, and is peppered with artificial cup marks, many clustered and touching. There is only one ring. On the top of the outcrop are two basins and cups. They face another ledge or plateau of land where a disturbed cist is still visible. Although no more rock art has appeared between this site and Corby's Crags, it is possible that more may be hidden in planted forest.

130 Left:
 Corby's Crags;
 right: Lemming-
 ton, Lamp Hill

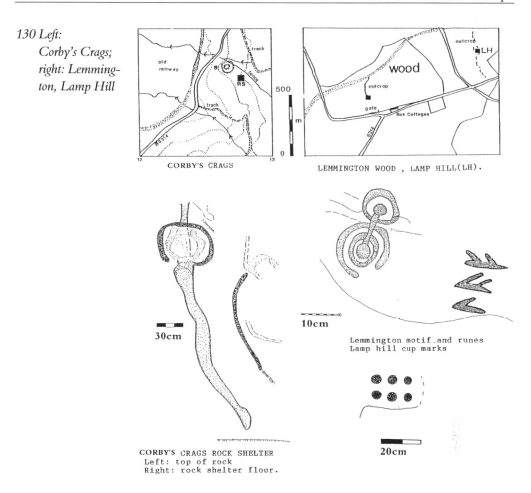

CORBY'S CRAGS

LEMMINGTON WOOD , LAMP HILL(LH).

Lemmington motif and runes
Lamp hill cup marks

CORBY'S CRAGS ROCK SHELTER
Left: top of rock
Right: rock shelter floor.

Corby's Crags *H00644 NU 1279 0962*

Visible from the road that runs past Edlingham church, castle and viaduct and from these structures is a long oblique slit of a natural rock shelter beneath a dome of sandstone on the horizon. Although it is not the highest part of the range, which rises to a hill that has some boulders that look as though they may have belonged to a disturbed monument such as a stone circle, it has one of the finest viewpoints in the area, with Thrunton Crags and the whole of the Cheviot Hills visible. Below it towards the road, on a sloping platform, there is an enclosure, possibly Iron Age, with two concentric walls that end at the cliff edge above a small waterfall.

The site was discovered when a local teacher brought to me some pottery rim sherds that he had dug up in the shelter. When I went at once to the site it was late afternoon and the low rays of the setting sun picked out a large basin with a groove running from it and a groove surrounding it. This is near the top of the dome, which has been cut into to provide a boundary between Percy and Swinburne lands (marked P/S on the rock) and continues down the rock in a series of cut steps. The boundary continues in the opposite direction as a wire fence. The dome outcrop has been partially quarried, with signs of millstone extraction, and this has confused the identification of what may be cup marks.

There are two standing stones on the slope below the overhang. Outside the fence boundary are disused bell pits for coal extraction, now filled in and grassed over.

I excavated the floor of the rockshelter, where there was a mixture of artefacts from the Middle Stone Age flint knapping (*c*.8000 years ago) to modern glass, clay pipes, a teacup and a penknife. This place had sheltered many people; an armchair and ledges cut into solid rock with metal tools was a good place to sit in a rock overhang with part of the open end screened off.

On the floor, leading to a triangular stone that covered a cremation burial in a food vessel of *c*.2000 BC, was a groove leading to it, picked out with a hard stone tool. Although it is not possible to be categorical about this, there is likely to be a link between the pick marks on the floor, and the basin and groove above. It is safe to say that no matter what the time-span may be, the place was of great significance to the makers of the motifs and those who buried the cremated remains of one of their people under the rock floor with a flat stone on top. A stray find nearby of an equal barb and tang arrowhead links the pot chronologically with hunting in the area.

I excavated the whole surface of the shelter and the standing stone 5m away on the slope; the latter proved to have been erected not in a pit, but by wedging its wide flat base with stones to prevent it from toppling over. A definite link between the time the stone was erected and the prehistoric use of the shelter cannot be made, but is likely.

Lemmington Wood H00643 NU 1294 1080

Further north-east along the scarp, at a lower level than Corby's Crags, is outcrop rock in a wood overlooking the old railway line, behind Ross Cottages. Found by others, but lost in the thickness of the newly planted wood, it was relocated with the additional discovery of three runes on the same outcrop. This was a major discovery, as runes in such a position are rare or even unique. Consultation with experts revealed they may have been part of a sacred text, and that their meaning was either 'to leave or leave behind', from the Old English verb *laefen*, or 'a remnant or relic', from *laf*. An alternative is that they are Old Norse, from the noun *lof*, meaning 'praise or permission', or *laf*, meaning 'bread or sustenance'.

The cup and ring motifs, over 2000 years earlier, are a cup connected by a straight groove to another cup. One cup has one ring, the other a ring and an outer penannular. It is difficult to say why it is there, but if the trees were removed it would command another extensive view, and be a marker to a higher place on the scarp.

Lamp Hill H00642 NU 1380 1125

On the highest point of this outcrop, with extensive views (including a view of the Midstead rock site), is a natural rectangular panel to which three sets of paired cups have been added, like a domino six. Although the domino arrangement of cups is not universal, there are others in the county. The site is at the edge of the scarp, which continues towards Alnwick via a military communications site with a 'golf ball'. The rest of the ridge has not, as far as I know, been explored.

All these scarpland sites are chosen in such a way that must have been visible for miles around. The marked rocks, however, can only be seen from close up, so people moving along this scarp would have known where to find them. Views to and from them, as I have observed before, would have depended on what sort of vegetation cover was there at the time they were made.

Morwick Mill, Warkworth
H00791-2 NU 2335 0445

Sandstone cliffs at Morwick, rising from the River Coquet at a fording place, have some of the most unusual motifs in Britain. They were discovered in the nineteenth century and drawn, but closer investigation has led me to find many more on the same surface. They are atypical, as a glance at the drawings shows, for they are based mainly on spiral motifs. Some others may have tumbled from the rock face into the river, where parts of the cliff have collapsed.

The site has a shut-in feel, despite the fact that the land opens up on the north part of the river. The sun seldom reaches the north-facing motifs, which are liberally distributed. Many are beyond easy reach, which suggests that either equipment was needed to reach them or the river was higher. To record some of them, I had to

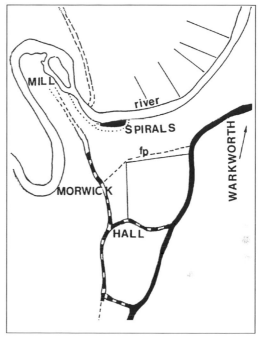

131 Morwick

have a ladder lodged in the river bed when the water was at its lowest. Locally the site has been known as the 'Jack Rock', with one design seen as a lion's face. This is an important fording place across a river that must have been a major food source and vital means of communication.

These motifs lie in isolation from any definite prehistoric sites. The spiral motifs are quite different from cups and rings. The only other examples in Northumberland are at Lilburn and West Horton. If we are looking for sea-borne sources of influence (although unnecessary), the obvious direction is not from Ireland, where spirals are frequent in decoration of passage graves. Further north, at Hawthornden in Scotland are similar spirals on cliffs, but that does not link them except stylistically. More obvious parallels would be in Galloway, to the west. So who put them there and why? Spirals of any kind are rare in Britain. Their contexts, spread widely, include stone circles, pottery, carved stone balls, maceheads, reused slabs in early Bronze Age graves, and in passage graves in Ireland, Anglesey and Orkney. Some are on rock outcrops. They are not all alike: the horned spiral occurs, for example, only at Morwick and Lilburn, and in Scotland at Temple Wood, Achnabreck, Lamancha, Gilnockie Tower and Orkney. It occurs too on a Grooved Ware vessel from Radley. 'Triple spirals' occur only at Morwick, Achnabreck, and New Grange (Ireland), but they are joined in different ways.

This is what makes Morwick so special, for it has single, S-shaped, horned and triple spirals as well as a unique design of three spirals linked to concentric circles and a spiral surrounded by a ring of cups. All this is to be set against the great rarity of spirals of any kind in Britain. Its position in the landscape makes it one of only 11 open-air sites in northern England and southern Scotland with spirals. Unlike the more usual cup and ring

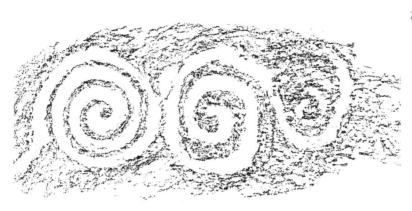

132 Morwick: a rubbing of the running spirals

motifs this is on a vertical cliff rather than on near-horizontal rock. Its position is in a very important river valley, with many prehistoric sites along the course of the river, close to access from and egress to the sea. There is no man-made monument there, but its position is naturally striking as an important river crossing, so to travellers, hunters, settlers and fishermen it would act as a reference point, taking on perhaps a ritual significance of such importance that it inspired a unique art form. No one had to teach the people to do that; we do not have to look for sources of this art; it may even have been *the* source. I believe that many motifs can be produced by many different people in different parts of the world instinctively. (Young children are particularly good at discovering spirals for themselves, and I have seen people who are bored in committee meetings forming them on their note pads and agendas.)

In Galloway the majority of spirals are not used in association with cup and ring motifs, but are on rocks by themselves, despite the latter being widely distributed.

The places where spirals have the most significance in England and Scotland are on stone circles, such as Long Meg and Castlerigg (Cumbria), in the passage graves of the Boyne valley (Eire), Anglesey and Orkney. At Newgrange (Eire) they are at particularly important places in the grave: as many are inside, only a few people at a time could view them; others are placed on the decorated kerbstones. Such placement gives us a rare dating possibility, but for that site only: later Neolithic. It is just possible that the re-excavation of the pit at Lilburn could provide more information by using modern methods of excavation. It has been said that the horned spiral at Achnabreck is earlier than the cup and ring motifs on the same rock; as it is in exactly the same condition as the best of them, I can see no reason for saying so.

Despite many attempts to explain them, much speculation remains in a world of fantasy — at least, it has yet to convince me! What we cannot deny is that they were very important to the people who made and used them; the motifs had a meaning that may continue to elude us. The danger is that we read ourselves into them — a natural response that brings many answers.

Morwick 1 (a-f)

1a is the most easterly vertical surface. Many of the motifs are very faint, either from erosion or because they were pecked on lightly. On the left-hand side is a faint series of

concentric rings that appears to start with a spiral. Below is an S-shaped spiral, not totally symmetrical. Further below is a pair of spirals turning clockwise that meet and run into each other, arranged obliquely like the motifs above. There are other faint peck marks, but in no obvious pattern. The left-hand side has a clockwise spiral at the top, a single turned horned spiral at the bottom; in between are incomplete pecked grooves like a question mark that reach the edge of the rock.

1b is unique, and the most complex of all the designs. To the right is a cup surrounded by two concentric rings. A groove runs round the outer ring to enclose an arrangement of three spirals that run from it. The top two (with some confusing additional pecking) are clockwise single 'shepherd's crook' spirals, and below is an anti-clockwise spiral that curls around itself before becoming part of the heart-shaped surrounding groove. The groove around the concentric circles, met by this groove from the spiral, ends at the rock edge. Below that is a groove running concentric to it. Further below is a square enclosure with rounded corners, with two faint cups inside.

Above this complex heart-shaped arrangement is a clockwise spiral of three turns that runs into the outer groove. Branching out from the same major groove is a clockwise spiral, linked to it by a long groove. Above are faint arcs that echo the shapes of the outer turns of the spirals, one then moving off to the left to join the next complex motifs. At the bottom of the left-hand side group is a horned spiral, very worn or unfinished in its centre. There is a deep oval groove enclosing the whole figure; from the bottom a U-shaped rise, echoed by another above it, provides the bridge in between the two horns, one clockwise and the other anti-clockwise.

A clockwise spiral joins the outer groove of the horned spiral from the right, surrounded by a ring. This ring has a groove branching into the outer curve of one of three spirals that are all linked. The bottom two spirals are arranged as a horned spiral, one clockwise, and the other anti-clockwise. The third, anti-clockwise, spiral is linked to the curved groove that joins them. There are three other fainter spirals, two of which are arranged clockwise and anti-clockwise as a horned spiral; between them is another clockwise spiral. A shallow circular depression lies between the motifs and the edge of the rock.

1c is on the eastern edge of part of the cliff, a small oval surrounded by two roughly square grooves, below which are three parallel arcs.

A panel of rock above an overhang has a set of running spirals (1d). From the east, two anti-clockwise turns curl round to form an 'S' with two clockwise turns. Touching this is a clockwise spiral of two turns, forming an 'S' with a fainter spiral to the west.

1e is a clockwise spiral with an outer unattached groove. Close by is a recently-discovered clockwise spiral of four turns. The outer part has been damaged or eroded.

The enclave ends at a vertical surface facing east, with 1f forming a splendid display of four horned spirals and three linked spirals, the latter the highest. All the horned spirals are aligned on the same oblique plane. The three spirals, boxed in by the edge of the rock and by three natural cracks, are arranged in such a way that they all turn clockwise, linked together by extensions of two outer grooves, and capped by a curved groove that runs from a small cup to one of the spirals. The other markings appear on the other side of this jutting vertical cliff, to the west, facing another enclave.

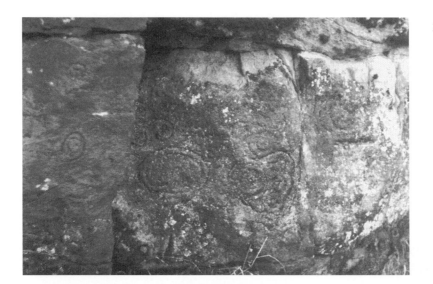

133 Main panel

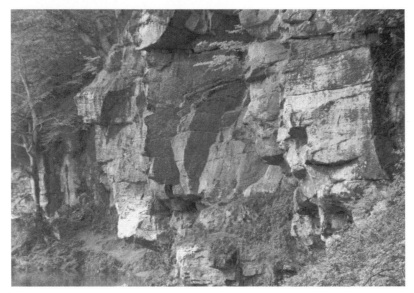

134 Cliff above the River Coquet

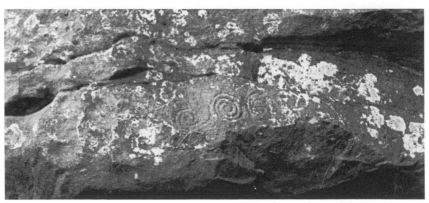

135 Morwick: running spiral

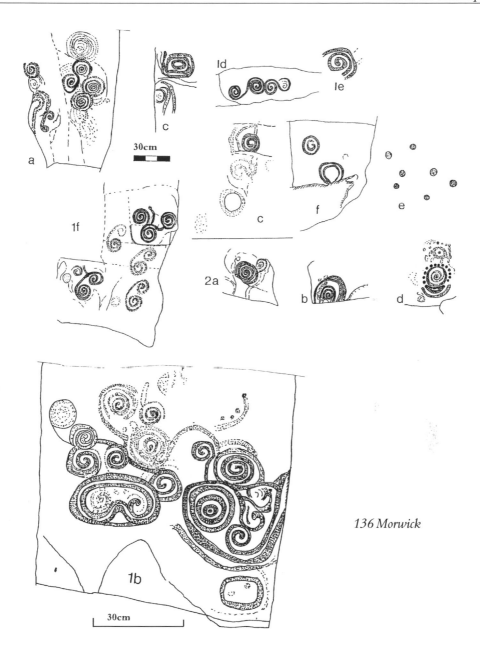

136 Morwick

Morwick 2 (a-f)

2a. High on the cliff face is a clockwise spiral of three turns, with the symmetry of the spiral disturbed at its edge. A faint motif of either a cup or the centre of a small spiral with two turns is attached to this outer groove.

2b. A sharp edge is the finishing point of an anti-clockwise spiral surrounded by two U-shaped grooves (half-ovoids) and an arc.

2c. A clockwise spiral of two turns, with two faint arcs concentric to it, stands above fainter motifs that include a ring and a possible S-shaped spiral.

2d. A unique design of a faint anti-clockwise spiral set within a ring that it joins, surrounded by an arc of 13 cups. Below it five cups are joined under the ring, with an arc joined to it below, and a detached arc below that. Above is a very faint cup and oval, with small pick marks around it.

2e. Seven cupmarks are pecked on a near-vertical surface.

2f. On a high vertical surface above a ledge is a clockwise spiral surrounded by a ring. Below are two concentric half-ovoids that meet at the edge of the rock.

Many of these motifs are difficult to see, as the rock surface is covered with lichen in parts. Assuming the motifs to have been put there at least 4000 years ago, they have been subjected to constant weathering since then. Could lichen growth have protected them?

Fontburn to Hartley Burn

Fontburn Reservoir

The marked rocks found here are located on either side of the Fallowlees Burn, in an area of prehistoric enclosures and barrows.

Fontburn a NZ 0223 9379

A rock measuring 2 x 1.5m (6ft 6in x 4ft 11in) was reported here with at least six well-defined cup marks on its surface, but I have not seen it, as it is now covered over.

Fontburn b NZ 0327 9330

A large table-like block of sandstone is similar to that at Old Bewick; this surface does not have complex motifs, but concentrates on cups, some with arcs or single rings. There are about 80 cups of various sizes and depths scattered over the whole surface. Seven have rings, and six have broken rings. It stands at the edge of a plantation where hollow ways suggest that it was a route to the stream valley, now a reservoir.

It is worth noting here that the large enclosure at Ewesley through which the old railway was cut in the last century is not positioned as a defence, but could be a henge or other enclosure. There is also a four-poster stone setting (c) with cup marks (see p152).

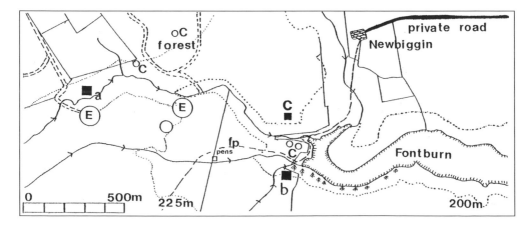

137 Fontburn locations

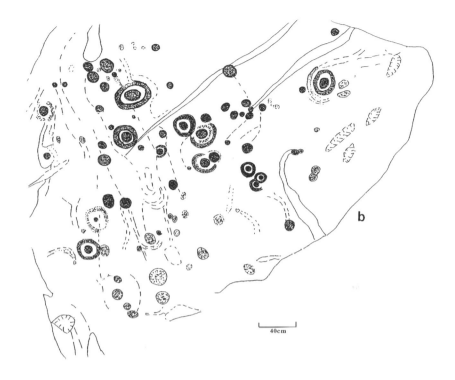

138 Fontburn b: the surface of the table-like rock

139 Fontburn: the large rock in its setting

117

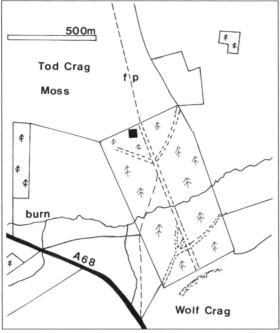

140 Tod Crag

recently in the same area.

Tod Crag, Ottercops Moss
H00761 NY 9720 8913

On Tod Crag Moss is a large marked outcrop. Until recently it was covered with forest in a rectangular plantation, which has now been felled, and the ground is rough. The main rock lies on the north boundary of this enclosure, which is bounded to the south by Wolf Crag. Mr Newbigin thought that the site lay on a prehistoric route, and found 'another low rounded hill with no less that ten typical burial mounds of stone on and close by it. This is one quarter to half a mile west of the crag.' Since his discovery and my first recording of the site, some cup-marked rocks have been found

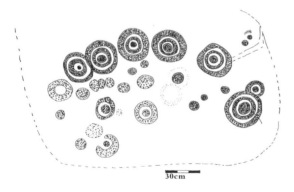

141 Tod crag motifs

The outcrop has a flat surface. Whoever made the motifs had a great liking for arcs and semi-circles, for the cup and ring motifs are arranged accordingly. There are many large cups, mostly contained within this arc; there is a group outside. Some have faint rings; whether they were earlier or eroded is speculative. Six sets of cups and two rings are deeply made, and the arc that they form is completed by two cups, a cup and ring, and by two cups with faint rings at the end of the arc. Four motifs are made up of two concentric circles around a cup. A fifth has a gap and an extension in the shape of a cup surrounded by an arc that meets the outer circle. At the opposite end a ring around a cup has a concentric penannular that meets the outer circle of the adjacent cup and two rings on its outer ring and is open at the other. The arc ends with a faint cup and ring.

Inside the arc are 16 cups, one with a ring, that vary in depth but are generally wide.

West of Ottercops is a group of rock motifs in the Bellingham area.

Padon Hill H00759 NY 8208 9210

West of the Pennine Way fence is an outcrop rock, north of Grey Mare, with 20 clear cup marks.

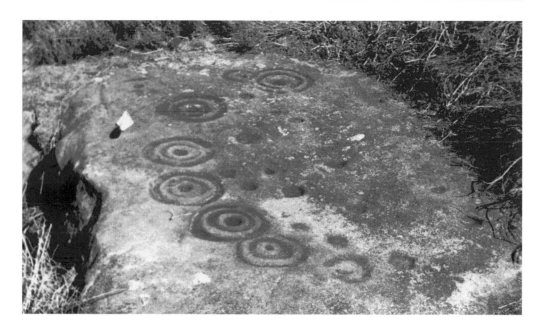

142 Tod Crag, over 30 years ago

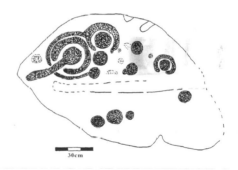

143 Black Bog Dean: this flat boulder is either in its natural position or has been brought there (see page 171)

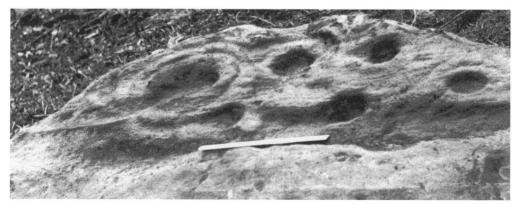

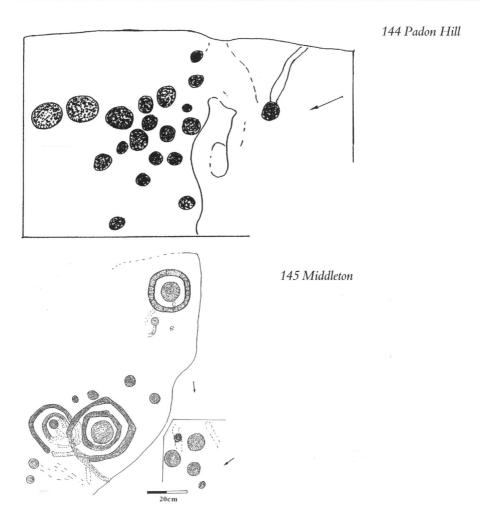

144 Padon Hill

145 Middleton

20cm

Whiteley Pike, North Sunday Sight (5 rocks) *H00760 NU 828 914*

The site was first reported in *Redwetter* (a local magazine). A cist was also found in the vicinity. I have not drawn the rock art, which is on a boulder-strewn moor. The small markings on five small boulders or outcrops are different from the usual, for they are recessed dishes or small basins.

Middleton Bank Top *H00752 NZ 0587 8395*

John Davies discovered these marked rocks and others at Shaftoe. As an insight into the almost coincidental way in which we make our discoveries, John tells me that this was the place that he chose for his lunch; he looked down — and there they were.

The flat outcrop has a cup and angular ring to the south with a small cup underneath. There are six cups outside a complex arrangement of two motifs that cross. The earlier one is a cup and penannular with surrounding grooves that run into the main motif: a large cup at the centre of an angular groove, with an angular groove that runs faintly to the edge of the rock. The motifs belong to the same tradition, and were probably made at the same time. Another piece of this outcrop has three large and two small cups.

146 Shaftoe (top) and West Shaftoe sites

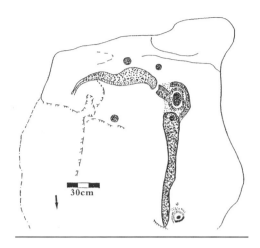

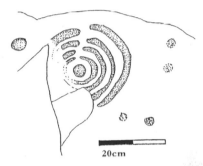

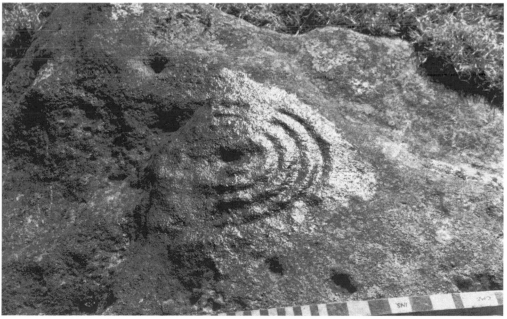

147 West Shaftoe

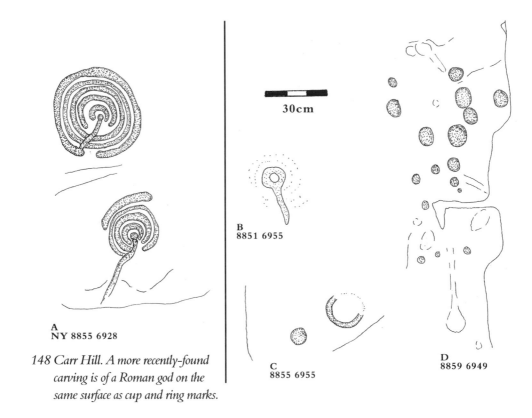

148 Carr Hill. A more recently-found
carving is of a Roman god on the
same surface as cup and ring marks.

A
NY 8855 6928

B
8851 6955

C
8855 6955

D
8859 6949

30cm

Shaftoe Crag, Jubilee Memorial Site H00754 NZ 0530 8335

Prominent on Shaftoe Crag, north of an Iron Age enclosure, is a natural platform of out-crop, quarried vertically on the north. The name means that the ridge is shaft-shaped.

There is a faint cup with a short arc, and two eroded cup and rings in natural hollows are the starting points for two long grooves. One runs north, to end in a point next to a faint cup and ring; the other is of irregular thickness, serpentine, running east, also ending with a point, and having three cup marks outside it. The viewpoint from this outcrop is very extensive.

West Shaftoe Farm H00753 NZ 043 817

On an outcrop rock, some fine cup and ring marks have been damaged. A cup is at the centre of four concentric penannulars, leaving a gap running through the rings from the cup. There are five other cups. It is very finely made.

Carr Hill, Frankham Fell H00769 NY 886 693

Between Fourstones and the Roman Wall, close to the disused quarry that was used as a major land-fill site until recently and to the Frankham Fell Kennels, there is a spring source of a small stream that drains towards Walwick Grange and the North Tyne. The land rises from this spring to Carr Edge on the north, where sandstone outcrop protrudes. A line of pylons runs across, and below these there are some cup marks that look across the south of this little valley. In a hollow, where the land begins to rise at the spring, the slope has earthfast boulders where the main rock art is, situated in such a way that it looks down the valley towards the place where it joins the Tyne. This is not the highest point in the landscape, but the concentric ring motifs give the place at a spring source an added significance.

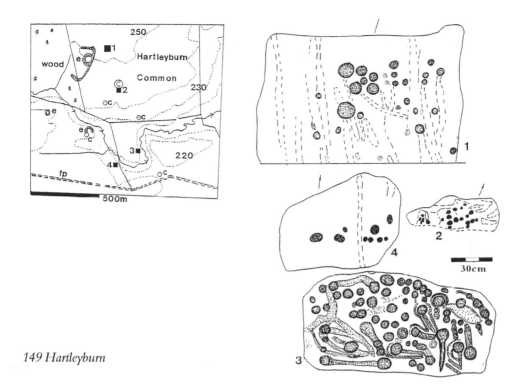

149 Hartleyburn

The motifs arc recorded from the south. One is a large boulder-like outcrop, and the top motifs are a cup from which a groove runs out to meet the outer ring of five. These rings are not complete, but begin with an arc over the cup, a penannular parallel to that, two complete concentric rings, and an outer penannular. Below is a cup with a serpentine groove running from it. The cup has three concentric penannulars; the groove does not run through the gap, but curves away to meet one end of these penannulars. Above all is a short groove concentric to the rings below it. There are three areas on the large outcrops with cups and one arc.

All the motifs appear to concentrate on the importance of the minor valley below them and on the spring.

Sewing Shields NY 80882 71324

A large earthfast boulder has been recently reported, 2.5m long, with eleven cups on its top surface.

Hartley Burn Common H00770-3 *four sites* NY 6395-6412 6058

This big expanse of coarse grassland, coniferous woodland, steep stream valleys and marsh, used for grazing, has prehistoric enclosures that suggest a more ancient pastoral role. Small round cairns seem to be burial mounds rather than field clearance. There is quarried rock, but no cobblestones left. The sandstone is naturally ridged, which gives an arrangement of cups a more elaborate appearance. The sites lie close to the Cumbrian border.

An outcrop slab that lies on the edge of a quarry, with its ridges running from north to south, has a cluster of seven well made cups at its centre, and four fainter peripheral ones.

The other three marked rocks are all 'portables', with a strong connection with cairns.

Summary

We have seen that there is a logic to the siting of rock art in the landscape: high places that command extensive views, especially of valleys. Some of these valleys lead to lower-lying areas such as the Milfield Plain that has a spread of ritual monuments, especially of henges. Thresholds such as Weetwood Bridge have marked outcrops where the valley enters such a plain. Minor valleys that enter the main river systems, such as the Doddington Dean and the Broomridgedean Burn, also have motifs on outcrops overlooking them. On such outcrops the motifs are mainly complex, with multiple concentric circles, rectangles, squares, heart-shapes and rosettes. Simple cup marks are still there in profusion, but are dwarfed by these more elaborate motifs.

None of this can be dated, even within its context. The distribution of motifs follows the natural landforms, the living rock, and blends with them, for it is part of them. Its use is related to the pattern of nomadic herding, which depends upon mobility, so we are observing the signing of the land by people who used it seasonally, giving special significance to particular viewpoints or to places where something of significance happened. In the latter sense, we may be looking at a monument within the landscape: who knows, but it may mark the place where someone died, or where some particularly great hunting feat took place. We cannot exclude a record of such events.

Areas such as Lordenshaw are in a sense monumental in the way the natural ridge that leads from the main river carries a series of motifs to the top of a hill, marked by burial cairns. At Carr Hill the rock art focuses on a spring, a vital ingredient in herding during the summer. At Fontburn trackways converge above the streams at a decorated table-like panel. At Morwick the fundamental factor in the siting of rock art seems to be that the cliff rises from the river at an important fording place. At Millstone Burn and Snook Bank panels of rock art mark a crucial route from low-lying land from the coast through to the hills, and they continue along the main scarp routeway north-east. At the Ringses the line of marked rocks keeps the traveller above the marshland. At Broomridge, Roughting Linn, Hare Law and Cairn Heads we are led by hollow ways and ridges from the Milfield Plain to another threshold, the Doddington Burn. From Chatton Park Hill to Hunterheugh we are taken along scarps that overlook a main river valley and the outlying sandstone uplands of Weetwood and Fowberry. This is only part of the story, for to look purely at the distribution of rock art on outcrop would ignore its connections with other prehistoric sites and artefacts.

We turn now to other contexts for rock art. Already we have seen that outcrop can also be monumental, particularly the rock overhangs and the cliff at Morwick, so the distinction is not clear-cut.

3 Art in monuments

The survival of motifs on outcrop is one result of people not wanting to use the uplands so much for modern arable farming. Monuments that stand in the way of modern agriculture tend to be destroyed, so we have to reckon that what we have left is only a small proportion of what might have been, a perpetual possibility.

There are two main monuments: standing stones and burial cairns. As it is possible to add motifs to stones already in use it is impossible to date when this happened or in what sequence. The addition of such motifs, bearing in mind the significance of standing stones as meeting places, community centres and places of ritual, suggests that the motifs could have had a similar significance.

Their use on burial cairns is even more suggestive of a special, serious significance, but some problems of chronology arise. Although some incorporated rock motifs show signs of erosion, and may be earlier than the monument, others are pristine and purpose-made for that monument. Not only can we assume a use into the period of the barrows, early Bronze Age, but we may also assume that some motifs continue to be made in that period. However, it must be taken into account that the use of rock art in burial cairns is in a tiny minority of such cairns, unless the detailed examination of the stones of cairns in the past was not thorough enough to spot marked rocks. Paul Frodsham and I wrote an article in which we examined all cairns in which rock art on northern England had been found, and came to the conclusion that we did not have a single *unambiguous* example of Bronze Age cup and ring art. In the same way we found that there are a few sites in which the reuse of Neolithic rock art in later structures may be suggested, but not one that can be proved.

Decorated rock art outcrops with cairns built on them suggest that either the cairn builders recognised such sites of great importance already, or that they themselves made the marks before building the cairns on them.

What follows now is an examination of all marked rocks connected with burial; this will enable the reader to consider the data and what it might signify.

Rock art in cairns and burial sites

Burial

There are three ways in which a body may be buried in the period of 'the round barrows': by covering it with a pile of stones, by digging a pit and putting the body or cremated remains into it, or by constructing a cist. A cist is a chest made of stone, with a slab to cover the cremation or inhumation. Sometimes artefacts were included, such as stone implements or weapons, pottery or jewellery. The most noticeable burial sites are covered with

a heap of stones (a cairn), but some may have been covered over at ground level. A burial may survive when the cairn has been cleared from above it.

What follows is an examination of the most 'secure contexts' for the inclusion of rock art in cairns that have been excavated in recent times. The examination then extends to sites dug up long ago, where reports are available, and sometimes objects from the graves themselves.

Another group to be examined is marked rocks that lie close enough to cairns to have a possible connection with burial customs. Cobbles, the most commonly used decorated stones in Northumberland's cairns, deserve special consideration wherever they are found.

We begin with the most important sites. As far as possible, marked rocks are listed from the north to the south of the county, but similarities of use make it important to consider them in a more flexible way.

The Weetwood Mound H00511 NU 0215 2810

By chance, I was in the area when the land around the Weetwood sites was bulldozed and cleared of heather and stone, ready for grass planting. I had often seen the low mound between the public path and the road, with a large stone projecting on the south side with two apparently natural cups on top. The low mound, no higher than the large stone, oval in shape, had not been recorded, and had presumably gone unnoticed when permission was given for the field clearance to go ahead in May 1982.

Boulders were removed from the area, and dumped beside the public footpath and at the edge of the outcrop hill, where some remain. The mound was bulldozed, and the large stone lifted and dumped with other clearance, north of the footpath. It was then that I saw the large stone, with its remarkable pattern of cup, concentric rings, and radial grooves. The shallow hole from which it had been taken was just about visible in disturbed soil. The farmer not only agreed to halt work at my (unofficial) request, but got his men to search the area for more decorated cobbles. He also agreed to my excavating the site, and to its reinstatement after excavation. He saved all the cobbles in a heap that had been removed from the site of the mound.

An examination of sparse documentation revealed that Canon Greenwell had investigated six possible burial cairns, two of which had cists with no bodies remaining. These did not have precise locations, and only one is still visible, outside the area of rock art on the public footpath leading west from site 6. I regarded the bulldozed site as a possible burial cairn, and set out my excavation grid in an area surrounded by recent ploughing. Field walking in the disturbed ground did not produce any flints or other artefacts. About three-quarters of the mound had been bulldozed away, and what was left was carefully trowelled to base. At the same time, marked cobbles were being recovered and saved. A team of eight people was involved in the excavation and recording. Every stone left at base level *in situ* was recorded, and the area carefully examined for evidence of burial (a cist pit, for example). There were no signs of burial.

The natural base of the field had a compact pebble layer, and the soil among the stones included pebbles. Most of the cairn stones were of the cobble type, rounded, and they included volcanic rock brought down by ice. The stones left *in situ* were not quarried, but were of the type found on the surface during clearance. Only one edge of the oval-shaped mound retained any kind of integrity. There was no kerb of larger stones, but the periphery was made up of cobbles, with the exception of the large, rounded sandstone boulder

150 The Weetwood mound. Only the south and south-west stones survived the bulldozer. Those marked in black had motifs. Loose stone and soil is marked by dotted shading. The broken line is the conjectured kerb. S marks the position of the standing stone

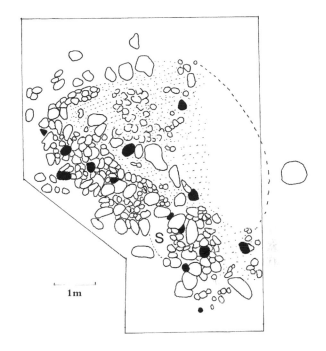

the motifs of which originally faced inward. Its base was flat and had been sunk in a shallow hole, its flat base giving it sufficient stability to stand upright.

The drawing shows the disposition of the undisturbed stones in the mound, but there was nothing more to report other than the extraordinary number of marked cobbles found in the mound's structure. Many were found *in situ*, mostly face-down. I had found four in the spoil heaps before the excavation began, and the rest of the 'loose' marked stones were picked up by the farmers. All the marked stones were sandstones, and no markings were found on volcanic rocks.

It was impossible to distinguish between recent and ancient disturbance at the centre of the mound, and there was no sign of a cist pit. Had the mound been built over a body, there would be no survival. There was no evidence of cremated remains or burning.

The large marked boulder could have been on the site as a standing stone; one might have expected it to be higher up the ridge to be very prominent, but it could have been leading up to the top of the ridge where the main rock art was situated. The oval mound was constructed with it as a kerb marker. The fact that the motifs face into the mound and were not meant to be seen is important. Even as a standing stone it is unlikely that its pattern would have faced north, for it was more likely to be viewed on the approach to the panels of rock art on the hill to the north. The deliberate obscuring of uneroded motifs means that the motifs were a private and not a public gesture — not meant to be seen — and more concerned with the dead than the living. They are different in concept from motifs in the landscape: it is as though they have been deliberately turned into the earth instead of facing the sky. Even though the mound may not have been used either primarily or exclusively as a burial, it had an important ritual function in the landscape. It does not lie among the markings on the hill, but stands on the edge of the concentration.

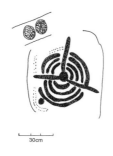

151 Standing stone radials

The placing of marked cobbles in a mound, a deliberate, calculated placement in the case of those turned face down, makes nonsense of the idea that they just happened to be a convenient building material lying around. It is more difficult to peck a design on a small cobble than onto a large horizontal rock surface. The cobbles had been selected for size, shape and surface area, probably held on the lap, and chipped with a hard stone tool to produce cups and grooves. All these pick marks are visible and uneroded, and some are marked on two sides. Not all the motifs are completed, and it seems that the act of putting some basic symbols on the rocks was sufficient for the ritual purpose.

The standing stone, now turned outward, has motifs that are echoed at Buttony and close by at Whitsunbank 2. There is a central cup from which three grooves radiate. The grooves were in position before three concentric rings were added. There is an additional concentric arc at the bottom, outside which is a single cup with a faint arc.

The marked cobbles, best appreciated in the illustration, are as follows: 24 have single cups; one has a cup, duct and ring; one has a cup and ring from which a duct reaches the edge of the cobble, and the cup has a penannular; one stone has a cup and duct, and a small groove beside it; another has a cup and thin groove beside it. There is a cup, duct, and penannular; a cup and penannular; a cup and arc; three cups on four stones; a cup and serpentine groove on another, and a cobble with a large cup and small groove. One of the largest stones has two cups and 'overspill' pick marks. Another has pick marks that do not form a recognisable motif.

Two stones have markings on two sides. A stone with two linked cups on one side has an opposite side motif of a cup and serpentine groove with an arc. Another stone has a cup pecked on two sides, meeting, rather like the technique used to produce a perforation in stone axes or maceheads.

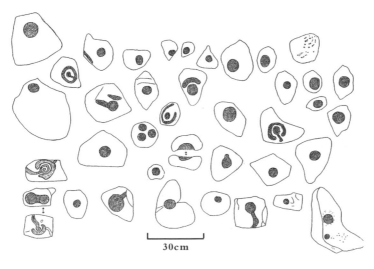

152 Weetwood cairn stones

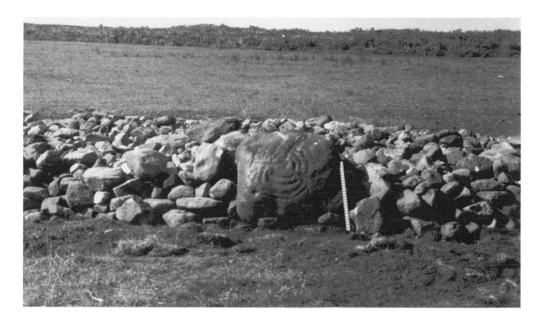

153 The Weetwood cairn. The higher ground behind it has outcrop motifs

Since the excavation and reinstatement of the mound there have been other finds of small marked cobbles in the area, one of which is at Fowberry Cottage. The presentation of the mound as an oval shape is largely conjectural, but it has the effect of allowing us to gather the loose stones together in one place, and of highlighting the position of the standing kerb stone. It will also keep machinery clear of this stone. Most of the marked cobbles are at Berwick Museum, but one was requested by the Science Museum, London. One was left on the mound.

This site, together with the one close by at Fowberry, has given us a new dimension on the use of rock art in monuments. Mounds incorporating marked cobbles are very rare, but the discovery of similar cobbles in walls and field clearance heaps suggests that other destroyed mounds might have contained them. When we excavated the massive cairn at Blawearie, we examined every cobble within the mound, and not one was marked. The reason why some mounds were chosen for this ritual is unknown. One may put forward the idea that the marked cobbles were rather like wreaths at a funeral: that people made them and placed them in the burial mound.

Northern Cairn, Weetwood NU 0155 2840

This cairn, dug out at the centre at some unknown time, was found to have decoration on it; it also appears to have been built against an outcrop that is decorated with cups and rings. There is a change of level on this block, where a thin rectangular piece has been broken off, leaving a flat surface on which a cup mark has been made. Another piece broken off this outcrop is in the cairn material, and there are two other cup marked rocks, one a cobble. To the west, just outside the cairn, is a small outcrop or earthfast decorated with three cups with single rings (**58**).

129

The significance of this site is that it may tell us whether the decoration was already on the outcrop before the cairn was built. We have little evidence of sequence generally, but there may be an opportunity here of finding a sequence.

Fowberry Excavation Site H00523 NU 0197 2784

In February 1973 a group of students from Alnwick College of Education, based at the castle, had asked me to take them to see some rock art. Their main course disciplines were different. When we were about to leave the site after looking at the North Plantation rocks as light snow began to fall, Murray Chisholm, a music student, called us back as we went to the minibus. He had noticed a large cup on a rock among dead bracken. This turned out to be the most southerly of a series of rock motifs that covered a whole spine of outcrop rock.

With Lance Strother's permission we returned, fully equipped, to see if any more rock art was hidden in the dead bracken; this proved to be so on the edges of the outcrop. A mound on the outcrop hinted at something else, so a 26m datum line was established along the length of the outcrop and trenches laid out parallel to it and at right angles. A careful systematic clearance of vegetation revealed piles of cobblestones and boulders on top, thinning out to the south. These were drawn and a pattern established where the mound was in the scatter. It had a double kerb and sat on top of the outcrop. The kerb was constructed by laying the two arcs of cobbles and packing the space between them with smaller stones. Cobbles were mostly used, but there was a small arc of pink igneous rock that had presumably been brought to the area originally by ice. A prominent feature of the inner kerb was an upright regular sandstone slab with two cups like eyes looking to the north.

As each cobblestone was cleaned as it emerged, some were found to have motifs pecked into them, mainly with simple cups but others more elaborately. There was sufficient of the mound intact to establish that it was not a field clearance heap, and that the motifs on the cobbles echoed those on the outcrop. The scale of this was unprecedented.

The northern part of the site was more confusing, and a large hollow with an edge of stone at first appeared to be an enclosure. It turned out to be a small quarry. The freestone here splits vertically and horizontally, producing good building blocks, until a

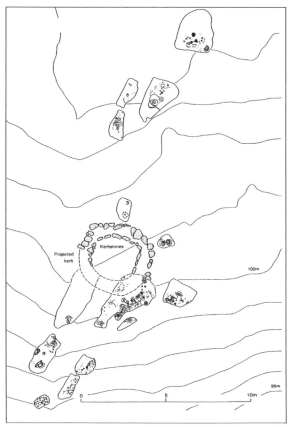

154 Fowberry plan. Richard Bradley

130

155 Fowberry cairn a

156 Fowberry cairn b

floor is reached. This quarry could have removed decorated rock. There were many small slabs and cobbles of the type normally picked up during field clearance that may have been thrown to one side so that quarrymen could get at the good rock surface. They were in lines immediately at the western edge of the working. It is possible that other cairns were demolished in this clearing process. There was less disturbance to the south, though there had been trees there. The whole area is surrounded by magnificent old beech trees, and the planting of these would have caused disturbance. To the east is a large circular hollow that we investigated; it proved to be another of these quarries also seen on Weetwood Moor.

A profile cross-section of the site shows that there was a very thin layer of sand above the outcrop beneath the cobbles of the mound; in this was the only artefact: a sealed-in worked flint that could be used as a scraper or knife and belong to the Neolithic/early Bronze Age period. There was no evidence of any time gap between the mound and the marking of the outcrop; the thin sand was sterile. The stones of the mound and other scattered stones were from 10-40cm long, mostly sandstone, with the odd volcanic erratic.

The most important feature of this site is the distribution of marked cobbles. Not only did they form part of the mound, but also four kerbstones were cup marked and have been left buried *in situ*. The rest have been removed to Berwick Museum.

The removed cobbles are illustrated here; the decoration varies from simple cups to a complex cup-penannular-radiate design. This complex design was on a cobble found south of the projected south edge of the outer kerb — unless the mound was longer along its north-south axis, which we do not know because there was only a light scatter of stone there and more possibility that the outcrop had been cleared of any covering stone.

Now our attention focuses on the decorated outcrop:

1 The south end of the upper surface is a viewpoint from which the whole range of country can be seen to the ridge of Ros Castle. There is a very large cup connected by a groove to a smaller one, on which 15 other cups roughly centre. This clustering makes a fitting end to the designs on the rest of the outcrop.

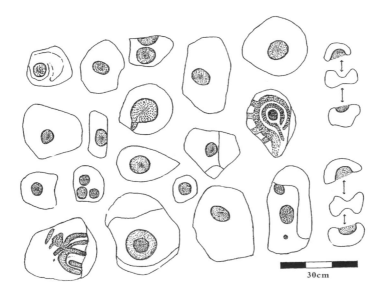

30cm

*157 Fowberry cairn
stones*

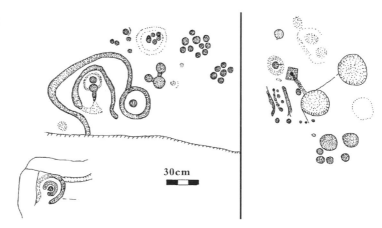

*158 Fowberry 13, 14
and 15*

30cm

2 On a slope, a slab-like outcrop has a cluster of 23 cups of various sizes and three fainter ones, concentrated at the edge.

3 The slope of the outcrop has been followed by a curved groove that has a following arc of cups. There are other cups and grooves.

4 This is a complex outcrop slab; here we can see superimposition without being able to determine the length of time lapse. We see this to the right where there is a cup at the centre of four concentric arcs which may have continued as rings had not two deep, spaced cups been pecked on, joined by a thick curved groove at the bottom and a thinner straight groove connecting the tops of the cups.

5 This has faint motifs.

6 The largest panel, that underlay the mound kerb, has a natural slope and irregularities that suggested the design. A flat-edged tongue to the left has only faint cups and arcs, but the rock then produces a triangular appendage that has been completely filled in with a cup and diametric groove at the centre of three deep penannulars. The theme of penannulars and cups centres on the upper slope of the east edge; from the cups at their centres are grooves that lead down towards the edge. Two of these grooves are used as parallel sides of a rectangle, one side of which is the edge of the rock; it contains seven cups, some with grooves leading out. It is a very 'busy' decoration, with some unattached cups included. To the left is an interesting variation on a theme, where an external arc embraces a cup and a cup and groove, echoing the direction of the external arc. A groove shoots out laterally to the left to a cup, over a penannular and cup and groove, above which are two linear grooves. The whole design flows in an arc laterally and down the rock, with a sense of integration and fluidity. It ends with a cup and two rings, an arc, and a faint cup and ring below which are three large cups. A cluster of cups at the top of the rock focuses on a natural fault in the rock that looks animal-like.

7 There is a detached isosceles triangle of rock below 6, and this has been used to centre an arced group of cups on three concentric penannulars around a cup where the groove, instead of being directed into the ground, points towards the downward grooves on the main outcrop.

8 A flat outcrop continues the theme of grooves from cups leading down the rock into the earth. The cups and grooves are the centres of penannulars (tree-like).

30cm

30cm

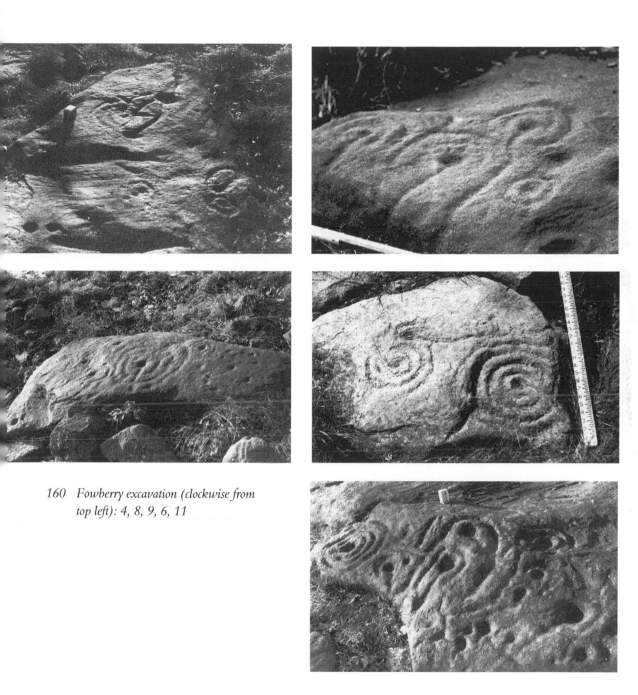

160 *Fowberry excavation (clockwise from top left): 4, 8, 9, 6, 11*

9 This flat slab is at the deepest part of the outcrop, and some rock may have been removed from above it before the decoration was added. There are two main motifs: a cup and groove moving to the right with four penannulars, and a similar figure facing away from it with three penannulars. They are linked by a single groove.

10 At a higher level, the markings on this rectangular slab are faint.

11 This slab shows one way in which the rings were made for there are joined cups that make up the ring.

12 The slab has a cup and ring and a groove joining two cups on one side, and two very small ringed cups on the other, with five faint small cups.

13 On the north quarry edge, this decoration has six domino cups, a cluster of ten cups, five cups enclosed by a faint ring, four small cups and three cups linked by grooves. The largest motif echoes the design on 6: a ring around a central cup has an arced groove curling away from it to the edge of the rock, enclosing two cups, the lower with a groove and the end of a faint ring, with a half-ovoid between it and the main surrounding groove.

14 To the north, over the edge of the quarry, are two large cups, one of which is linked by a groove to a lozenge-shaped depression at the centre of which is a cup. There is a cluster of seven cups at the edge of the rock.

15 There is a cup, and two penannulars.

This is one of the most important sites in Britain, not only for the variety of its motifs but also for the existence of a double-kerbed mound on the outcrop that contains many decorated cobbles and four kerbstones which have cup marks. It is impossible to date rock art except when there is some dateable context, but there is at least a link between cairn and outcrop motifs. We cannot assume that the mound was constructed for burial, so the site cannot answer all questions to which we need answers. However, it is unlikely that a mound so carefully constructed with two kerbs was built to retain field clearance stone. The information that we have uncovered here must be added to that gleaned from other sites such as at Pitland Hills and Weetwood. The excavation of the Fulforth Farm site in County Durham produced pristine decoration in a late Neolithic/early Bronze Age cremation burials context in a cist. The Fowberry cobbles had been buried in the mound with their decoration fresh.

Adjoining Fowberry to the south west is Lilburn.

Lilburn H00258 NU 013 256

The most important site is of a burial at Lilburn Hill Farm. In 1883 James Moffat of Lilburn Cottage wrote about it in some detail, but the picture he gives us is somewhat confusing. Some men broke up a large stone while a field was being prepared for turnips. Bones appeared. Mr Moffat found fragments of stone lying around; he says that the grave had been opened to a depth of 16in, leaving 2in of soil above the top deposit of bones. (But where did the scattered bone come from?) The grave was 9ft 2in from north to south. A trench had been dug 20in wide on each side of the bones, leaving a section with deposits in it. He trowelled this and discovered that there were cremation burials in two of the pits, one above the other as follows:

There were seven shallow depressions with three small whinstones (dolerite) over each, allowing for a half inch of soil. There was evidence of cremations, with teeth and bits of jaw. After the removal of this layer, four to five inches lower was a row of five circular

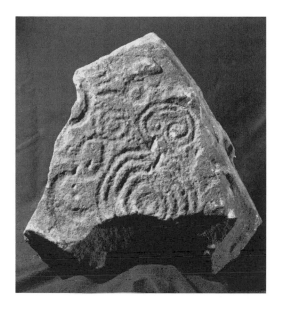

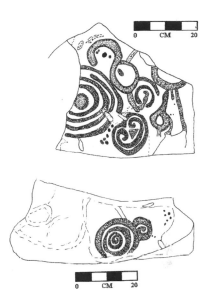

161 (left) Lilburn stone, from a burial pit. Newcastle University
162 (right) Lilburn stone: two decorated faces

depressions, rather larger than those above. Four had three small whinstones over them, and the largest pit at the north end had five. There was evidence of cremation, but the bones found here seemed larger.

It is quite likely that the pit, with its multiple burials, was Neolithic rather than early Bronze Age. It is also likely that it would have been capped by a long mound. It is characteristic of a long barrow site: not on the hilltop, but visible from lower ground over a great distance.

The stones that came from the pit burial are at Newcastle Museum of Antiquities. Mr Moffat explains:

> Mr Tait (the tenant farmer) informed me that the stone with the marking on it found at the west side of the south end of the line of pits was a thick massive stone, shaped like the apex of a pyramid, and carved on each side but one, which has suffered partial demolition at some previous period.

It appears, then, that the stone might have been broken before it was put into the pit, assuming that the workmen had not damaged it. The drawing shows it resting on the base of a triangle, on which is a cup with four concentric arcs. As the edge is broken off, could the arcs once have been concentric circles? Spiral and curvilinear design on the rest of the rock make it unique in Northumberland burials, but there are spirals on the cliffs at Morwick (see p111-16). The horned spiral is similar to one at Achnabreck in Argyll. There are also serpentine grooves that curl up on themselves. On the side of the block are three concentric rings with no cup at the centre and an attached ring. It is difficult to

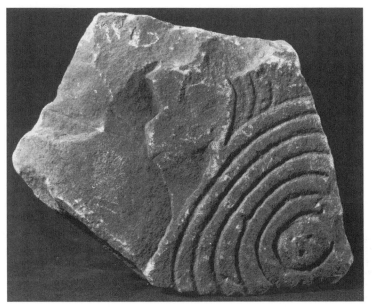

163 *Second Lilburn stone*. Newcastle Museum of Antiquities

164 *The grave (sketch)*

see how the other piece of rock fits in with the rest, but it was certainly recorded as part of the pit deposit: the fragment has had part of its decoration broken off; the main motif is a ring around a boss and six concentric rings that are more incised than pecked. Four similarly concentric arcs, cut off, join the outer ring, moving in a different direction. In Northumberland the centres of arcs and rings are normally cupped. In Langdale (Cumbria), however, on a recently-recorded massive block of rock marked on its vertical face, an unmarked centre is common. Could it be a Neolithic motif rather than a later one, or just a variation on the same theme?

On two Lilburn farms many examples of barrow digging were reported. One had a marked rock, an 'inscribed stone, with one large and two double circles and central pit (cup), supposed to have come from a cairn'. Another had a cist cover that is now in the British Museum.

In contrast to these very informative sites we have others that are only just beginning to be investigated as part of a wider landscape. For this I return to the far north of the county. Near the Scottish border, near Rochester and the military ranges two mounds assumed to be Neolithic long barrows mark the approximate east and west borders of a region of moorland and planted forest that includes a number of round cairns.

Dour Hill Long Cairn *NT 792 021*

This has been known for many years; it is 50m long and 2m high. It has an early Bronze Age burial cist in it. Another cist was excavated 200m east of the long cairn, and other possible round barrows were noted in the area. The mound is now in thick forest, which

165 Dour Hill

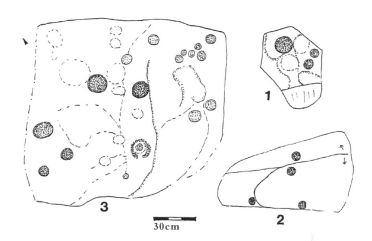

30cm

makes exploration difficult. There are five cup marked rocks in and around the mound, one with a faint ring. There is often a problem of deciding what is a naturally formed cup and what is artificial, especially when there are no pick markings visible, either because erosion has smoothed them, or because the cups were smoothed artificially. It is possible, of course, that stone with natural cup marks may be used as the 'real thing'. Fortunately, doubts only arise in a few cases. This possibility is taken into account in the drawing.

Bellshiel Law *NT 803 011*

This has a long cairn as the prominent feature of this area, built on the south of a spur just below its highest point. Some recently-recorded cup marked stones have been found in the same area. In the north is a boulder and two slabs that have cup marks varying from a basin size to smaller ones. On the north side of the cairnfield, south of the long barrow, are three boulders, embedded in the ground, with cup marks. The south cairnfield, 575m south of the long barrow, includes seven marked boulders and slabs. One has a particularly large cup

The significance of these finds is that a large number of boulders within and around cairnfields have well-made distinctive cup marks. Until we know more about the monuments in the area it is not possible to speculate about the relationship between rock art and burials or about the nature and date of those mounds. The coincidence of marked rocks with cairnfields, cairn structures and burials continues throughout the county; we shall now look at these.

Ford Westfield *H00401 NT 939 370*

Ploughing in 1850 revealed:

> a considerable number of graves east of Ford Westfield House. 20 burials came to light. The bodies had been burnt, and their remains and charcoal were placed in circular hollows scooped out of the natural (rock) and each covered with a stone.
>
> Two of these stones were marked on the underside, the one with the usual series of concentric circles, and the other with the rarer class of these markings, which consists of small hollows or pits.

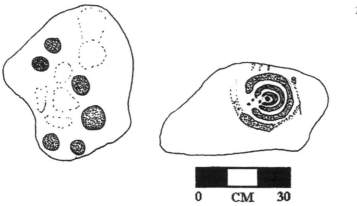

0 CM 30

From Canon Greenwell's report we gather that neither of the two decorated stones was a cist cover, though George Tate describes them as such. The larger of the two marked stones has a curved edge and a flat edge; the design of three rings around a cup, from which an incomplete groove emerges, fits the rock, suggesting that it was not outcrop rock onto which it was picked, but that the stone was chosen for the motifs. The figure has pick markings, without any attempt to smooth out the grooves, and the freshness of the motifs indicates that the cover had been placed over the cremation burials deliberately. The beginnings of a fourth groove are visible, and there are other marks on the slab that may be prehistoric. The other marked slab, roughly the same size, has six definite cups, and other possible ones.

Lowick Lowsteads H00403

East of Ford, near the village of Lowick, Mr Collingwood Bruce recorded in 1880 a cup-marked stone that came from a barrow. Its location is unknown.

Dod Law

A large stone on show at Newcastle Museum of Antiquities is from Dod Law and this supposed cist cover has some interesting features. It is apparently complete, slightly damaged in moving, and the whole uneroded surface has been pecked with a heavy, wide-bladed stone chisel. The main motifs are four concentric rings around a boss, and the rings are made partly by straight lines. Outside this figure, which neatly occupies nearly half of the rock, are deep pick marks, some joined. There is a similarity between the way the surface of this rock has been battered with the portable slab found during the hill fort excavation, except that the pick marks are widespread over the rock surface. It is unusual to cover the whole surface in this way. The marks are fresh, as though the rock had been covered in antiquity, so if it were a cist cover it might have been placed decorated face down, or buried.

At NU 003 318, north of the hill fort, was a small cup-marked cobble, now at Newcastle Museum, which lay on the surface close to a low-profile cairn from which the above cist slab might have come.

An incised cist cover NU 02380 30360 81m

In 1938 a cist was uncovered during ploughing close to the Till, with 'incised markings' on the underside. One third of the stone was sent to the Museum of Antiquities, Newcastle. Human bone was also reported from it.

East of Doddington
Hazelrigg H00468-471
Named after a ridge on which hazels grew, Hazel-rigg is visible from Horton Moor, with the small village school at 90m.

Hazelrigg 1 H00468 NU 0491 3285
Opposite the old school is a field, and inside its fence in a corner, along with clearance cobbles, is a fine slab with motifs. The underside has not been examined, and the upward face is slightly concave. In this area burial cairns have been reported, so there is a possibility that this may have been part of such a structure. It would serve very well as a capstone, and the motifs are in pristine condition,

167 Dod Law 'cist'

indicating that it may have been face down in the field before it was dug out. The location and structure of the rock make it very unlikely to be from outcrop.

The long slab is shaped like a shallow trough, curving outwards from a centre line that has a cup at the centre, from which a line of pick marks runs in one direction, and a line of cups flanked by a picked groove in the other. It is like a curved spine. The cup also acts as a focal point for five picked grooves across the width of the rock, and these roughly parallel grooves are underlined by a long lateral groove that crosses the rock and ends in a large cup. Traces of incomplete cross-hatched grooves are seen at the bottom of the rock, indicating that someone thought of continuing the idea further. These finely-picked grooves cover much of the rock and continue the motif of parallel lines crossing a central spine, with some variation such as a groove that loops from one cup to another, and a serpentine groove that curves round two large cups. But the other element is the use of cups, and if one shuts out for a while the grooves, the cups form their own pattern — a curved enclosure confined to the right-hand side of the rock, and a line of four large cups across it. The effect is unique in rock art, and again we see how individual manipulation of common symbols can produce different effects.

The slab has many small cobbles scattered around it, presumably taken from the field at the same time as the slab, and a cairn source is possible. The removal of the marked stone to a secure place and the examination of its underside and the cobbles should be undertaken as soon as possible. There is no documented history of this stone.

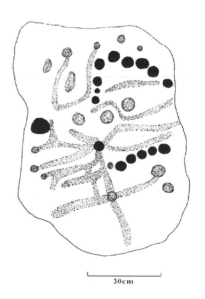

30cm

168 Hazelrigg: a possible cist cover

Beadnell Caravan Park H00622 NU 230 299
When in March 1970 a field between Beadnell and Seahouses was developed as a caravan park, mechanical excavators disturbed and later destroyed two

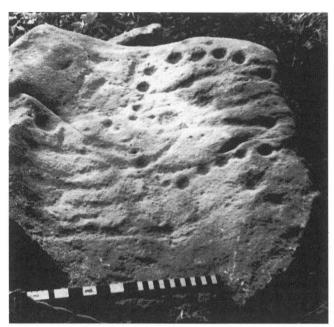

burial mounds. The first was 315 yards south of Linkhouse Cottage, opposite an inlet called Collith Hole, west of the main road. It had a large cobble kerb around a mound of beach pebbles.

The second mound, 25 yards further north, was 19ft (5.79m) diameter and 4ft (1.22m) high, with large cobbles as kerbstones. Inside was a stone cist that had later been enlarged to make another. There were many bones of 19 people, one with a penannular brooch that dates the enlargement to Iron Age or Romano-British times. The original burial contained a piece of sandstone 38 x 36cm which had 26 small cups and a small cup joined to a large one. The stone had been broken.

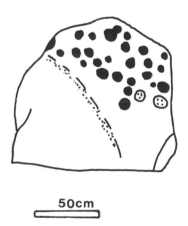

50cm

170 Beadnell

Was the insertion of the slab its reuse as building material or of symbolic significance, or both?

Hepburn Moor

Meaning 'the high burial mounds', on Hepburn Moor on the high ridge there are several burial cairns, one with a fine open cist at the south end of the ridge overlooking the Blawearie cairns (see below). One cairn has a cup marked stone as one of its kerbstones.

Whitehill Head/Chatton Sandyford *NU 099 272*

This area is rich in burial and other cairns, and three marked stones were found flat on the ground among them. At Chatton Sandyford there were five cups on a barrow stone; the barrow had three beaker inhumations and two cremations, one with an enlarged food vessel. The earliest beaker was dated to

142

171 *Camp Hill/*
Chatton Sandy-
ford

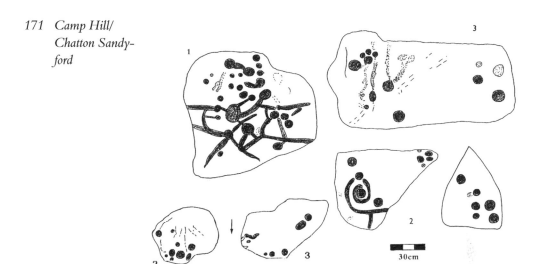

1670 +/- BC and the second was close to this date. The third was inserted later, perhaps 1500 BC. The cup marked sandstone was local, with five cups pecked on one face, and a small one broken through. It was found in a disturbed area and could have been associated with a cremation contained in an inverted enlarged food vessel that had been shattered by the disturbance. Adjacent to the cremation was a large limestone column with natural pitting that could have been a marker of some kind.

George Jobey, the excavator, reports the five cups on one side and 'Five cups have been started on the second face but not completed.' As part of one of these cups lies on the very edge of one face it is likely that the stone had been broken from a larger slab.

Thirteen cup marked rocks have been found recently among cairns in this area. The motifs are no more elaborate than one or two cups, but their occurrence in cairnfields makes them important. The most significant are those in burial cairns: one kerbed cairn has a prominent central stone with a cup; two others have a cup mark on the kerb. The maximum number of cups is five. Forestry Commission ploughing prior to planting revealed a large triangular-shaped sandstone (H00563a, NU 080 250) close to the site of an excavation of three joined cairns. The stone has six clear cups and a fainter one. The bottom four cups appear to be paired. It is on display in Chillingham Castle.

Old Bewick

Towards the edge of the scarp on which the fort is situated the land slopes down to a precipitous edge marked by a line of trees. Where it levels off before the crags there is a small prehistoric enclosure and the remains of a large cairn made up of cobbles, its structure sadly confused by quarrying and stone dumping. There is also a low-profile round barrow covered with grass that has an embedded cup marked cobble beside it and an ominous depression at its centre where it has probably been robbed, and from which the marked cobble may have come.

The Blawearie Cairns

Apart from the two hill forts in this area, on Old Bewick Hill and Corby Crags, there are surprisingly few traces of settlement; this is an area rich in burial cairns rather than field

172 Old Bewick cobble

clearance heaps. Hepburn, a continuation of the scarp north overlooks the area that we have been examining, including the largest cairn of all, part of a cemetery known as The Blawearie Cairns. This is not the place to describe our excavation of the fascinating site, which produced multiple burials of the early Bronze Age, and was used and reused as a focus of ritual and burial, but to comment on the fact that there were no marked rocks at all found during the excavations. Out of hundreds of cobbles and slabs of kerbstones this underlines the point that rock art occurs in a very small minority of burials, if we can trust antiquarians not to have overlooked it. The cairnfield extends to the rock art sites and beyond. There have been recent discoveries in a large cairnfield that we call Harehope Burn that include a decorated flat slab among the cairns, similar to those found at Chatton Sandyford.

The Harehope Burn Cairnfield

This is situated east of Corby Crags hill fort and Blawearie house, where the moorland slopes down to the Harehope Burn. There are many large blocks of stone lying around. There are two major cairnfields with over 40 cairns, some lying open, one with a particularly massive cist. There are a few scattered cups. In the more northerly cairnfield is a cairn that is either a ring cairn or round barrow with its centre dug out that includes a standing stone in its kerb. A triangular-shaped pattern appears on the inner face of this stone that is possibly artificial.

Bewick Moor North *H00579 NU 098 225*

A small flat earthfast block among cairns on Bewick Moor North (the cairnfield is at *c*.NU 098 225) is covered with cups, some with single rings. Nearby is a small boulder on the north edge of the same cairnfield with a cup and faint ring (see p147).

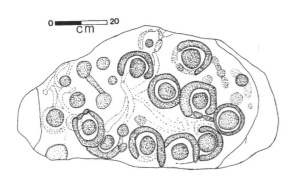

173 Bewick Moor North cairnfield slab (Harehope)

There is a group of artefacts in the Rogerson collection taken from this area and from the garden of Blawearie house that includes some fine quality flint work and ornaments made of shale and jet. Some came from burial cairns, but we know nothing more than that. When these are added to the high-status objects excavated at the Blawearie cairns, belonging to the transition from the Neolithic to Bronze Age, we cannot make a definite chronological link between rock art and burials. We can see that the

144

areas were very important in the ritual life of the people who used this landscape. From soil samples taken during our excavations, we know that the area was more wooded, but not so dense as to hinder movement through the woodland. The absence of settlements earlier than the hill forts may mean that the land was used mainly for hunting and gathering, and that such shelters that were used were temporary. Even so, there is a high proportion of burials, so where did the people live?

Mountain Farm, Whittingham
H00607 NU 0527 1275

Here a cist capstone from a burial was covered with incised circles, but there are no further details, and the stone is lost.

Turf Knowe North

The excavation of the Turf Knowe North cairn overlooking the Ingram valley is part of a large investigation of an area that includes lynchet field systems, rig and furrow,

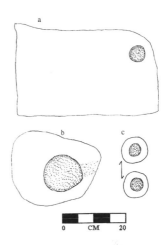

174 *Turf Knowe: cup marks on the cist cover edge (top) and in the cist pit filling*

old field boundaries and settlements of different periods. Undertaken by the Northumberland National Park, the University of Durham and the Northumberland Archaeological Group, it is an ambitious and exciting investigation of a large sweep of landscape. The cairn was one of two that did not show up before the excavation. The south cairn was a rare 'tri-radial' type, with cremation burials of the 'food vessel' type; one cist had been emptied of its food vessel and bones and an iron spearhead replaced it. The north cairn, built on an artificial platform that had flint artefacts from the Middle Stone Age onward contained at least 17 cremation burials and some food vessels. The large cist at the centre of this mound had a food vessel and beads, accompanying the cremated remains of at least two people, but the pit filling around the cist included two small cup marked stones and a saddle quern set on its edge. Another possible cup mark was found on the edge of the capstone. The cups do not seem to amount to much, but it is important to note that they are there.

Harbottle Peels H00725 NT 943 047

South of the Cheviot Hills, where the volcanic rocks give way to sandstone, is Harbottle Peels. Because this is one of the ubiquitous Canon Greenwell's sites, the slab that he dug up from a multiple burial site is now at the British Museum, where all his finds were sent. He recorded its position on the south side of a cist, facing inward, describing it as 'reniform', or foot-shaped. The site contained four cists, six unburnt and three burnt bodies, with food vessel pottery of a very attractive type. The site was exposed by ploughing up a cist in the last century. Canon Greenwell discovered that there had been a cairn on the site that had been demolished to help build a field wall. The cists were close to the surface, but had been formed in pits dug below the natural level of the field. The cist that had the motif had a food vessel in its south-west corner. He did not include a picture of this food vessel, but drew one from the burial area that was almost identical. There is now nothing to be seen at the site. We cannot assume that the motif was put onto the rock at the time of burial; had it been, the date would make it early

145

30cm

175 Harbottle Peels

Bronze Age. The motif itself is uncommon: there is one like it at Old Bewick, 3a.

The River Coquet has one of the most important valleys in the county, with many prehistoric sites in the course of its eastward journey to the sea. Rock art associated with burial appears in the Rothbury area.

Cartington Castle H00662 NU 037 053

Near here a most unusual burial was found in a hollowed-out tree trunk that formed a coffin covered with stone. The site is north of Cartington old farmhouse, east of the Lorbottle road; there is nothing to be seen of it today. Half a mile away another prehistoric discovery was made, not related. when a triangular-shaped stone was found lying in a field facedown (NU 037 053). It was moved to the farmhouse, where it was photographed leaning against the wall, and eventually it ended up at the Museum of Antiquities, Newcastle. It was thought at the time to be part of a cist, with no further details given.

There is a strong design element in this, governed by the shape of the rock (which may have been deliberately shaped for this purpose or have been found like that naturally). The main motifs fit inside it with a definite relationship and sense of space. A similar use of a triangular shape is seen at Baildon caravan site, Yorkshire.

We have seen that the Football cairn is built on marked outcrop north of Rothbury. To the south of the river is the Lordenshaw site where the Horseshoe rock, part of the kerb of a grass covered mound, has already been described. In the same area, small cup-marked cobble was found on the edge of an earth mound, and is now at the Visitors' Centre, Rothbury. East on the higher ridge which the large decorated block of stone dominates there is a small cairn a few metres away that was assumed to be a round cairn dug out to its centre, with two contiguous cup marked stones visible in a crescent-shaped disturbance. It is now possible that it is the remaining part of a tri-radial cairn. North of the hill fort is a cairn standing on cup marked outcrop with a decorated kerbstone. On the south part

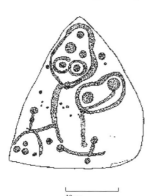

30cm

176 Cartington slab

of this moor leading up to the hill fort are cairns made of large blocks and cobbles, one or two of which are the 'radial' type, with three 'walls' coming from the centre. This type of cairn, on a larger scale, was excavated at Turf Knowe (see above) in the Ingram valley and contained cremations and food vessels.

Ravensheugh H00700 NZ 017 991

Mr D. Dixon was at the excavation of the site on Simonside which he described as 'just below two sturdy stones, called by the country people Kate and Geordie'. It stood on a projecting ridge with a steep slope in front and Ravensheugh rising behind. The kerbed cairn measured 27ft from east to west and 30ft north to south. Ten feet from its apex was a cist of four slabs of freestone with a massive capstone.

146

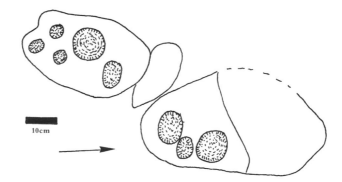

177 Lordenshaw cairn 2a

There was no trace of burial. 'Near the centre of the cairn a pit-marked stone was met with.' It was cup marked, and now lost.

Debdon Whitefield *H00660 NU 076 036*

Among quarrying, bellpits for coal extraction, and some modifications of small streams connected with the hydraulic re-arrangements on the Cragside estate, is a cairnfield on the edge of the slopes of Soulby Shield, overlooked by a standing stone. There is also a small pre-Roman group of stone-based roundhouses. One of the kerbstones of a cairn was reported to have 27 small cups, but I have not been able to find this.

Ray Burn *NY 958 859*

Of the nine cup marked and grooved stones found in the Ray Burn area, the three associated with burial are of particular significance. Two are on the stones of tri-radial cairns and one is on the inward-facing east end slab of an open cist.

Land clearance and quarrying have caused inevitable casualties to prehistory.

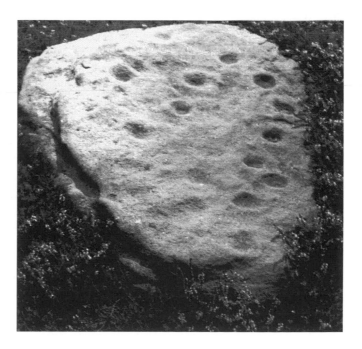

178 Bewick Moor North: slab in a cairnfield (see p144)

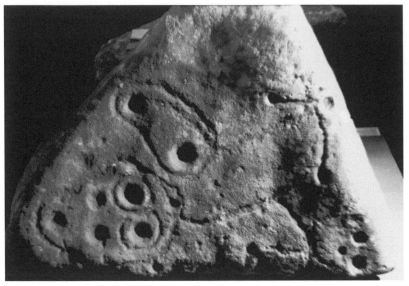

179 Cartington

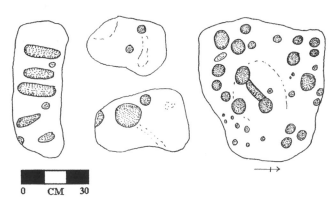

*180 Ray Burn: marked
stones in a cairnfield*

The Pitland Hills Cairn, Birtley *H00763 NY 828 844*

The Rev. G. Rome Hall, vicar of Birtley, excavated a number of burials in the Pitland hills, but only one included marked stones. The mound was 46 x 35ft diameters, and 5ft 5in high. (14 x 10.6 x 1.65m). 17 stones with cups were discovered in the mound, varying in size and shape. The largest number of cups on any stone was 12. The barrow had been carefully constructed, and in places slabs had been laid in overlapping courses. There were signs of burning in various parts of the mound and there was an inverted cinerary urn on a flat stone, crushed beyond restoration. It had 'lozenge-shaped scorings made by a twisted thong'. Some cremated bones of a young child lay among the sherds.

There were two cists. One, with a 3ft 6in cover (1.07m), contained a contracted skeleton, its knees doubled up to the chin, its left hand under the thigh and right arm across the chest. There was a food vessel with a rim decorated with herringbone ornament inside. Under the right cheek of the body, a man of about 40, was a rounded and flattened pebble-hammer with signs of abrasion. The second cist was not so well made, and was smaller. There were pieces of charcoal inside.

*181 Pitland Hills stones (from
a photograph, as the stones
are lost). All were found in
a cairn*

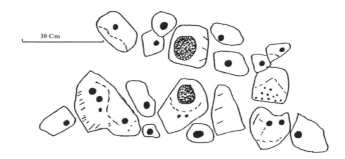

30 Cm

A large unshapely block of stone was placed so as to project slightly over the cist at the south-east corner which was near the site of the broken cinerary urn. Upon this stone on the upper face were two cup markings, one of which was smoothed.

There were 17 cup marked stones, all made of rough sandstone, although the parent rock was limestone.

Hallington, Cheviot House H00750

The Northumberland County History records that 'Traces of an early settlement are to be seen in a series of British graves on the outcrop of basalt half a mile to the north of the homestead of Cheviot. Within the mounds have been found a fragment of a whetstone of schist, a 'cup-marked' stone bearing traces of fire . . .' This is now lost.

The Black Heddon area H00745 NZ 084 752 (a-d)

Although there is nothing to be seen now on the ground, antiquarians reported many stones associated with burials. These included cupped stones over cremations in a barrow and a cup and ring marked cist with a cremation urn. Some stones appear to have been lost, and their location is not precise; South Moor is mentioned. A stone at Newcastle Museum has its provenance as Stamfordham.

a Canon Greenwell wrote:

> About 1820 a tumulus, formed of earth and stones, on the South Moor, near
> Black Heddon . . . was removed when three of four urns, containing burnt
> bones, were discovered each covered with a stone, having on the underside one
> of the circular markings.

Only one of the stones remained, and Greenwell kept it.

b Mr Tate noted that two stones

> were taken from an old dyke near to Black Heddon, and both have been traced to
> interments. One of them, which is inscribed by a series of four concentric circles
> around a cup, originally covered an urn containing burnt bones under a tumulus.

c The other had cup marks and formed part of another barrow about a mile distant.

d Canon Greenwell opened a tumulus in 1862 to the north-east of Black Heddon. On examination it proved to have been previously disturbed, but there remained in it a cover stone, having on it the pits or hollows, similar to one of those from Ford, and which, from

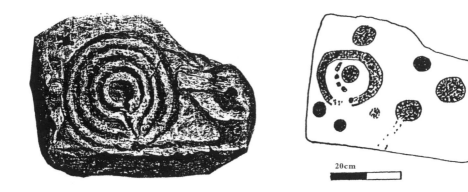

182 Stones associated with burial. A (left): Black Heddon, Stamfordham (Alnwick Castle) and b: Stamfordham cist. Newcastle Museum of Antiquities

the remains still existing in the tumulus, had entirely covered a burial after cremation. I believe that an urn was taken from the tumulus.

The Stamfordham Cist Cover

In the Museum of Antiquities, Newcastle, there is a stone entered as a cist cover that is probably that excavated by Greenwell. This has sometimes been used as evidence for an eroded stone taken from an earlier context and then used to make an early Bronze Age cist. One needs to be cautious in coming to such a conclusion, for there is no sign that this has been taken from outcrop, and the cups and rings are certainly not eroded, as the pick markings are as clear as can be. The cup and ring has not been finished, for an arc of pick markings between the outer ring and the central cup may be the tentative beginnings of an inner circle or arc. It is a good candidate for a purpose-made decorated slab in a cist.

Ouston, Pike Hill *H00749 NZ 0774 7048*

When a barrow 12 x 11 yards x 18in (10.97 x 10.06 x 0.46m) was excavated, two marked rocks were discovered. The barrow had two cists, the primary oval one being dug into the base rock. The cist was empty. A secondary cist, very close by, rested on the base shale, and measured 2ft 3in x 2ft x 17in (0.69 x 0.61 x 0.43m) deep. The floor was roughly paved. At the time it was reported:

> Only the side and end stones remain, but on the centre of the inner face of the southern side stone is a fine cup mark 1 1/2 in diameter and 3/4in deep (0.013m, 0.019m).

Three feet away from this disturbed cist lay what was probably the cist cover, described as an irregular heart-shaped rock 24 x 21 x 5in (0.61 x 0.53 x 0.13m). The design was:

> an irregular trapezoid with a cup at each angle, and two cup marks are outside the figure but have no apparent relationship to it. The markings are well and deeply cut and in some places show the rough pick marks of the first operation of incision but are generally smoothed by grinding.

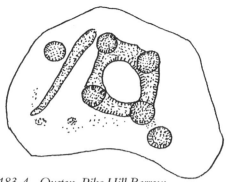

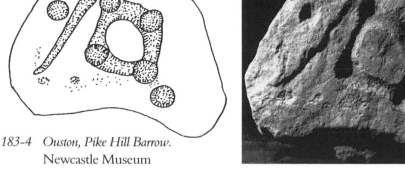

183-4 Ouston, Pike Hill Barrow.
Newcastle Museum

The description shows that the design on the cist cover was probably facing into the cist. What is on the stone does not quite tally with the description, for the pick marks show no signs of being smoothed. The motifs on this stone are clearly made to fit the shape and size of the stone. They are pristine, and therefore the rock has not been exposed to any erosion (i.e. it was buried). The location suggests that it was specifically made for the cist of an early Bronze Age burial. Because it does not have concentric circles this does not make the design 'simple'. There are four deeply pecked cups that form a square. They are linked by wide, pecked, straight grooves on three sides and the fourth by a slightly curved groove. The interior of this motif appears as a square with rounded corners. In a Dod Law context this would be an unusual design: a deep cup lies between a corner cup and the edge, with very faint pecking that may have been intended to link the two. There are pick marks between the central motif and the edge, including two faint cups. On the other side there is a long groove and a large cup, with more scattered faint pick marks. The quality of the pecking is outstanding.

Standing stones

Standing stones with cup marks come singly, as part of a small circle or of a stone setting. A high proportion of standing stones in Northumberland is thus marked. They are examined from the north of the county southwards.

The Duddo Stones NT 931 437

The Duddo stone circle is one of the most attractive monuments in Britain, with a setting that looks towards the Cheviots and to Scotland, including the Eildon Hills. Its purpose may have been to mark a cremation burial at its centre, which has been inexpertly dug in the late nineteenth century, when charcoal and cremated human bones were disturbed in a central pit. Its stone settings are far too small in circumference to place it with those circles that may be meeting places or religious centres for large groups of people.

The six stones are naturally shaped for the most part, but at the bases they have been narrowed and smoothed. One local name, 'The Women', probably refers to their waists, and another, 'The Singing Stones', to the fluting, believed to trap the wind. There are

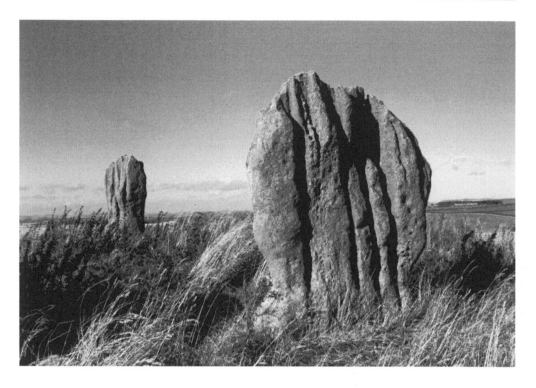

185 Duddo: the cup marks are at the right edge of the nearer stone

natural cups, deep and large, on one of the stones, but the most easterly has an oblique line of artificial cups. The site is private, but permission from Duddo farm may be given. It is reached by a well-defined track north from the road, and the protected site is one of the most rewarding. There would be a case for excavating the centre to locate the original pit, but at the moment it sits happily in a field that is constantly in use. The centre has had clearance stones from ploughing added to it, otherwise it is left to its grass and nettles. There are many instances in Britain of standing stones with cups, linear grooves, cups and rings and spirals.

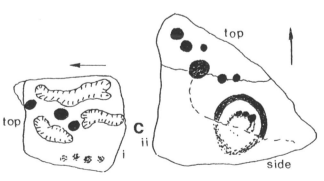

186 Fontburn; on a 'four poster'

Fontburn c.NZ 0324 9366

This is a four-poster stone 'circle'. There are three cups among natural grooves on the east stone. There are six cups on the top of the north stone, and a cluster of cups that seem to be the part of the inner circle of a double ringed motif on the vertical face of the same standing stone (for map see p116).

Goatstones, Simonburn *H00766 NY 8293 7471*

The major feature is a 'four poster', which until recently was the only location of cup marks in that area. Now the search has extended their presence southwards to the Roman Wall.

The four-poster is on a rise between the Ravensheugh cliff edge and the valley to the south made by the Coal Burn flowing east and rising just south of the stones. Small shaped standing stones mark an area of common quarry rights for limestone. The Ravensheugh scarp has a profile of limestone overlying massive sandstone, and to the south is coal. The land has thin, poor acidic soil suitable for rough grazing.

When Mr Honeyman inspected this site in 1931 he thought that he could detect an undisturbed rise in the centre, but later there were only signs of untidy digging. Aubrey Burl, the expert on British stone circles, says that the four stones belong to a type called a four poster, most commonly found in Perthshire. Generally there are four stones set in a rectangle whose sides average 16ft (4.88m) east to west by 14ft (18.59m) north to south. The stones are usually graded in height and 'a quarter of the sites have cupmarks, but these, unlike the tallest stone, are invariably on the eastern side, nearly always on the south-east stone'. He declares them to be 'primarily sepulchral', having cremations that date to about 1800 BC. The reported rise in the centre of this one may have been such a location.

I have recorded and drawn 12 large cups and 13 smaller ones on the top surface of the eastern stone. The south stone with the largest top surface has four cups and two grooves that may be slightly enhanced with pecking. There are three, possibly four cups among natural grooves on the north stone and the west stone has four cups on top and 12 small, faint ones on the side. A few metres to the east of the 'circle' are the remains of a cairn.

Other cup marked stones at Goatstones

a NY 8335 7445. This is an elongated small piece of sandstone that has eight cups in a line, three of which are larger, and there are two pick marks. The stone does not appear disturbed; it lies to the south-east of the summit on a grassy slope near the public path with views across the valley to the Whin Sill and Pennines. It lies in coarse grassland in an area that has been quarried. The other marked rocks lie higher up the slope from a, in disturbed ground, but not the most intensively disturbed.

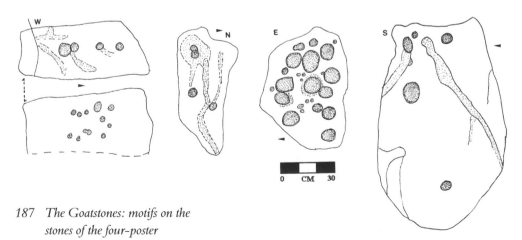

187 The Goatstones: motifs on the
 stones of the four-poster

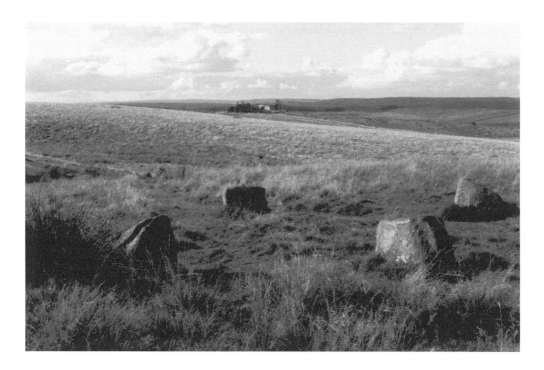

188 Goatstones

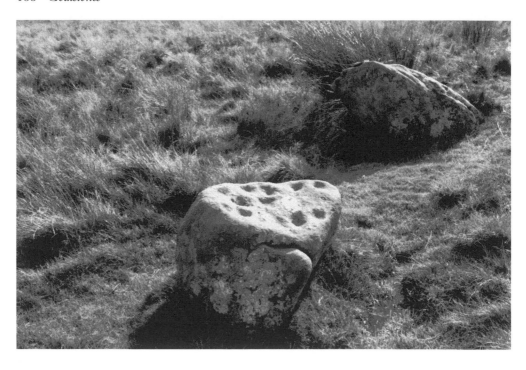

189 Fenwick Fell Field

b This thin slab has three cups in a row. It is at the edge of a bell-pit collar, and is either from broken outcrop or a cairn. It lies north of a small boundary marker, with another mound to the east of it.

c In a disturbed area of stone, bent and grass, 30m east-north-east of a small marker stone, is a small mound, next to which is a rounded stone with a single large cup and a natural groove running through it. There is another small cup.

Fenwick Fell Field NY 848 735

Between this site and the Roman Wall to the south are two cup marked cobbles found in a dyke (earth and stone field wall) beside a public right of way.

The smaller cobble has a cup and the other has two cups joined by a short groove. There appears to have been a cairn on the line of the dyke, the building of which incorporated the cairn; the cobble could have been part of that.

The Warrior Stone H00756 NZ 044 747

Close to Sandyway Heads in a field sloping to the south, this standing stone has seven clear cup marks on one face and three small pecked cups.

The Matfen Standing Stone H00744 NZ 032 705

The stone is at the roadside opposite a house named after it. It may have been moved from its original position. On three sides of its base, close to the ground, are many cup marks. Whether they were put there before or after the stone was erected we do not know. The stone is naturally fluted, which makes it impressive. The cup marks are best seen in oblique sunlight. There are 29 cups and three fainter ones on one side, five cups and an arc around a fainter cup on another, and 23 cups of various sizes on the third side.

Swinburne Standing Stone H00768 NY 9390 7460

The largest standing stone in the county, on private land, has cup marks on its north and south faces. It stands in an intriguing landscape of cultivation terraces and burial cairns.

The north face has four ovals and about 15 other cups, some small; there are two prominent cups on the south face and 10 faint cups.

Other monuments

The Milfield South Henge H00601 NT 939 335

The Plain is a very rich Neolithic landscape. Fifteen 'hengiforms' have been identified, for example, and the Coupland 'Henge', recently partially excavated, has proven to be earlier than the earliest Stonehenge. It also may be a cattle enclosure; perhaps animals were driven

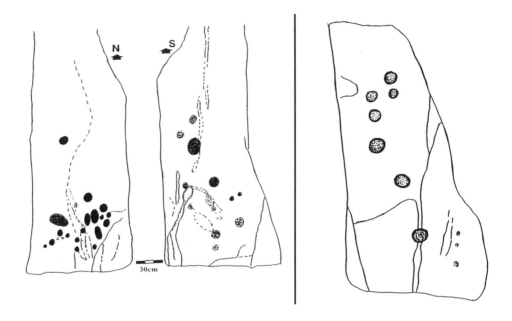

190 Cup marked standing stones: left: Swinburne; right: Warrior stone, Inghoe

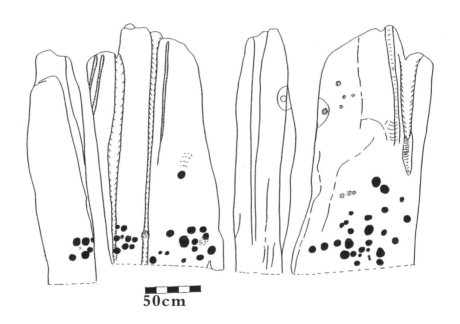

191 Matfen stone: all the decorated faces

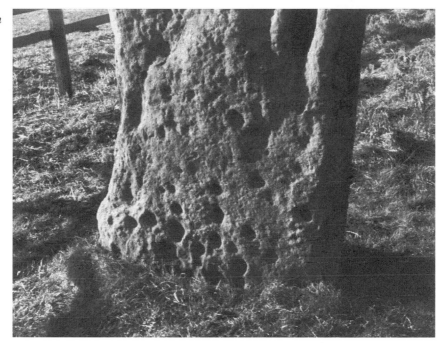

192 Matfen detail

from the grazing areas where the decorated rocks are, and corralled before the onset of winter. It is connected to Roughting Linn, for example, by an ancient trackway.

The Milfield South Henge, however, has been extensively excavated, where Professor Harding found a segmented and flat-bottomed ditch with a single entrance that surrounded a deep pit in the west-centre part. It appeared as a dark patch 3.60 x 3.20m which excavation proved to have been dug originally with a rectangular stone setting at the bottom. Inside was a cup-marked stone and burnt material placed in position at a date in the early Bronze Age. Then a large post was inserted, not to the bottom of the stone setting, and big stones were used to pack it. The post was later removed, and the pit slumped in. It is not known what the pit was

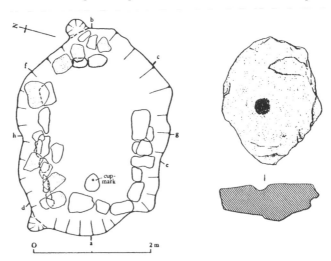

193 South Milfield henge pit.
A. Harding

157

used for. Obviously we must not make too much of this isolated find, but it will alert further excavations to the possibility of finding others. Cup marks are easily filled in with compacted soil and can be overlooked. It is the only one to be found in this monument-littered area.

Rock shelters

Ketley Crag, Goatscrag and Corby's Crags have already appeared in this account. There are two more.

Cuddy's Cave *H00459 NU 00360 31010*

At Gled Law, from the minor road to the west of the scarp, Cuddy's Cave is visible, and this small dome of sandstone juts out from the scarp. There are many similarly named caves in the north, some from a pet name for St Cuthbert, whose body is said to have rested at various places on its long journey from Lindisfarne.

Although motifs on it have disappeared, George Tate has left an account and drawings of them. He says:

> On the scalp of the rock where it dips into the hill, four figures are traceable; but from being very much defaced, it is difficult to make out these forms, even when viewed under a favourable light.

The figures that he draws are a cup and ring, a cup, ring, a second interrupted ring from which curved grooves extend, a cup and three concentric rings, and a cup and two concentric rings. On the perpendicular western face he found and drew some other designs which are not of the same type; he thought them more likely to be medieval. The importance of this place therefore continued, and from it the Milfield Plain and Cheviots are viewed.

The landscape has changed since then, in that some monuments have been cleared away. The most recent disturbance is the laying of a gas pipeline. The ritual significance of the area is suggested by reports of burials.

W.B. Davison said that 'evidence still exists to show that Gled Law was used for burial purposes. It would be interesting to excavate at least two of the large mounds on the hill, either of which may be a barrow.' It is likely that more archaeology has been destroyed or covered.

Cartington Cove *H00671 NU 0444 0186*

The cave or rock overhang was destroyed by quarrying; it was reported that some unspecified cup and ring markings were inside it.

194 Tate's sketches of markings in Cuddy's cave

4 Portable and reused stone

From Berwick to Old Bewick

This part of the survey begins with three detached marked rocks that have been incorporated into a wall. Such rocks can come from sources such as destroyed outcrop or from destroyed monuments, and the distinction between these sources and motifs on undisturbed outcrop figures extensively in this survey.

Ord *H00400 NT 9645 5035*

One site lies close to the Tweed, at Ord, Berwick. A wall between Longridge Towers and East Ord farm is the location of three marked rocks. One is built into the wall, and its motifs are not cut through, as though it had been deliberately incorporated as a feature. A large cup is surrounded by two penannulars that stop at the groove leading out of the cup. Five cups form a rough arc outside the penannulars. A portable sandstone block lay at the foot of the wall, and is now in Berwick Museum as part of its collection of 'portables'. East of this, a small stone with an oval cup mark lies at the base of the tumbled wall.

South of Berwick on the coast at Scremerston there is a phenomenon within the sandstone rock formations that appears to be cups and rings, but the formations are almost certainly natural. When layered rock is eroded, the varied hardness of the layers can produce such an effect. There are no examples of prehistoric art on beaches anywhere else. However, the formations are interesting in that they remind us that the origin of prehistoric symbolism can be in the natural world.

Watch Law Farm *H00414 c.NU 963 396*

During ploughing here a square stone was unearthed that has an almost complete design on it. A central cup and groove has two penannulars separated by a continuous ring, and above the outer ring are two cups. Only a little of the outer ring has been damaged. If this has been cut from decorated outcrop, care has been taken to remove a complete design. The squared shape and traces of mortar suggest that it may have been built into a wall of a house or barn. It came from the Joicey estate, and is now in the James' Study at Ford Castle.

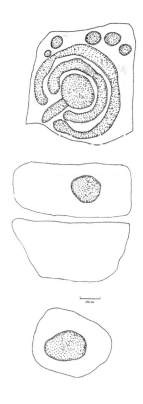

195 Ord: marked stones in a wall

159

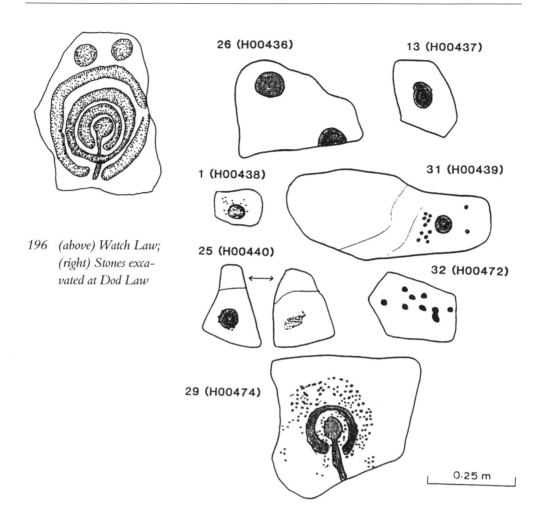

26 (H00436)

13 (H00437)

1 (H00438)

31 (H00439)

32 (H00472)

25 (H00440)

29 (H00474)

0.25 m

*196 (above) Watch Law;
(right) Stones exca-
vated at Dod Law*

Dod Law *H00426-8/433-40 NU 0041 3178*

The excavation at Dod Law produced a number of portable stones — cobbles and angular blocks that had motifs pecked on to them. Six have simple cups and pick marks, but the largest, found as part of the enclosure walling, is unusual, for although its main motif is a cup and groove surrounded by a penannular, the surface over the motif had been pecked, apparently indiscriminately, as though to erase or vandalise the motif with a heavy, sharp pick.

The excavation shows that more marked rocks may be lying below the surface. The rock art comes from the periphery of the main fort, and its building may have destroyed some. A cup marked portable stone at the Ringses (H00481), found near to H00461A, is now at Berwick Museum.

Gled Law 8-10

South of 6 and 7, a fragment of rock, 8, was found beside a wall, into which it had been incorporated as building material. It was rescued and is held by the owner of Weetwood Hill Farm. It has very fine motifs: a cup and duct with two penannulars. Another groove joins the outer ring (**40**).

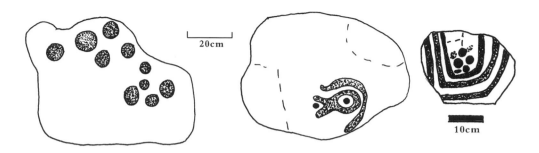

197 *Hazelrigg 2-4*

At the same site, 9, NU 018 295, is a large flat-topped boulder with a very deep, wide cup is in the Museum of Antiquities, Newcastle. The precise location is unknown, but it came from the Weetwood Bridge area. It is difficult to say whether it is from outcrop or had a monumental or domestic function. It is unlikely to be from the period of the cup and ring marked stones.

Weetwood Hill

Finally a 'detached stone with two deep cut circles and large hollows' was found by a Mr Bolam in the Weetwood Hill area, recorded in 1875 by J.S. Robson (10, NU 01 30).

This area has been well cleared for pasture below the 90m contour, and these 'portable' finds indicate that the spread of motifs may have been on rocks overlooking the place where the River Till breaks through the scarp to the Milfield Plain.

Hazelrigg

There are three recorded portables here. 2 (II00469 NU 0497 3231) is a small block of sandstone with 10 clear cup marks. It lies in a wood to the east of the road from Hazelrigg old school to Spylaw and West Lyham. It is overgrown and difficult to find, and ought to be moved.

On the opposite side of the road is 3 (H00470 NU 0497 3231), a small boulder with a small central cup with an oval groove around that branches two small grooves (like a snail) that enclose a small cup. There is an arc on the outside.

Further south in the Big Harkers Field west of Spylaw (H00471, NU 0505 3117) a small stone was found and removed by W. Nesbit (who keeps it at Wooler). There are four cups clustered in the centre of three angular grooves, all well defined with clear pick marks. Part of it has been broken off, and it is possible that this rock has been taken from outcrop.

Hetton North Farm NU 023 363

This is north-west of the above sites, on the Devil's Causeway, and this is a good place to record a carved stone ball that came from field clearance, found by James Nesbit in 1973. It is one of only two from northern England, though they are common in Scotland. Mr F. Berthele collected three smoothly carved stone balls at Chillingham/Amerside and an ovoid one, now in the Chillingham Castle collection. The Hetton one, made of grey granite, has six low discs defined by faint grooves, and conical depressions at each end. Presumably it had some symbolic significance, but we know little more than that.

161

0 _____ 10cm

198 (above) Hetton ball. S. Speake
199 (right) North Sunderland wall (destroyed)

On the coast a wall outside an eighteenth-century cottage, near the old North Sunderland railway station, contained a clearly visible motif (NU 2160 3202). The wall was demolished early this century and the stone disappeared, but a photograph by Mr O. Hughes remains.

Clavering

Along the line of the north west-facing Weetwood scarp is Clavering fort and settlement, and to the east of it, by the Wooler-Chatton road, a flat slab of stone with motifs was found during ploughing (H00502, NU 025 294). 'Clavering' means 'clover field', and is a local surname. Apart from minor plough scratches, the motifs are very well preserved, with fresh pick-marks. In the same area on the Weetwood sites, a splendidly pecked small boulder was used as a coping stone on a wall, and is now in Berwick Museum (**58**).

The Way to Wooler *H000533 NU 0325 2646*

Two marked stones were found in and on an old wall that flanks the old road. One is in the wall, a broken piece of outcrop with a cup, duct and broken arcs that may have been two or three concentric rings. The second, on the wall, has seven cups, one of which is cut through.

Deershed Plantation

The earlier name of Deershed Plantation may have been 'Island Plantation'. If so, it is the place where in 1934 Mr Davidson reported 'an unrecorded camp' and 'the vest pocket edition sculptured rock found by Mr Wake and given to the Black Gate Museum'. The rock is now in the Museum of Antiquities, Newcastle.

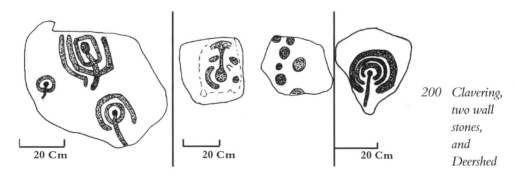

20 Cm 20 Cm 20 Cm

200 Clavering, two wall stones, and Deershed

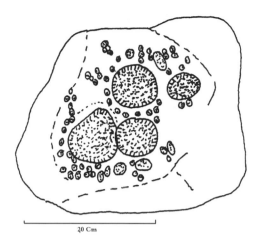

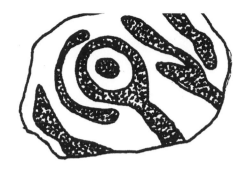

201 (left) Lilburn wall
202 (above) Hepburn wall

Lilburn

On loan to the Berwick Museum by Neil Miles of Haugh Head Farm, Wooler, this portable stone came from the Lilburn area (H00529d, NU 0195 5208). It has two sets of large cups and an interesting scatter of pick marks around them.

Hepburn

Hepburn lies on the same outcrop ridge as Ros Castle, on the west. The ridge overlooks the valley of the River Till to the Cheviot Hills. Its name has long recognised that it has burial cairns upon it. Some portables have been found. At the west foot of the ridge was a portable cobble (H00563a) that has a complex decoration for such a small stone: a ring around a cup with a groove leading from it, flanked by arcs and lines. It appears to have been used in wall building, but it is not clear whether it is from broken outcrop or a cobble used in a structure. Mr Dwyer still has it. F. Berthele found a decorated cobble (H00516b) in the Hepburn Moor area with symbols on two sides, a large and a small cup; another (H00561), on display at Chillingham Castle, is triangular with two cup marks.

In the Museum of Antiquities at Newcastle is a cobble or small boulder that is marked 'Chillingham' that came 'off the fell'. Centrally placed is a cup at the centre of two concentric circles, well made. It was apparently rescued from someone's rockery.

Between the sites and the coast is some scattered rock art.

Bellshill Quarry H00559 NU 301 115

Two marked blocks taken from field clearance were among piles of stone dumped at a disused quarry. One boulder has a large cup and arc, with six other cups arranged in its centre. The other has a cup and groove at the centre of a penannular, a cup and groove and five cups. The sandstones are coarse and gritty on the marked surface, and have been uprooted by heavy machinery. The area from which they came is extensively cultivated, and has produced some good prehistoric flint artefacts.

Ellingham H00624 c.NU 169 260

At Ellingham are four marked sandstones; one came from the garden of the bungalow 'Suilvan' and the others from the Quarry Field. The most interesting is a large cobble with a line of three cups surrounded by two angular grooves. The surface has a thin coating of ironstone which has flaked away in places. The design fits the cobble; it is an elaborate

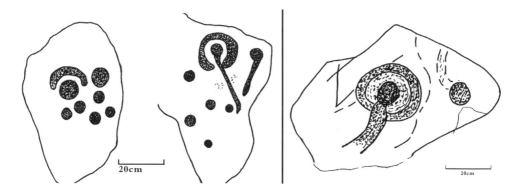

203 Bellshill quarry, Ellingham
204 (right) Brockdam

decoration for such a small stone, and may have had a special significance in its (unknown) context. The area where it was found has been cultivated for many years; there are no traces of any structures. The other cobbles, that fit quite easily into the types found in the Fowberry and Weetwood mounds, have cups: two have one cup each; the other has a cup and groove that reaches the edge and three small cups. All are in the Museum of Antiquities, Newcastle.

Brockdam Moor *H00628 NU 155 242*

Here a marked rock was discovered in a stone heap, a small boulder with a countersunk cup from which a groove ran, surrounded by a ring; there was another cup on the surface. We arranged for a team to excavate the mound, hoping that a context might be available for the rock art. The mound turned out to be little more than a heap of field clearance stones riddled with rabbit holes, and underneath it was a warren. An examination of the area adjoining the heap indicated that there might be a low-walled stone enclosure. A search of the moor and the excavation of two other mounds revealed that one was also field clearance, but that the other, with its tell-tale depression on the top, was a disturbed burial cairn that stood on the ridge overlooking Ellingham and Tynely to the North Sea. The burial cairn had been dug from the top through its centre to the cist below: this was an oval shape of small vertically placed stones the centre of which had been dug, leaving a depression suspiciously in the shape of a pot at one end. Each stone of the cairn was cleaned to see

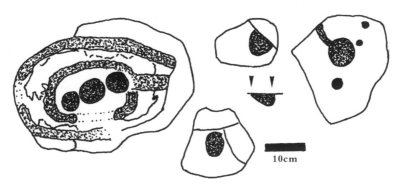

205 Ellingham

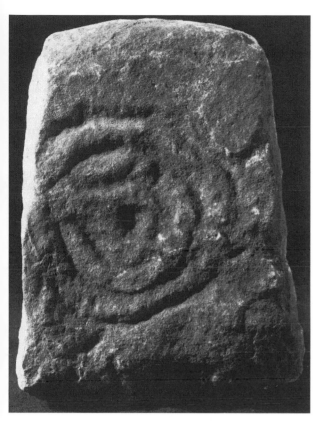

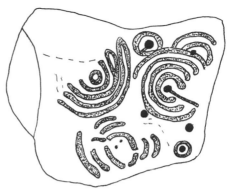

208 (left) Wooler Cottage.
Newcastle University
209 (right) The Whitelaw stone, Kirk-
newton, based on an illustration in
B.N.C. *Vol. 6. Scale unknown*

if there were any markings; there were not. At the farmer's request we re-established the cairn to its former profile, but left the centre open with the cist filled with gravel to stabilise and protect it.

We move west to the Cheviot Hills.

Wooler

A quarried stone in the Museum of Antiquities, Newcastle, came from a demolished cottage at Wooler. It has been squared off, cutting the outer ring of three around a cup.

Whitelaw H00603

A marked stone was found on the north side of Whitelaw, a hill that lies to the south east of Yeavering Bell. We have only a drawing left in the BNC Vol. 6, p.453, which I have reproduced here. The stone is now lost.

West Hill

In 2000 a cup-marked volcanic slab was found during the survey of the West Hill (Kirknewton) prehistoric enclosure. This is only the third site in the Cheviots where volcanic rock has been used in this way, the others being at Turf Knowe and Alnham.

South Middleton Moor H00608 NT 992 270

About 250 yards (229m) north of the beginning of the moor road to Threestone Burn farmhouse, on a bracken-covered brae facing east, a single cup and ring was carved on a small isolated sandstone on South Middleton Moor.

From roughly the same area came a well-pecked deep cup in a sandstone cobble.

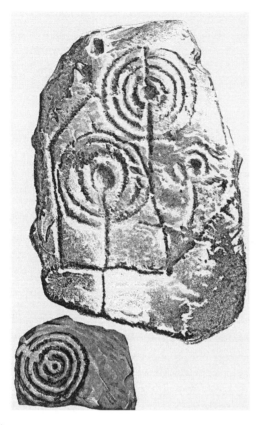

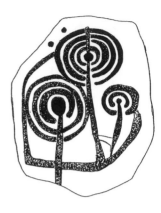

210 (left) Beanley. Collingwood Bruce
211 (above) Beanley

Beanley

At Beanley around the Ringses are field divisions, hut circles and small quarries. To the west is a recently discovered slab embedded in the ground horizontally with cups, single rings and grooves. This has yet to be investigated; the rock is in the vicinity of some low stone dump walls and mounds, which makes placing the rock in a context possible.

The discovery is doubly important because a well-designed slab (H00591) was found in the area of the Ringses in 1864, covered with vegetation. It is now in Alnwick Castle Museum. It has always been referred to as a cist cover, without further evidence. The pick marks are still fresh on the slab, suggesting that it had been buried shortly after it was made. The design makes it one of the finest compositions, as there is clearly a careful use of the shape of the rock surface that partly decided the design. There is an interesting and simple mathematical relationship between the motifs: four, three and two concentric rings around cups. All the figures are deliberately linked, not only from the grooves from their cups but also from the embracing outer grooves.

A second, smaller slab was found in the same area, with a cup at the centre of four concentric penannulars; this is also in Alnwick Castle Museum.

Powburn *H00590 NU 058 170*

Powburn lies at the centre of thick gravel deposits and on a glacial meltwater channel. Here the River Breamish begins to bend northwards on its way, under the new name of River Till at Old Bewick, to flow towards the Milfield basin. A large boulder exca-

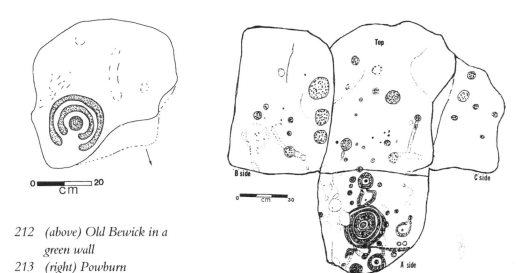

0 ━━━ 20
cm

212 (above) Old Bewick in a
 green wall
213 (right) Powburn

vated by gravel extracting machinery lay near to the manager's office in 1994. It had been apparently found at a depth of over 3m in gravel, in a hollow filled with 'black silt', according to the operator. The manager saw the concentric circles on it and kept it safe. Its future was subject to discussion between him and the County Archaeologist; I was able to make a detailed recording of it. The boulder is marked on four sides; the drawing opens them up. What was it doing there, and why so deep? The problem is to be weighed against the recent work of Peter Tipping in assessing the extent of prehistoric fills in the Cheviots. The great depth of gravel now being extracted at Powburn is the result of erosion in the Breamish valley in late prehistoric times, and the build up of these deposits in the valley had buried the boulder. If so, the boulder could be in its original position at the entrance to the valley, which has field systems, settlements and cairns that speak of intense activity there. What we cannot be sure about, though, because of the nature of the excavation, is the precise location and nature of the burial of the stone.

Yetlington Lane H00606 NU 032 107

A decorated cobble was found on the edge of a ploughed field. The owner took it to High Humbleton, Wooler, but he has now left there. The stone has a motif that fits exactly on the surface of the cobble: a cup and groove at the centre of two fine penannulars.

Old Bewick Hill H00581 c.NU 080 218

To the north of the wall dividing moorland from pasture is a green wall close to the stone wall gap; it includes a boulder with a cup at its centre surrounded by two concentric rings. We now turn towards the double hill fort on the western edge of the pasture, where a low-level outer wall marks the last enclosure wall of the more massive hill fort ramparts. It is not obvious what the relationship is of this wall to the others; perhaps it was established as an extra enclosure for cattle. What is relevant here is that embodied in the wall and the overspill are several marked rocks of varying size, and that they are not necessarily in their original contexts.

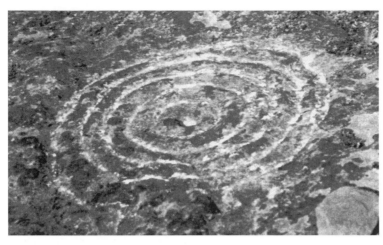

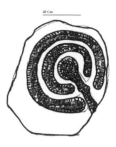

214 *(above)*
Yetlington Lane
215 *Old photo*

 A large rectangular slab or boulder (3a. NU 0771 2160) is embedded in the earth and stone wall; it has the unusual motif often described as foot-shaped or reniform: a rectangle with rounded narrow ends. There are five cups at the centre of arcs or penannulars. The lower motif has an angular groove directed at the outer edge of the rock. The right-hand side has two very deep penannulars on a natural promontory below which is a cup and a single ring. There are five other rocks, 3b-3f, all part of the wall or displaced part of it.

 There is reason to think that the construction of the double hill fort on the edge of the scarp in the Iron Age might have disturbed and incorporated rock art, which would have given a splendid view across the Breamish/Till valley to the Cheviots. We have seen that the outer low wall of the enclosure has rock art; I have also in my possession a black and white photograph labelled 'Old Bewick Ancient British Camp' on the back, showing a complex panel of outcrop that we have been unable to locate (**215**).

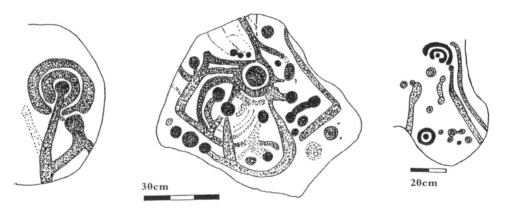

30cm

20cm

217 *Alwinton-Clennell*

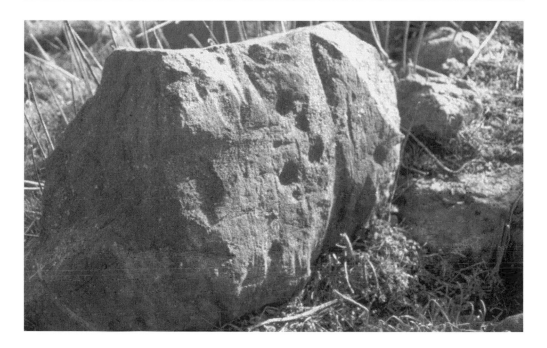

216 Alnham

Alnham to Alnmouth
Alnham Northfield *H00714 NT 9850 1167*
An igneous cup-marked stone lies among field clearance at the north-west corner of the Northfield, by the third gate on the public footpath (the Salters Road) leading north from Alnham church. The five cups have clear pick marks and there are also single pick marks visible on the surface of the slab. Most of the field clearance stone here is of the cobble type, but there are also some other volcanic slabs similar to the decorated one. Whether these are quarried, uprooted outcrops or erratics is difficult to say, but the plough scarring on the cup marked slab suggests that it had been buried.

Alwinton-Clennell Cottages
On a ridge with wide views to the Cheviots and the south these four marked boulders have been disturbed by field clearance, so it impossible to say what their original context was. All are on private land.

One boulder (H00721, NT 9379 0689) was taken from a pile of field clearance stones in a field called 'Whitehope', was bought at an auction sale at Wilkinson Park between 1965-7, and is now in private hands. The rest of the stones had been cleared away by April 1978. One area may have been a cairn (935069). Two stones from this clearance (H00702, NT 9358 0702) are just inside the plantation fence; one with a clear cup mark and the other a boulder with complex motifs. It is very 'busy' with straight and curved grooves linking up with each other and with cups.

Cartington Carriageway
NU 0460 0225: the carriageway is a hard track, built by Lord Armstrong, that leads from

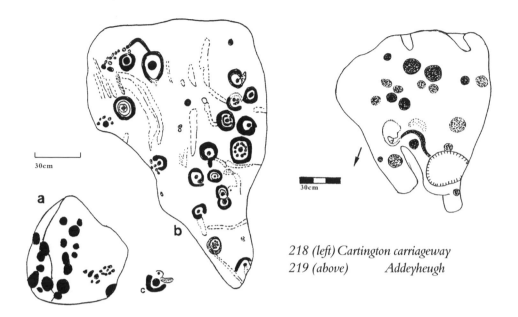

218 *(left) Cartington carriageway*
219 *(above)* *Addeyheugh*

Football Cairn. 45m west of it there is a heather-covered plateau with a little scattered stone before the land falls sharply away. At the edge is a cupmarked stone, possibly a fallen standing stone.

Between this and the next marked rock are three cairns, possibly burials, that lie between a stone dump wall and a path leading down to a huge block of stone and a quarry. NU 0470 0418: almost invisible on this slab are many small cups and rings, including tiny cups that seem to be pick marks ready to be joined together into grooves. Further east is an isolated stone with a cup and arc.

All the views from this ridge are extensive, with a particularly fine view of Old Rothbury, an Iron Age enclosure, below.

The easiest way to find the next site is to go back to Physic Lane by following the track downhill past the enclosure, via Brae Head, or to approach from Hillside Road west.

West Hills *H00667 NU 0380 0212*

Two cup marked rocks lie beside a stone burial cairn that is tree covered, east of the camp. Three other rocks are marked. The second, a boulder (H00668, NU 0395 0208) in a triangular enclosure, has some faint cup marks, south-east of a wall bordering pasture.

On outcrop, 200m north-north-east from the camp centre (H00669, NU 0385 0225) are three sets of cup marks, now covered with vegetation, including eight cups with vertical sides and an oval.

There are supposed to be two cups and weathered rings here at a site in Bracken Wood (H00670, NU 0421 0221), but I have not found them.

Addeyheugh *H00664 NU 0553 0293*

This site lies to the east of the above. Near the footpath from Debdon Farm to Addeyheugh there is a large boulder with a natural basin and 19 faint and distinct cups, including two large ones. It lies on that part of the moorland where there are small standing stones that may be markers or trackway guides.

*220 Alnmouth;
stones built
into a wall*

Black Bog Dean

To the east of the Alnwick-Chatton road, B6346, the Black Bog Burn flows through a narrow wood. When the wood was being cleared at its eastern part, an earthfast rock that protruded from the stream valley on its south side was found to have cups and grooves (H00629, NU177 162). The position of the rock art is very unusual, although in other parts of north Britain some decorated rocks mark the sites of streams and springs (see p119).

Alnmouth *c.NU 248 109*

Overlooking the coast north of Alnmouth village is a flat-topped hill with a triangulation pillar, north of which runs a boundary wall in part obscured by high bracken, gorse and haw-thorn. It is capped by a fence; where the middle section of the wall has been broken down it is replaced entirely by a fence. The base of the wall appears much older than that built of regularly-shaped, quarried ashlar blocks of maroon coloured sandstone. Approximately 30 of the wall blocks, some *in situ*, others fallen, are cup marked. Some of the cups appear in a ro-sette form. There is light pecking on one fallen stone. I have recorded only 30 of the stones, as the wall would have to be cleared to reach the others satisfactorily.

The origin of the stone blocks is almost certainly outcrop. As most of the boundary walls are built largely of this stone, the surface of the outcrop must have been extensive, and as some of the blocks have cupmarks on two faces, part of the original outcrop had a marked edge.

It is not unusual to find cups and cup and ring marked stones in walls; what is different here is that they rarely represent such an extensive expanse of rock, and are so varied in depth and size. Neither is it unusual to find outcrops on which the predominant or exclu-sive motifs are cups.

*221 Reenes and
Houxty*

20cm

20cm

The south of the county

Reenes Farm *H00762 NY 828 844*

A stone with a deeply made cup and concentric circle was found on Reenes Farm where it formed part of an old stone dyke (wall) that had fallen down. It was moved to Hesleyside, where I recorded it.

Houxty Cottage *H00764 NY 951 791*

This site stands on a hill beside the Bellingham-Chollerford road. There is a well-executed motif built into the outside of the kitchen wall. It has four concentric circles, with no cup at the centre.

Old Deanham Farm *NZ 0330 8350*

This farm was owned by Chris Whaley, who has now retired to Cumbria and taken six portable stones with him. He still keeps in touch, and assures me that they are being well looked after. The north field of the farm, with its deep, curved medieval rig and furrow runs down to Paines Bridge over the River Wansbeck. Old Deanham is a deserted medieval village (at NZ 0340 8380). It is probable at the time of land clearance for ploughing that cobblestones were taken off the fields and built into walls. This is where some of the marked stones were found; others were found in pasture. The larger picture of the area has been well recorded by John Davies.

Wallington Newhouses *NZ 0433 8461*

John Davies has also recorded single cup-marked stones from this Romano-British site, one of the three he thinks may have been the pivot stone for a gate.

Old Deanham *H00751 NZ 0330 8350*

The small cobbles here are extensively decorated; someone went to a great deal of trouble to do this.

a Both sides are decorated, one with a cup and groove, with a smaller cup above and the whole enclosed by a curved groove. On the opposite side are six cups, an arc, all enclosed by an angular groove that is open at one end.

b A small cobble is covered with six cups in an arrangement of 3-2-1 that echoes the roughly triangular shape of the stone.

c This roughly triangular cobble is very elaborately decorated, possibly in two phases, not necessarily with a big time gap between them. The whole design is enclosed by a continuous

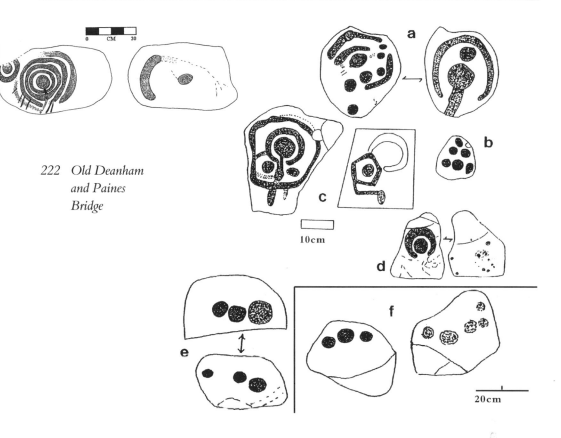

222 Old Deanham
 and Paines
 Bridge

groove that follows the slope of the stone; this encloses a large cup and penannular with a groove running from the cup in two stages through the surrounding groove onward towards the edge, with a cup to one side. On the reverse side is a cup with a groove above it that joins the outer groove and a faint groove below it that completes the enclosure of the cup. Close examination shows that a cup at the centre of a five-side enclosing groove with an extending groove that bends almost at right angles to reach an oval may have been an earlier beginning of a design, then incorporated with what we see now.

d A double-sided triangular small slab has a cup and penannular on one side and pick marks on the other.

e This double side cobble has a sharp edge. On one side is a row of three cups; on the other is a row of three faint cups.

f There are three cups in a row on one side and five faint cups on the other.

There is a marked boulder buried in the field north of the farmhouse. Many other signs of prehistoric activity from Mesolithic to Roman have appeared in this area. The cobbles are very important additions to our knowledge, for there is a strong possibility that they may have come from destroyed burial cairns, linking them with sites such as Fowberry, Weetwood and the Pitland Hills cairn.

Paines Bridge

Here there are two marked cobbles embedded in cement at the base of the eighteenth-century bridge support — the central arch on the south side of the river. The oval-shaped

173

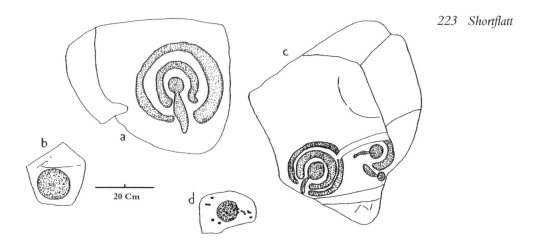

223 Shortflatt

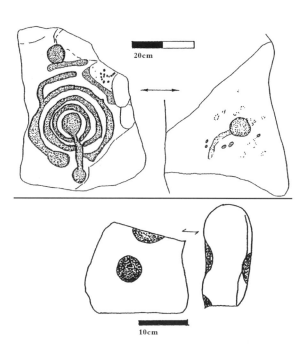

*224 Top: Sandyway Heads, Ingoe;
bottom: Carry House*

cobble has a central cup, three definite concentric rings and a less defined fourth. There are scratch marks and modern incision that have marred part of the surface. Another cup and ring motif is partly obscured by cement. The second is an elongated cobble, which has suffered some damage; there is a cup and an arc with faint traces of its extending into a longer curved groove. These discoveries are linked with the finding of decorated cobbles at Old Deanham to the south, and may be from the same source.

Cambo H00742

North of these sites, presumably, the Rev. Rome Hall noted over 100 years ago a stone of 9in diameter and 3in thick that had a cup mark.

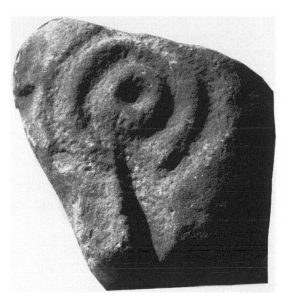

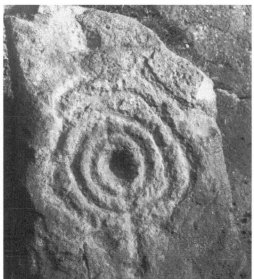

225 Clockwise from top left: Weet-
wood wall, Sandyway Heads
(Ingoe), Clennell, St John Lee
(Acomb)

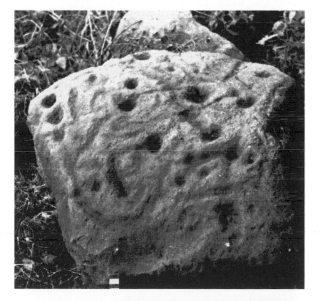

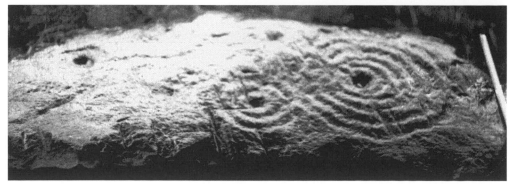

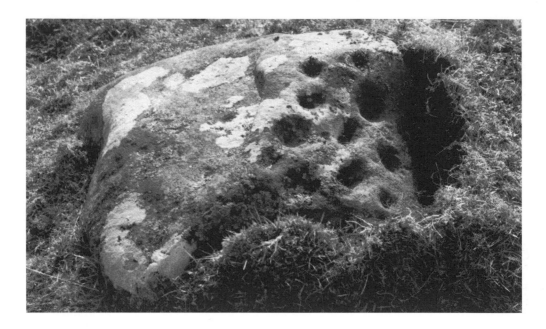

226 Greenlee Lough: an embedded boulder on the edge of a Roman camp

West Park Camp, Birtley *H00764 NY 871 786*

This site has prehistoric monuments of different periods; the discovery of a cup marked slab in an Iron Age structure may be simply a reuse of material. The details given of the discovery are vague, and it is not possible to consider that it might have been chosen and placed in a special position.

Shortflatt *H00787 NT 079810*

At Shortflatt four marked rocks appeared in fields dominated by a huge, unexcavated burial mound on a ridge. One is now in the wall of Shortflatt Tower in a purpose-built niche (a). A small portable (b), was found in the same field (NT 082807), and the other two, now at the farm, were found in the adjacent field (c and d).

Ingoe *H00755 NZ 043759*

A very fine portable slab in a garden at Sandyway Heads was removed from a nearby field. It has an impressive well-executed design on one face and a cup and groove pecked lightly on the opposite face. The design fits the shape of the rock, and is thus likely to have been purpose-made for that slab. Nearby is the Warrior Stone.

Carry House Camp *H00765 NY 875 794*

The Rev Rome Hall wrote, 'I have met with one cup-marked stone in a hut-circle at High Carry House.' The site includes a rectangular enclosure with hut circles, cairns and 'ancient dwellings'.

Gunner Peak Camp, Barrasford *H00767 NY 9135 7485*

A $10\frac{1}{2}$ x $7\frac{1}{2}$ x 3in (0.263 x 0.193 x 0.08m) stone was found among the walling of an oblong building. It had cups of 1-2in (0.03-0.05m) diameter, five on one side and three on the other. It is now lost.

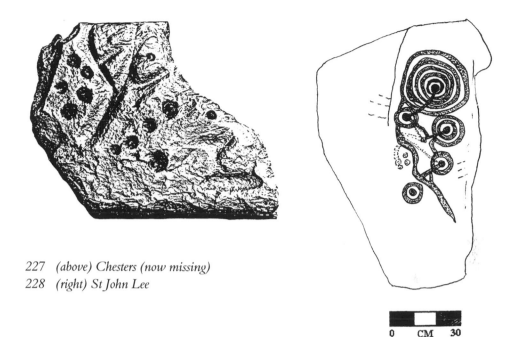

227 *(above) Chesters (now missing)*
228 *(right) St John Lee*

0 CM 30

Greenlee Lough *H00810 NY 775 694*

A single cup-marked stone, flush with the surface, lies on the edge of a Roman earth and stone-walled 'camp' that proved to be imposed on earlier 'cord-rig' cultivation. To the north-east is an abandoned shieling that has a marked rock that may have had a prehistoric origin, but worked much later into a large and smaller basin, connected by a thin serpentine groove or crack.

Chesters *H00783 NZ 909 703*

Two marked boulders have been found at the Chesters Roman site. In the Museum porch was a broken slab that is divided by branching grooves, on either side of which are 12 cup marks and an elongated groove.

At NZ 914 708 an excavation of the north bank of the River Tyne on the site of the Roman bridge abutment revealed a sandstone cobble with three clear cup marks. It was found at the south-east terminal of the northern water channel. Wedge marks on its long edge show that it had been split off a larger piece. As the Romans used quarries some distance away from the Wall, it is not possible to say precisely where it came from.

St John Lee *H00784 NY 9370 6559*

The ridge on which the church stands is a terrace of the River Tyne on the opposite bank from Hexham. The ridge has been ploughed for arable farming, which may have destroyed monuments; nearby quarries at the junction of the two rivers to the west have destroyed early Bronze Age graves. The ridge is an important landscape feature, high above the floodplain, and under some large beech trees, among field clearance close to the church, a marked slab was found by a lady out walking her dog. The slab from there is now in the church, thanks to the action of the PCC. I had recorded it *in situ*, and noted that there were chain marks around it where it had been dragged from the field to join

177

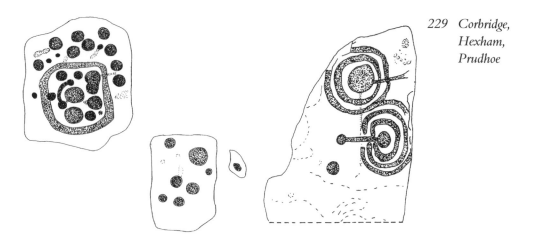

229 Corbridge, Hexham, Prudhoe

a pile of stone, some cobbles. It was not in its original place; despite the battering it had received from machinery, the motifs were clear. The slab is now displayed in the church between the font and a Roman altar.

It is likely that this well-designed pattern could have been purpose-made for a cist, but we cannot say for certain. It does fill the slab very well and the design appears complete.

Shield Croft Farm, Hexham H00784 NY 944 634

Two stones in a garden came in with hardcore, so we do not know their origin. One is a slab with seven cupmarks; the other, a small cobble, has one oval cup.

Corbridge H00782 NZ 982 648

A massive block of sandstone lies on the foundations of buildings to the north of Stanegate within the Roman settlement of Corbridge (Coria). It is not possible to say whether the Romans cut it from outcrop rock to incorporate in the building; it seems most likely that prehistoric people made the pattern on this flat-topped boulder, as the design has not been cut up. The site is a multi-phase one, with both Mesolithic and Iron Age represented.

Prudhoe Castle H00781 NZ 092 634

During excavations by the Department of the Environment, a decorated stone was found face upwards in the foundations of the early fourteenth-century hall. I was asked to record

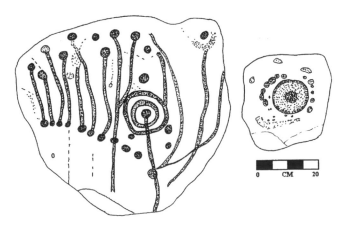

230 Hunters Hill and Nafferton

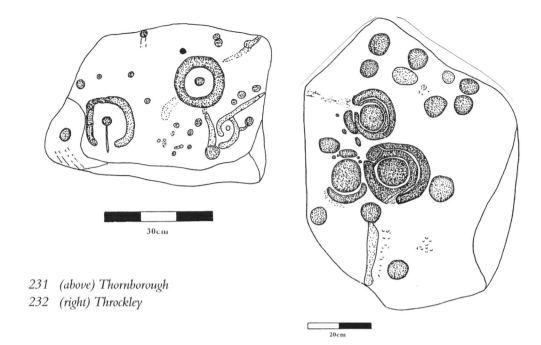

231 (above) Thornborough
232 (right) Throckley

this stone, which has now been erected outside the visitors' entrance to the castle. It is likely that the stone was cut from outcrop rock and used as building material without any regard for any other significance.

Hunters Hill NU 071 648

South of the A69 east of a minor road to Ovington is a wide trackway cast that leads past Overdean farm to the Whittle Burn, a tributary of the Tyne. At a site called Hunters Hill the track is banked on either side by field clearance which accentuates it in some places to a hollow way; among the stones and other rubble, among holly and hawthorn, a large sandstone boulder that is illustrated here was discovered and photographed in 1984. The stone has disappeared, and conversation with the farmer at Overdean confirms that it has probably been broken up and used for building. He had no idea that it was there. It seems likely that the boulder was a glacial erratic that may have been originally on or near Hunters Hill, a striking feature that commands views across Whittle Burn to Prudhoe and beyond. There is nothing quite like it anywhere else in the north, with such a profusion of linked cups.

Thornborough High Barns H00788 NZ 0210 6480

A displaced boulder lies on a public path under a fence. From it there are wide views south across the Tyne valley.

Nafferton c.NZ 655 060

A cup marked stone was found in the Nafferton farm area, north-west of Hunter's Hill, north of the A69 and north of the same feeder stream of the Whittle Burn. The stone has a 6cm deep cup, finely tooled and narrowing towards the bottom in a compact heavy sandstone block. There are pick marks around the cup, which may be the beginning of a ring.

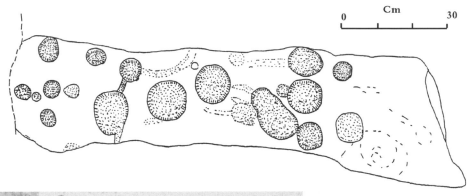

Cm
0 30

233 (above) High Shaw
(left) Allenbanks

Throckley Bank *H00806 NZ 149 667*

This is part of Tyne-Wear, but it is appropriate to report the discovery here. When I first recorded the stone it was lying just inside a wood to which the public has access. I was told that it came from a field to the south of the Roman vallum. Since then it has been turned face-downwards to protect it from damage. There are few marked rocks south of the Tyne.

High Shaw Farm *NY 8100 5917*

A cup-marked gatepost leading into the farm is a rare example in this part of the Shire. The source may be a quarry to the north, about 200m away, a prominent place in the landscape. It has some large well-made cups, mostly round and one oval. 17 are definite; there are three other possibles. Two of the cups are joined by a short groove.

Allen Banks

On the riverbank on a popular walk at Allen Banks near Ridley Hall, Michaela Long found a water-rolled cobble with a very fine cup mark. It could have been rolled for some distance by the river.

Joicey Shaft *c.NY 829 665*

Two large cup-marked earthfast boulders, 2.5m apart, were found recently at a site north of Haydon Bridge just beside a trackway, thus extending the area of finds.

One of the most recent discoveries was seen by many people on the *Time Team* programme, on Holy Island when a large stone fragment found in a trench had cup marks on two sides. Other portables with no fixed location are drawn here; they are in the stone store at the Museum of Antiquities, Newcastle.

234 Unprovenanced stones in the Museum of Antiquities, Newcastle

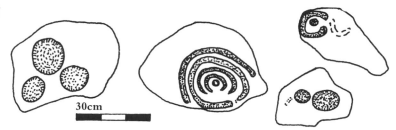

30cm

Mount Farm, Simonburn *NY 853 742*

Soon after completing this study I was asked to look at some very unusual formations on a sandstone boulder by a stream, possibly fossils, and to examine a crumbling defensive tower. At the end of the day I was stunned to discover a large boulder at the end of a wood in such a position that it commands a great sweep of landscape in south Northumberland. So here it is: a boulder that has been pushed over from its flat base with, of all things, some very clear linked cups on what must have been the top of a standing stone. I had been telling friends that I was really at the end of my discoveries, and that there was no more to say. The new discovery will join the archive; meanwhile I share its picture with you.

235 Mount Farm, Simonburn

5 What do we make of all this?

You have been given a detailed picture of what we know about rock art in many different contexts, and the drawings and photographs may well have provoked a reaction. The universal nature of these symbols has led some people to speculate that they have a common origin within the human neural system, by observing that the making of concentric circles and spirals, for example, is inherent, especially in young children. Others in our drug-obsessed culture have seen in primitive societies an origin of the symbols in drug-induced states of trance. Others do not think it necessary to attribute this to drugs, but to states of trance produced by dance or rhythmic chants and clapping. Observations of many Third-World living cultures have been used to support this argument.

This is all speculative, but it is understandable that we want to know, for example, why some Californian rock art looks like panels in Northumberland, or why there are strong similarities between Galician rock art and British. Producing theories about what they mean is not surprising because you can often see in them whatever you are looking for. Ronald Morris did a great service to archaeology when he investigated the large number of theories and put forward 'one hundred and four varieties' of explanations in his book *The Prehistoric Rock art of Galloway and the Isle of Man* in 1979. He was a solicitor, used to weighing evidence, a scholar and discoverer of rock art, and his informative and amusing excursion resulted from his observations, reading, and contacts with many people working in this field. He looked at all the theories, and gave them marks out of ten.

He supported Professor Thom's arguments that some were placed on standing stones that had important astronomical alignments. He noted their use and reuse in burials. One of his strongly-held beliefs was that their proximity to copper and gold sources was deliberate, but others see this as merely coincidental. He was strongly convinced of their religious and magical significance, but not at all moved by theories that they denote breasts, the Mother Goddess, eyes and phallic symbols, or that they were connected with fertility rites. He pointed out that there was no evidence to link them to sun worship, water divining, their use as mixing vessels, for casting bronze or colour, quantity measures, or the Freemasons' earliest symbol, the All-Seeing Eye.

Copies of worm casts, tree rings, and ripples made when stones are thrown into water were given very low marks. Druids don't come into it because they didn't exist then, and the idea that blood was poured into the grooves is not supported by any evidence. Their use as clocks was dismissed. Messages from outer space rated zero. He listed other theories such as bonfire ritual site markers, an aid to seed production, early pilgrimage marks, dye and transfer moulds, maps of the countryside, building plans, star maps and a tattooist's shop window.

Although he dismissed suggestions that the markings were placed where they were in the course of some sort of search for food, and gave the theory 2/10, we believe that there is a more convincing case here, and that they could be boundary markers of sorts (1/10) and route markers. Could they be merely decoration? Doodles? Could they have been games? Do they represent parts of animals? Are they primitive lamp bases? Water images?

Among the explanations that he dismissed completely were their use as secret treasure maps, plans of megalithic structures, for mazes, field ploughing plans, victor marks, early masons' marks, marks made by adders coiled up on the rocks, an early form of musical notation, a tuning device whereby wise men could alter the pitch of a rock's natural vibration by chipping it, a locked-up force, worship of the sea goddess, markers for healing wells, children's art, or just natural marks. The rest of his research brought in oath marks, knife-sharpening marks, early astronomers' night memoranda, and inclusive birth-growth-life-and-death symbol, healing magic, a mirror with its handle, and a womb symbol.

This breathless list of possibilities will no doubt grow, but the crucial point is that the acceptance of any theory is that it must be supported by evidence. It is different from simply having a 'gut reaction'. Because contact with rock art can produce strong reactions, including a great sense of wonder, one must remember that poets, other writers and visual artists are going to respond to it in different, personal ways. This is to be expected and encouraged, but no theory of origin and use can be accepted unless there is evidence to back it up. Sadly, we are being plagued with some quite absurd 'explanations' of the rock art symbolism that exist only in the minds of the proponents.

Meanwhile, we have many other questions about Northumberland's rock art to occupy us. There are other regions in Britain that have concentrations of rock art; why is it that we have so much and in such a variety of contexts? Why is art in the landscape concentrated so much in the north of the county? Why is there so much portable rock art?

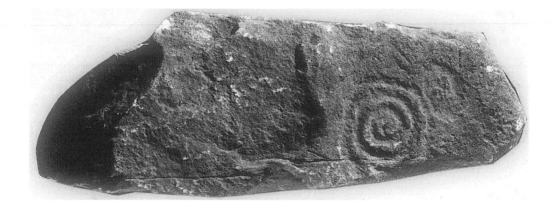

6 The future

The detailed archive and the substance of this book show that in Northumberland we have a good tradition of reporting and recording rock art. This has been done largely by individuals who have been self-supporting and who have worked for the best of motives: interest. Now that rock art has been recognised as nationally and internationally important as a vital part of the archaeological record, money and time have become available to further its study. Researchers and recorders do not have to start from scratch in this county; that is very obvious, but they can now bring extra skills to bear. Hopefully that will give us more information and a highly developed recording system, but whether it leads to answers to questions posed at the beginning of this book is another matter.

The Rock art Pilot Project commissioned by English Heritage in 1999 is the first concerted attempt to find out what techniques have been and should be used for a study of rock art, and to lay out a programme for the future. At last this means that English Heritage has recognised it as a priority in its research agenda. The project recognises the need for a common language in a set of definitions. No one will disagree with the terms used to describe its situation: in the open air/landscape, in monuments, and on portable stones. Those of us who have been writing for years about rock art have become accustomed to using a term like 'portable', and prefer that to 'mobiliary', because it implies people doing the moving. When we look at a perfectly clear term like 'cup', and are presented with the alternative 'cupule', which is an aesthetically awful word, with connotations of some sort of skin disease in its sound, we might not wish to change. In fundamental 'units of record' there are definitions that can be argued about. For example, whereas I prefer to see a single element, such as a cup, as a *symbol*, and a combination of symbols as a *motif*, others may see it the other way round. The Oxford English Dictionary defines *symbol* as a representative sign or mark; it is a summary. To symbolise also means 'to combine, to unite with elements to form a harmonious union'. A *motif* is 'a constituent feature of a composition, an object or group of objects forming a distinct element in a design'. The term *engraving* is inaccurate for a process that depends on using a pick. Some object to *rock art* as a term because it clearly is not all 'art'. Dictionary definitions too make *carvings* a dodgy term, because carving means to cut and is often used synonymously with *sculptures* and *engravings*. Carving, according to the OED 'is now usually restricted to work in wood, ivory, etc., sculpture being work in stone'. So we have compromises to make through discussion in order to agree on our essential terminology, and my hope is that it will be as simple as possible so that we make it easy for everyone.

Just as we need a common language to define what we are recording, we need a common system of recording. The best ways are the most expensive, so we have a problem. A laser scanner is an excellent way of recording what is on a rock surface. A GPS system that

locates the exact position of rocks on the earth's surface through satellites is the best way to pinpoint the rock's position so that it can be found even when covered up. To make sure that a rock is not recorded twice in different positions and to locate it, some form of electronic tagging is possible. Once the positions are plotted on a map, the sites can be related to all other finds in the area.

The standard of recording what is on the rocks varies considerably. At one end we have the equivalent of pin-men figures, simplified, inaccurate, and telling us very little about, for example, differences in depth of pecking or about order in which the marks were put on. At the other end we have an accurately scanned image that can be reproduced three-dimensionally. My own recording has been based on wax rubbings that take hours of patient work. I am happy about the results as I have had plenty of practice and means of comparing results with conventional and digital photography at different seasons and in different lights. If too many people make rubbings, it might endanger the rock surfaces.

The use of substances, even chalk, on marked rocks is not to be encouraged; this imposes an interpretation on the supposed pattern that often proves inaccurate. The use of colour in grooves is making an assumption about the prehistoric use of rock art that is totally unjustified. It forces the next visitor to see it that way; it is a kind of arrogance. It is better to leave them alone and view them when the sun is low in the sky, for sharp shadows do so much to reveal subtleties. The worst episode that I observed in Northumberland was when some group painted inside the grooves at Roughting Linn with gloss paint and lit a bonfire in the wood.

Another important element in recording is to give details of the condition of a rock and its immediate surroundings. Some of my earliest photographs at Weetwood site 3 were taken in black and white in 1970 when the rock was covered with lichen. At that time the rock outcrops were in heather moorland. Since then a combination of animal access (and all that it involves) and increasing visitor interest, has discouraged lichen. The images taken recently are still very clear, but the rock is quite bare.

There is a wide implication in this example: we need to know what threats there are to rock surfaces, not just from being plough-scratched, trampled by animals or people, but what growths are bad for them. Does lichen growth (and of which kind) protect a surface or destroy it? Does it protect it from further erosion? What about pine needles? Are they acidic? Coniferous trees have been planted on two major sites. Should they have been? How far are planning authorities aware of such considerations?

The immediate environment of rock art has been little studied. A programme is needed in which we can more carefully look for clues about what the immediate landscape was like at the time when art was pecked on the rocks. There are some important questions that we pose, and palaeobotanists may be able to answer. We need to know what was growing around the marked outcrops at certain times so that we can begin to understand what could have been seen from them thousands of years ago, otherwise our assumptions about their being at viewpoints remains conjectural. If we could go even further and determine whether there were woodland clearings and paths we would be able to further understand how the marked rocks were used to focus on some particularly significant places. Of course, there may not be any material there today to give us such information, and we must be prepared not to know very much. That some material is present is indi-

cated by the uneroded rock surfaces that sometimes emerge; if they have been covered for so long since they were made, perhaps the surrounding soil may also be relatively undisturbed.

Another issue to be addressed is that of access. Whose rock art is it? Should people be excluded from it? It is the responsibility of all landlords, tenants and County authorities to agree on a programme of access and display of rock art sites. Some sites are fragile and should be covered over if that is the best way to protect them. Others are more robust and have been open for centuries without much harm, such as the main rock at Old Bewick, where erosion may have deepened the grooves on its sloping surface. If we have money to spend on our past, one way forward might be to get landowners to set aside patches of ground and access to them, and to co-operate with them in its management and access. Once a spread of rocks to which the public has access is agreed, and others covered over, the next issue is how they should be displayed. An example of intelligent and sensitive practice is to be found in the Kilmartin area of Argyll; there the largest panel of rock art in Britain has been cleared of trees and scrub, surrounded by a fence which has a wooden walkway in parts, and provides the visitor with information panels that blend well into the site. We may not like the idea of metal fences, but it is one way forward. One only has to visit the Cow and Calf rocks on Ilkley Moor to see the results of terrible vandalism on open sites. We may not be able to control it fully, but we can make it clear to the public why these sites are important by giving them concise and interesting information, and by appealing for their help to preserve them.

People enjoy rock art. Thousands have bought books about it. Pieces of pottery and flint implements may be some of the things that help us to understand the past, but people like being in a vast, beautiful landscape, able to stand at a place with great views, look at art on the rocks, and to continue to wonder. People love places. People love a mystery. Give them the chance and they will be the best preservers of our rock art heritage. Try to exclude them physically, intellectually and spiritually, and they will resent you, for rock art is not exclusive to a favoured group. It is the earliest means of 'communication' that we have in symbols with people from the deep past. It will continue to intrigue us, worry us, and we want to remain linked to it.

Northumberland Rock Art in the New Millennium

Since this book was first published in 2001, there have been a number of significant developments in the UK rock art studies, which have increasingly nudged it from the fringes to the centre of archaeological practice. The first major development was an Arts and Humanties Research Board funded project awarded to Professor Geoff Bailey, Dr Clive Waddington and Glyn Goodrick, at Newcastle University, for a project entitled 'Web Access to Rock Art: the Beckensall Archive of Northumberland Rock Art'. I was extremely fortunate to have been given the opportunity to undertake the project, between 2002 and 2004. This involved working closely with Horacio Ayestaran, Marc Johnstone, Jess Greenwood (née Kemp) and, of course, Dr Stan Beckensall to create the database and deliver the website, which was launched in January 2005. The work with Stan Beckensall revolved around recording known and newly found panels, digitising his line drawings and pictures, and utilising his written descriptions of rock art and then include all of this in the website, which we called the 'Northumberland Rock Art: Web Access to the Beckensall Archaeology' (http://rockart.ncl.ac.uk). The website broke new ground in the UK and internationally for providing open access to a large corpus of rock art data and supplementary material. At the beginning of the project we didn't know the extent of the Northumberland rock art assemblage, however, at its completion we had information on about 1060 rock art panels. The Beckensall website confirmed what many of us had suspected through a long history of public engagement about rock art such as giving public talks and leading trips that there was widespread public interest in ancient rock art: in its first three and a half years the website received over 17 million successful hits from about 110,000 individual web visitors who derived from over 100 countries!

The Beckensall website project was succeeded by the English Heritage funded Northumberland and Durham Rock Art Pilot project (NADRAP; 2004–2008), which continued with the recording of rock art in Northumberland and created a website entitled 'England's Rock Art' (ERA; http://archaeologydataservice.ac.uk/era/). This project added three important elements to the study of rock art in the north of England. Firstly, as reflected in its title, NADRAP included Durham County, which meant that an additional 300 panels were recorded, thereby complementing the Northumberland datasets and significantly expanding the corpus of data available to rock art specialists for research and for the public to enjoy. Secondly, NADRAP enriched the recording of rock art using photogrammetry; hundreds of panels were recorded using this technique greatly enhancing the visual insights that we are able to obtain for rock art. Thirdly, NADRAP involved around 100 volunteers in the recording of known panels and the discovery of new ones. The NADRAP model of involving volunteers in rock art studies has recognised that archaeology should be open to all as reflected in the recently established Tyneside Archaeology 'north of the Wall' society

that has discovered and recorded new archaeological sites that include rock art panels at Ravensheugh, Standing Stone Ridge and Sewingshields. Stan Beckensall was invited to be President of that society, in recognition of his contribution to archaeology, including the study and popularising of rock art.

Another two rock art initiatives can be traced back to the Beckensall project: (i) the first, led by Newcastle University, is the Arts and Humanities Research Council (AHRC) funded 'Rock Art on Mobile Phones' (2010–2011) project, which was led by Areti Galani and myself and supported by Deborah Maxwell and Kate Sharpe. Its aim was to 'enhance visitor experiences at rock art sites…by re-purposing information and images from Beckensall and ERA, and delivering them on site via a mobile platform'. This was achieved focusing on the Northumberland rock art areas of Dod Law, Lordenshaw and Westwood Moor (http://rockartmob.ncl.ac.uk/). (ii) The second, acknowledging the importance of the protection and management of rock art, combined Newcastle University (David Graham, Myra Giesen and myself) with Queen's University Belfast (Patricia Warke) in a joint effort to enhance understanding of the factors influencing the decay of rock art and to explore scientifically robust methods of monitoring these processes. This research project, entitled 'Heritage and Science: Working Together in the CARE of Rock Art' (2013–2014; http://research.ncl.ac.uk/heritagescience/), jointly funded by the AHRC and Engineering and Physical Sciences Research Council, has focused on Northumberland, Dunfries and Galloway (Scotland) and Donegal (Ireland).

Reflecting back on the last decade, the Beckensall website and NADRAP projects have not only led the way internationally in providing unrestricted access to large rock art datasets that are now available for research, but they have also laid the platform for additional work into the public presentation of rock art and the safeguarding of this vulnerable heritage resource. While these developments are very encouraging it needs to be acknowledged, that only limited advantage has been taken of the extensive datasets that we have for over 1500 rock art panels in Northumberland and Durham to generate new insights into the lives and history of the Neolithic and Early Bronze Age people who created them between *c*. 3500 and 6000 years ago. More research is required, for example, into the different types of motifs and designs spread across the extensive landscapes of these counties to investigate the distribution of motifs and designs and what this can tell us about the regional differences among the people and communities that existed thousands of years ago? Furthermore, we need to know more about the age of rock art so that we can integrate it more effectively with the other types of knowledge that we have about Neolithic and Early Bronze Age society, such as their subsistence and funerary practices. This will be achieved, in part, by carefully targeted excavations that systematically explore the context of the rock art through focusing on posts, ditches, enclosures and other associated features. Plans are underway at Newcastle University to secure funding to undertake excavations at selected rock art panels and to analyse the extensive Northumberland and Durham rock art datasets. Should this happen, it will build handsomely on the achievements of the Beckensall and NADRAP projects and usher in another new phase of rock art research in the north of England.

Aron Mazel
International Centre for Cultural and Heritage Studies,
Newcastle University

Bibliography

This bibliography is selective. Many of the books listed contain extensive references for those who wish to read more; the archive will give more details.

General surveys

Beckensall, S. 1999. *British Prehistoric Rock Art*. Tempus

Beckensall, S. & Laurie, T. 1998. *Prehistoric Rock art of County Durham, Swaledale and Wensleydale*. County Durham Books.

Beckensall, S. 2005. *The Prehistoric Rock Art of Kilmartin*. Kilmartin House Trust

Beckensall, S. 2002. *Cumbrian Prehistoric Rock art*. Tempus.

Beckensall, S. 2001. 'British Prehistoric Rock art in the Landscape', in *European Landscapes of Rock art*. Ed. Chippindale, C. & Nash, G. Routledge.

Beckensall, S. 2001. 'British Rock art', in *Entering 2000: the State of rock art (20 years of C.A.R.)*. C.A.R., Comite International ICOMOS pour l'art rupestre.

Bradley, R. 1993. *Altering the Earth*. Edinburgh.

Bradley, R. 1997. *Rock art and the Prehistory of Atlantic Europe*. Routledge.

Bradley, R. 1998. *The Significance of Monuments*. Routledge.

Bradley, R. 2000. *The Archaeology of Natural Places*. Routledge.

General works on Northumberland

Beckensall, S. 1983. *Northumberland's Prehistoric Rock Carvings*. Rothbury

Beckensall, S. 1991. *Prehistoric Rock Motifs of Northumberland. Vol.1*. Hexham. (Privately printed, now out of print)

Beckensall, S. 1992. *Prehistoric Rock Motifs of Northumberland. Vol.2*. Hexham. (Privately printed, now out of print)

Bruce, J.C. 1869. *Incised Markings on Stone*. London.

Tate, G. 1865. *Sculptured Rocks of Northumberland and the Eastern Borders*. Alnwick.

Articles on prehistoric rock art directly relevant to this text

Beckensall, S. 1976. 'The excavation of a rock shelter at Corby's Crags, Edlingham', *Arch. Aeliana* (5), 4, 11-16.

Beckensall, S. & Frodsham, P. 1998. 'Questions of Chronology: the case for Bronze Age Rock art in Northern England', *Northern Archaeology* 15/16.

Beckensall, S. 1995. 'Recent Discovery and Recording of Prehistoric Rock Motifs in the North', *Northern Archaeology* 12.

Bradley, R. 1996. 'Learning from Places — Topographical Analysis of Northern British Rock art', *Northern Archaeology* 13/14. Newcastle.

Burgess, C. 1990. 'The chronology of cup and ring marks in Britain and Ireland', *Northern Archaeology*. Newcastle.

Frodsham, P. 1996. 'Spirals in Time: Morwick Mill and the Spiral Motif in the British Neolithic', *Northern Archaeology* 13/14. Newcastle.

Harding, A. 1981. 'Excavations in the prehistoric ritual complex near Milfield, Northumberland', *PPS* 47, 87-135.

Hewitt, I. 1991. 'Prehistoric rock motifs in Great Britain.' Unpublished research thesis, Bournemouth University.

Simpson, D. & Thawley, J. 1972. 'Single Grave Art in Britain', *Scottish Archaeological Forum*, 4.

Waddington, C. 1996. 'Putting Rock art to Use. A model of Early Neolithic Transhumance in North Northumberland', *Northern Archaeology* 13/14. Newcastle.

Waddington, C. 1998. 'Cup and Ring Marks in Context', *CAJ* 8, No.1, 29-54.

Since 2002 there have been many important rock art publications. Many of these are listed in 2009 Beckensall, S., *Prehistoric Rock Art in Britain* (Amberley), to which the reader may refer to get a fuller picture.

Acknowledgements

My thanks to Gordon Highmoor for the book cover, Paul Brown for some of the maps, Irene and Ian Hewitt who shared my work for many years and to so many professional archaeologists, enthusiastic independents, landowners and tenants who brought to my notice many sites and points of view. Many friends have shared my enthusiasm for this research. The staff of Newcastle University have been particularly helpful, and their uploading of my archive onto a very successful website (http://rockart.ncl.ac.uk) has been an important event.

Index